industrial interiors

SHOPS

RotoVision

First Published in Singapore by
Page One Publishing Private Limited
20 Kaki Bukit View, Kaki Bukit Techpark II
Singapore 415956
Tel: +65 6742 2088
Fax: +65 6744 2088

ISBN 2-940361-03-7

First Published in the UK by
RotoVision SA
Route Suisse 9
CH-1295 Mies
Switzerland

RotoVision SA
Sales & Editorial Office
Sheridan House
114 Western Road
Hove BN3 1DD, UK
Tel: +44 (0)1723 727268
Fax: +44 (0)1273 727269
Email: sales@rotovision.com
Web: www.rotovision.com

10 9 8 7 6 5 4 3 2 1

Editorial/Creative Director: Kelley Cheng

Art Director: Jacinta Neoh

Sub-Editors/Writers: Hwee-Chuin Ang, Narelle Yabuka, Ethel Ong

Designers: Chai-Yen Wong, Sharn Selina Lim, Soo-Shya Seow

Editorial Coordination & Text
(in alphabetical order):
Anna Koor (Hong Kong, China)
Masataka Baba (Tokyo, Japan)
Meng-Ching Kwah (Tokyo, Japan)
Reiko Kasai (Tokyo, Japan)
Richard Se (Kuala Lumpur, Malaysia)
Savinee Buranasilapin (Bangkok, Thailand)
Thomas Dannecker (Bangkok, Thailand)

industrial interiors

SHOPS

contents

contents

introduction

Since consumer culture began with earnest in America during the 1950s, shopping has grown into somewhat of a national pastime in most developed nations. In fact, one could argue that it has become the primary mode of urban life, and further, that it even generates urban spaces. Shopping has certainly become a defining element of the urban city; shopping malls are taking over from the public realm of the street and square, and advertisements for retailers cloak architectural surfaces.

With the rapid expansion and proliferation of the shopping environment that is underway today, shop design has grown into a major branch of architectural and interior design practice. Competition between shops can be fierce, so shop design has had to move beyond the simple pragmatic considerations of product placement, circulation, lighting, sound, and street or mall presence. Today, shops must vie for the attention of customers by creating an attention-grabbing and memorable image that will not only stand out from the neighbouring outlets and reflect the products on sale, but that will stay in the customer's mind, prompting them to return.

With rich colour photographs and descriptive and analytical text, *Within Shops* showcases close to fifty of the most recent and exciting retail designs from around the Asian region, which range from a science-fiction inspired telecommunications "pod" in a Singaporean shopping mall, to a museological couture clothing shop in Bangkok, to a spacecraft-shaped menswear outlet that steals the show in downtown Akita, Japan.

From fantasy spaces to serious trading turf, *Within Shops* features fascinating outlets for established names such as Issey Miyake, Alain Mikli, Vidal Sassoon, Camper, Reebok and Toni&Guy, as well as many smaller locally-owned outlets that are by no means less cutting edge. Reflective of the new direction of the urban environment, these shops offer an exciting insight into the realm of retail design in some of the most consumer culture driven economies in the world.

SCULPTED SHEETS

paperpoint

Paperpoint is both a showroom and a retail outlet. The concept of referencing physical characteristics of paper (such as the ability to be folded and rolled) is used in form making, textures and displays within the store.

NAME OF SHOP **PAPERPOINT**
OWNER/CLIENT **PAPERPOINT**
ARCHITECT/DESIGNER **BBP ARCHITECTS**
PHOTOGRAPHER **CHRISTOPHER TALBOT OH**
TEXT **BARBARA CULLEN**
LOCATION **597 CHURCH STREET, RICHMOND, MELBOURNE, AUSTRALIA**
TEL (OF SHOP) **(61) 3 9421 5322**

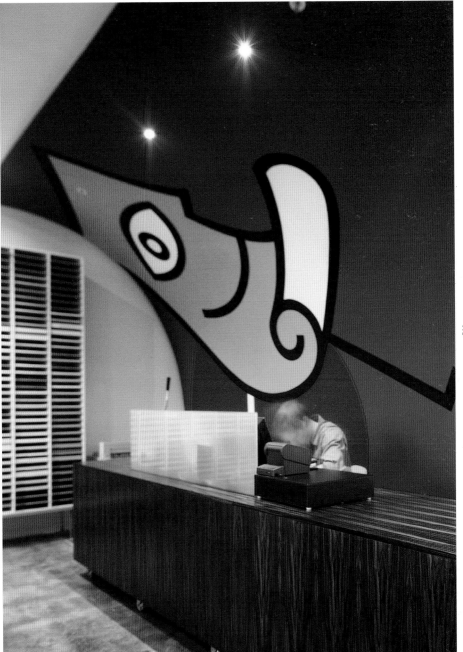

The main function of this small 645 square foot space is to showcase various paper products, ranging from interesting paper for printing through to a wide variety of envelopes in varying paper textures and colours. It was a requirement that the interior would demonstrate Paperpoint's corporate identity both graphically and architecturally. The recurring "Paperpoint man" logo is commonplace to all of the Paperpoint stores, and here he emerges at the rear of the shop, on a wall resembling curled paper, which creates a backdrop to the space. This curved wall rolls up the back wall and terminates at the ceiling level. It articulates the space and gives the room a sense of exaggerated perspective.

The curved wall also acts as giant signage. Rather than fixing elaborate signage to the exterior of the building, the entire store is illuminated at night with particular emphasis on the rear wall. The result is a 3-dimensional sign showcasing corporate identity, product and space. This holistic approach has created a continued expression of identity and branding for the client.

Merchandise in the store is displayed in a variety of different display units. A wall of paper is displayed in a continuous library-style bookshelf unit with a rolling stair. Envelopes are displayed in mobile units on the floor. Each system allows for a diversity of displays, which can be changed regularly to showcase various products. The space is completed by a long counter at the rear, which acts as both a workstation and as a service counter for customers.

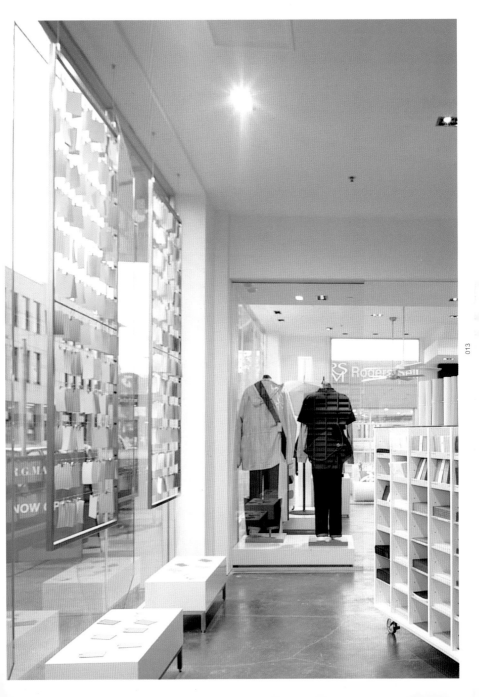

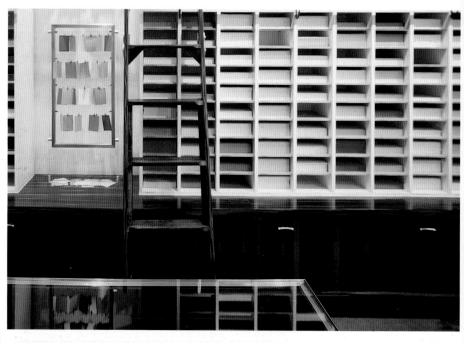

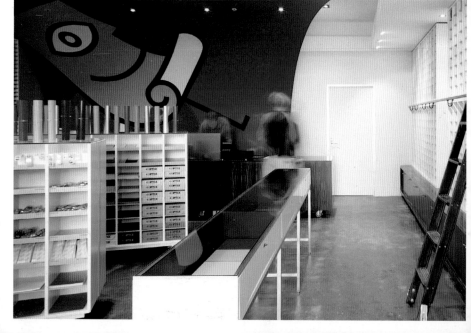

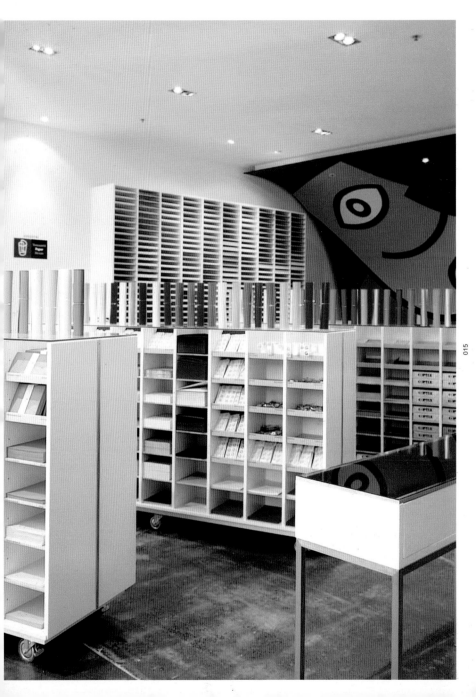

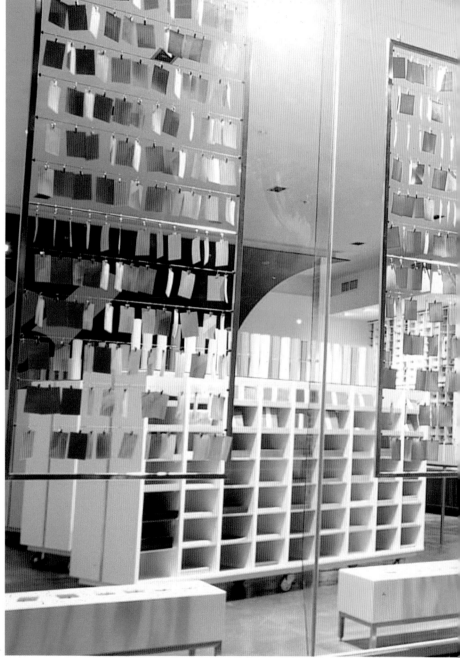

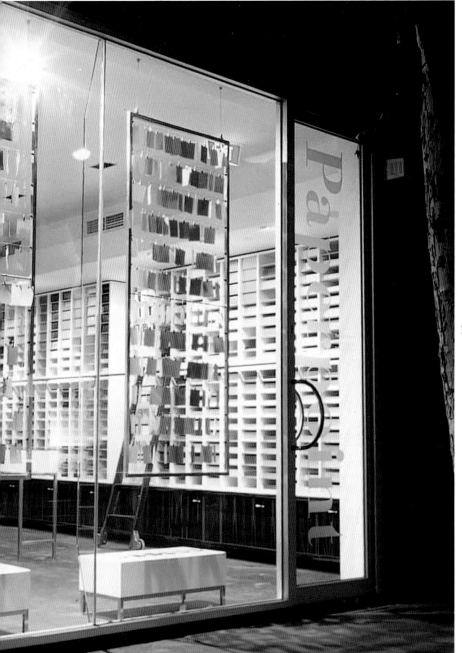

CLEAR AND SIMPLE

synergy hair

Synergy Hair in Sydney is an award-winning and enticing exploration of glass, voids and forms, carried out deftly by a designer who approaches his work with the aim of resolving material and detail.

NAME OF SHOP **SYNERGY HAIR**
ARCHITECT/DESIGNER **THOMAS JACOBSEN**
PHOTOGRAPHER **WELLIEM RETHMEIR**
TEXT **THOMAS JACOBSEN**
LOCATION **20 OXFORD SQUARE, DARLINGHURST, SYDNEY, AUSTRALIA**
TEL (OF SHOP) **(65) 2 9360 7739**

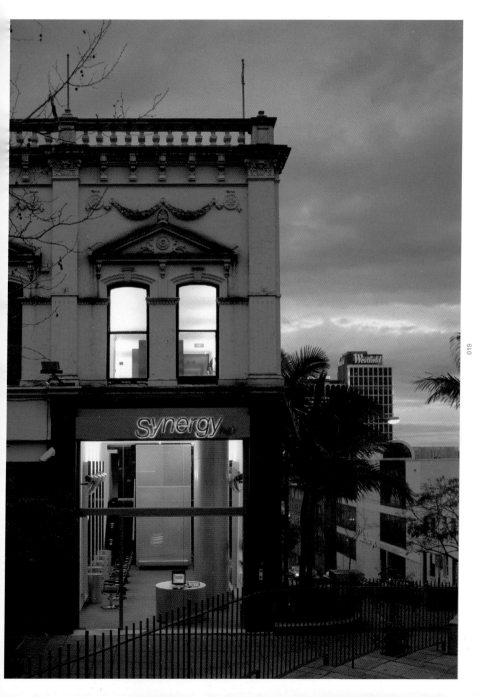

The Synergy Hair salon is a conglomeration of mirror, glass, stainless steel and aluminum, which are layered and repeated to provide an illusion of endless surfaces within the generous volumes of the existing structure. Internally, the existing structure has been stripped bare to support the new form. There are two levels, and each ceiling void is five metres from floor to finished level. Jacobsen's insertions serve to reinforce the strong volumes and scale inherent within this original structure.

Within the overall space there are more than 12 metres of blue resin glass in vertical lengths, which enhance the notions of transparency and reflection. There is an emphasis on verticality, with the mirrors at each workstation being 4 metres high. A new steel skeleton has been inserted into the old building, supporting a central staircase. The new staircase is a central point of the internal works, acting as a core within. The new shell has been designed as a glass curtain wall, which fuses the blue glass into the structure.

Two types of lighting have been installed: up-lighting designed by Porsche provides a non-directional source. This light is reflected onto the mirrored surfaces, and thus, all around the salon. In the evening, halogen down-lights are used for display and security.

When regarding the exterior of the building as a whole, what is actually the fabric of the interior appears to be a reflection of the skyscrapers of the Sydney CBD, which is close by. Only upon further inspection is the depth of the layering within the space revealed. Synergy Hair is a work of transparency. It is clear and simple without pretension.

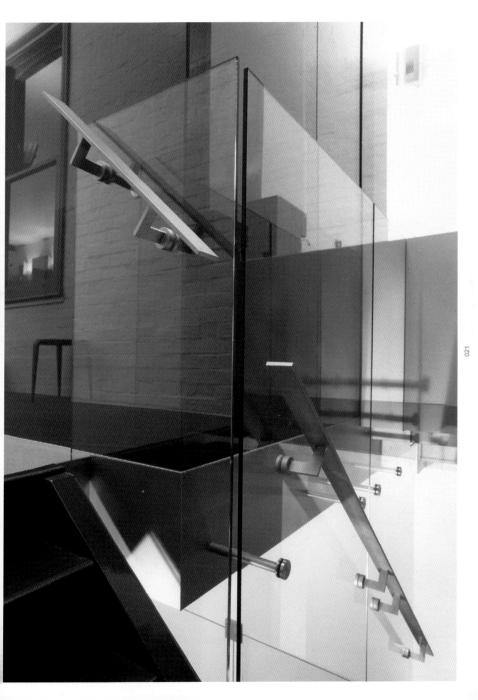

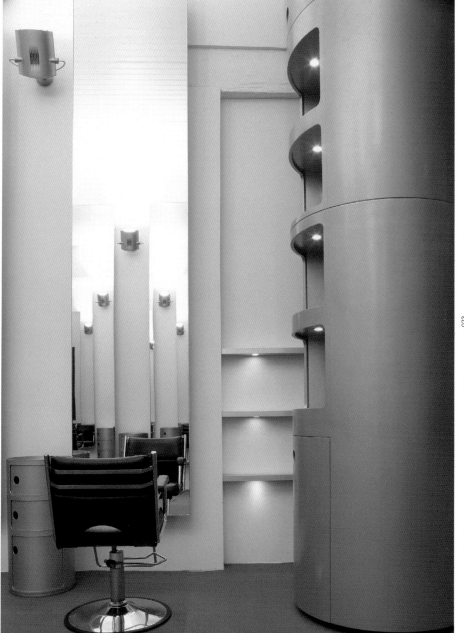

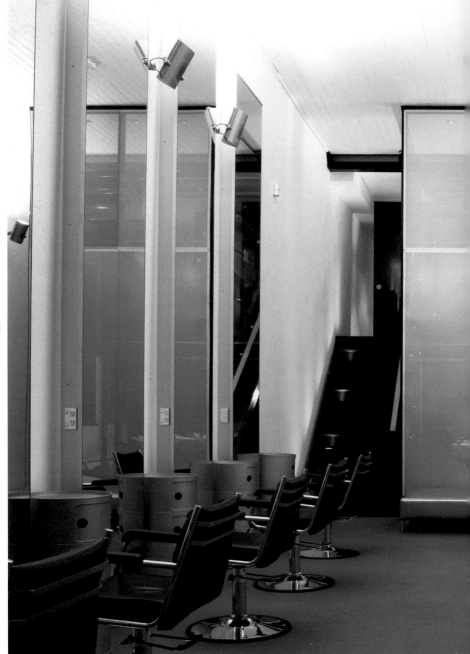

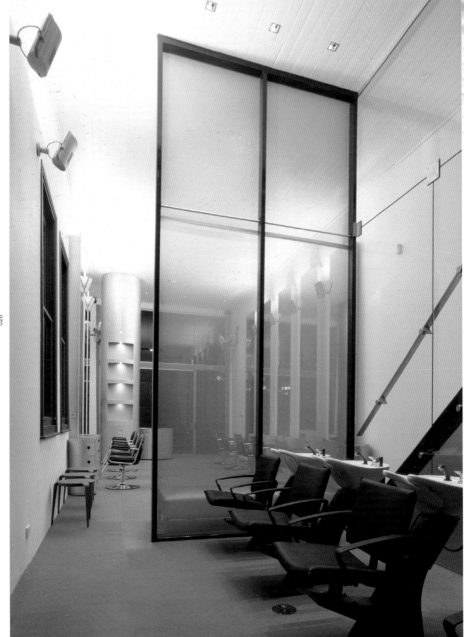

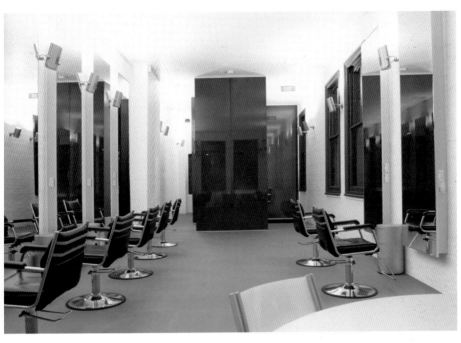

SEE AND BE SEEN

alain mikli

Eyewear designer Alain Mikli's desire is to maintain a constant balance between the technical aspect and aesthetic value of his products, and to promote the idea of "frames to see as well as to be seen". These sentiments equally apply to the interior concept for his first shop in Hong Kong, designed by Philippe Starck.

NAME OF SHOP **ALAIN MIKLI**
OWNER/CLIENT **MIKLI ASIA LTD**
ARCHITECT/DESIGNER **PHILIPPE STARCK**
PHOTOGRAPHER **VIRGILE SIMON BERTRAND/COURTESY OF MIKLI ASIA LTD**
TEXT **ANNA KOOR**
LOCATION **28 WELLINGTON STREET, CENTRAL, HONG KONG**
TEL (OF SHOP) **(852) 2523 0103**

With visibility being Mikli's specialty, it is no surprise that the boutique occupies a highly trafficked corner site marking the lower gateway to the Lan Kwai Fong entertainment playground. Besides his own collections of eyewear, clothing and bags, the 1,830 square foot shop had to create space for other ranges designed by Issey Miyake and Philippe Starck. The intention is to offer customers a panorama of the brand's creations. Technical innovation and ergonomics are paramount to the Alain Mikli product and the retail interior reflects this. What would normally be considered a sober palette of materials and finishes – timber, engraved windows and fine net drapes – is assembled to far greater effect than the sum of those parts.

Bar-height counters and stools for perching on are a significant departure from standard optical retail practice, leaving more room for casual circulation, but also room to stand and "pose" whilst experimenting with purchases. Impact is achieved through a gridded white monolithic facade of crushed marble. Why compete with the tangle of signage, colour and neon of one's neighbours when it's far more logical to do the reverse? The effect is almost detachment from context; the white cube of the shop looks more like a gallery space. The walls provide a solid frame to the glazed frontage, allowing passers-by to zoom in on the interior. A narrow layer of double height space just inside the entrance provides a glimpse of the upper floor.

A series of crystal glass cabinets stand just proud of the periphery. This appears to serve two functions, the first being to hang tissues of white sheer fabric as a soft backdrop against all that hard reflection. The second function becomes obvious with the temptation to delve right in and touch the product – an action that is abruptly halted with the realisation that the front of the cabinets are solid, and that access is permitted only from the rear.

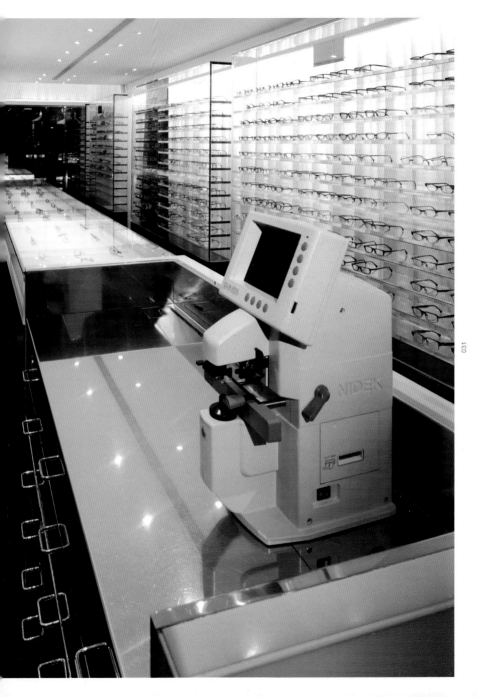

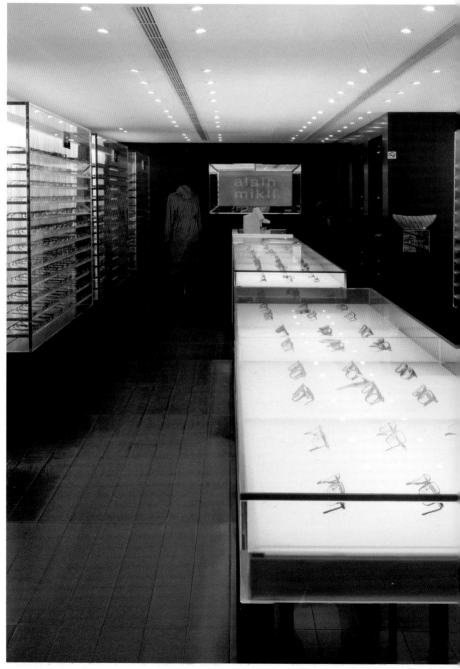

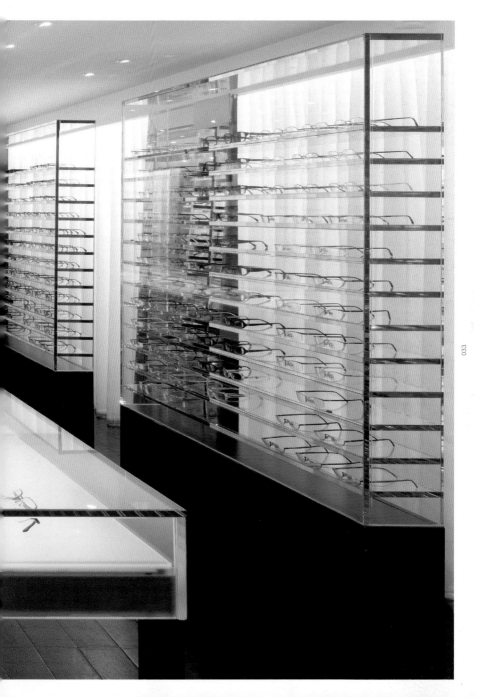

ORIENTAL ORCHESTRATION

beijing
hair culture

As its name suggests, this salon wishes to capture the niche market of oriental beauty. Its interior is grounded in the context of ancient Chinese symbolism, which is expressed through layout, materials and colour, and manipulated creatively from its primordial beginnings.

NAME OF SHOP **BEIJING HAIR CULTURE**
OWNER/CLIENT **BEAUTISEA LTD**
ARCHITECT/DESIGNER **SUNAQUA CONCEPTS LTD**
PHOTOGRAPHER **KEN CHOI**
TEXT **ANNA KOOR**
LOCATION **HYATT REGENCY HOTEL BASEMENT, TSIM SHA TSUI, HONG KONG**
TEL (OF SHOP) **(852) 2366 6208**

The 2,300 square foot plan is divided into four zones: the reception and frontage, the egg-shaped core that houses the operational and back-of-house facilities, the cutting floor, and the treatments area. A wall of stacked timber boxes along the window is a loose reminder of the geometry associated with traditional Chinese chests, and the choice of Rosewood also harks back to that era. The design was strictly guided by feng shui principles at the request of the client. Partially frosted glazing forms a visual barrier so that the clear entrance path directs positive forces towards the cashier's desk.

Feng shui considerations also dictated the balance and arrangement of certain elements and materials. The ovular management hub is pivotal to the axis of feng shui forces. Lying at the centre of the space, it provides a central focus through incongruity, both in its curving shape and laminated shiny brass surface. Its free-form presence, amongst such geometrical uniformity, is rationalised in terms of the paradoxical philosophies of Confucius and Tao, and is a statement of the coexistence of both.

Semi-private cutting booths are demarcated by Rosewood laminate partition walls sandwiched with self-illuminated perspex. Concealed sliding doors provide flexibility to screen off four areas for VIP customers. The divisions are generous enough to allow stylists maximum movement from all angles around each chair. In the washing area, intimacy and calm is reflected in subdued lighting and soft drapery. The colour palette has regal overtones – purple and gold reign in swathes of wallpaper. The obligatory red makes its presence felt in the seating, which is more akin to lounging sofas than the typical cutting chairs.

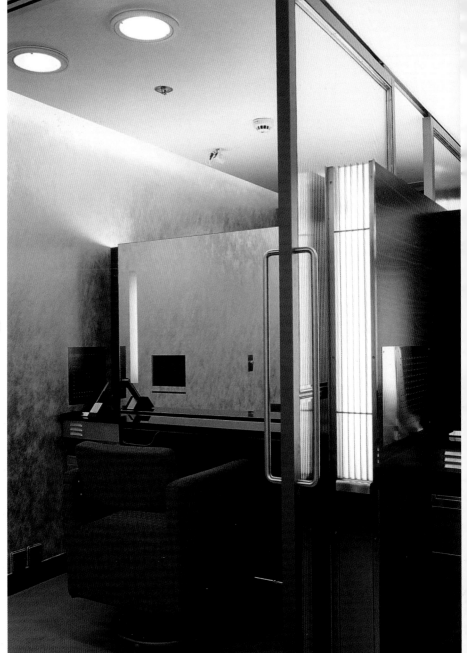

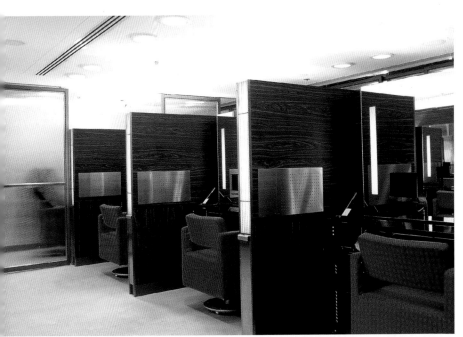

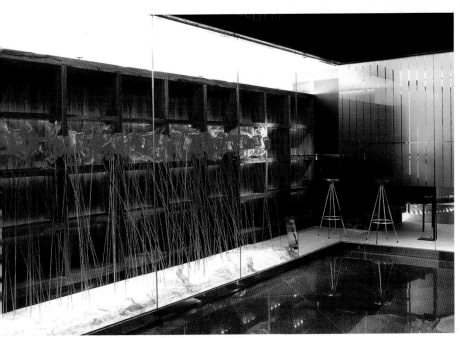

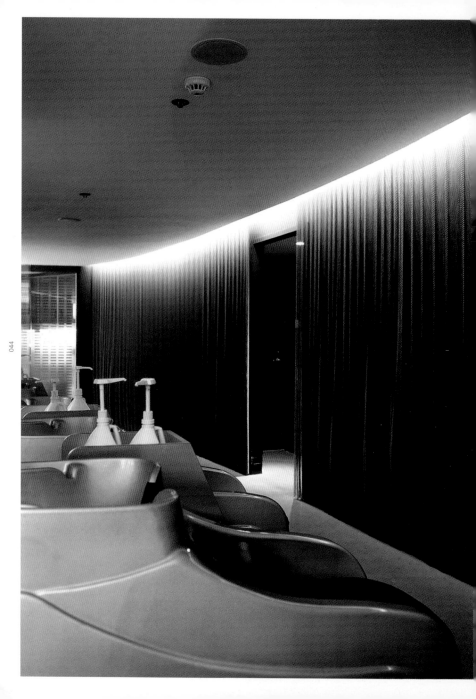

CLEARLY BRANDED

giga sports

A challengingly deep floor plan and the need to showcase a myriad of sporting merchandise in an organised fashion were the overriding issues that drove the interior design of Giga Sports.

NAME OF SHOP **GIGA SPORTS**
OWNER/CLIENT **SWIRE RESOURCES LTD**
ARCHITECT/DESIGNER **THREE DOGS STUDIO**
PHOTOGRAPHER **JOHN BUTLIN**
TEXT **ANNA KOOR**
LOCATION **1/F PACIFIC PLACE, QUEENSWAY, HONG KONG**
TEL (OF SHOP) **(852) 2918 9088**

Fitting Room

In the context of an increasingly competitive, and converging, retail market, it was critical for Giga Sports to distinguish itself as a professional sporting goods specialist and brand themselves clearly. Besides planning the layout of the store, Three Dogs Studio was also asked to develop the company's graphics and signage scheme.

The store is roughly divided between three zones, denoting the footwear, apparel, and functional products associated with particular sports. The overall identity of a store too often gets lost in a sea of brand names and logos. Rather than each sporting brand being accommodated by its own fixtures, the designers proposed a generic, modular wall display system for products that would project the identity of the retailer whilst ensuring that the merchandise receives maximum impact. Whilst each of the brands carried by Giga Sports is clearly recognised, the various labels are moulded into the overall identity of the store.

The interior fixtures are designed to cater to a volume of stock that is in constant flux. Shoe supports can be plugged in or out as desired. Racks and rails were rationalised into a minimal collection of multi-use components. Point-of-purchase signage can be mounted over fixture islands. A grey/white wall grid has sporting connotations without being too obvious. This runs round the store as a continuous curving ribbon, thereby enhancing customer flow. Lines of sight are kept unobstructed so that patrons see right into the rear of the store. The colour palette is severely restricted in a bid not to fight with the multi-coloured nature of the product. However there are a few accents such as the soft upholstered seating benches. And at the back, a strict colour-coding system is adopted to signify the various sporting segments.

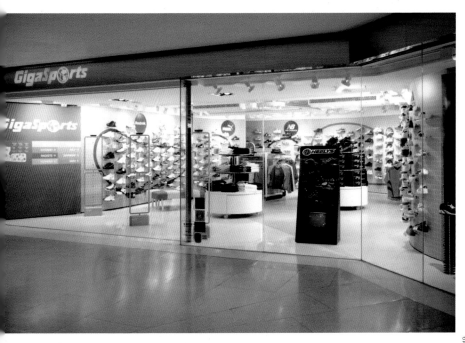

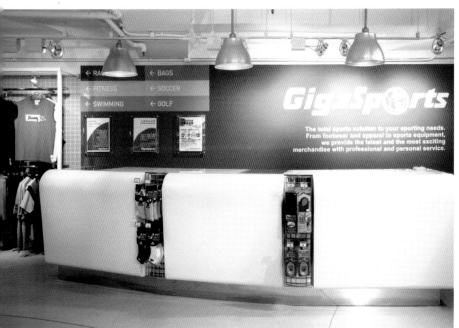

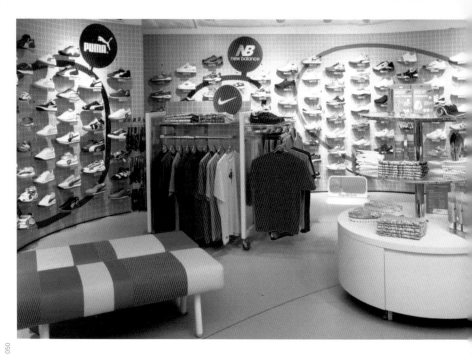

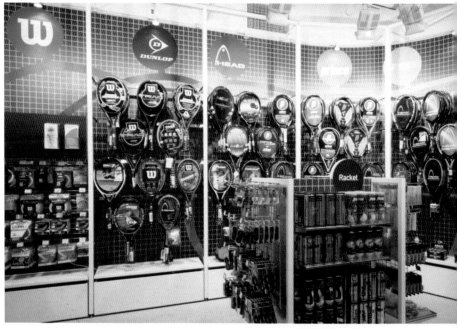

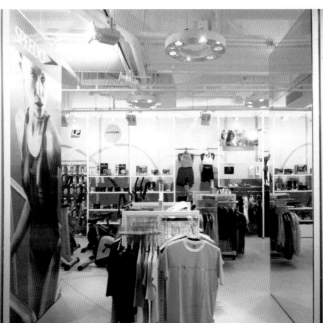

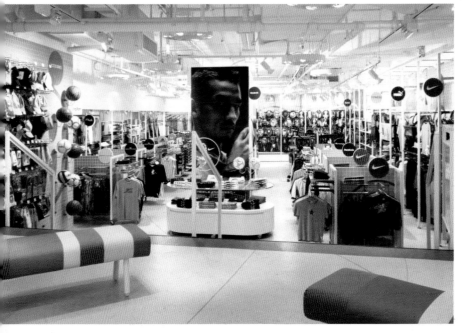

BETTER LIVING BY DESIGN

god ltd

This 22,000 square foot lifestyle emporium is a dramatic stage for GOD's furniture and homeware collections. The space was designed as a series of distinctive mini-environments in a semi-industrial shell.

NAME OF SHOP **GOD LTD**
OWNER/CLIENT **GOD LTD**
ARCHITECT/DESIGNER **ATELIER PACIFIC LTD**
PHOTOGRAPHER **JOHN BUTLIN/ARCFOTO PHOTOGRAPHY**
TEXT **ANNA KOOR**
LOCATION **LEIGHTON CENTRE, SHARP STREET EAST, CAUSEWAY BAY, HONG KONG**
TEL (OF SHOP) **(852) 2890 5555**

The semi-industrial context provided an invitation to explore familiar and often mundane materials that are associated with the local cityscape and domestic life – shop doors made of corrugated sheet metal, floors laid with old forklift pallets, and accent walls finished in discarded tea chest packing crates. Using these materials in unorthodox ways and lending them a new lease of life is a concept that fits well with GOD's philosophy of "better living". In the candles area, for example, the surfaces are covered in zinc plate, whilst in the bedroom area all of the shelving uses "reversed" plastic laminate to echo the effect of timber grain. A prominent street level frontage is formed by giant red and black interlocking circles. An adjoining gallery space incorporates a changing programme of art in support of local artists.

The layout encourages customers to embark on a journey through the various functional sections – living, sleeping, bathing, and so on. A large and airy all-day cafe anchors the store at one end whilst a forest of fresh flowers and plants occupies the other. However, different areas are subject to change, which is why they are treated as theatrical settings rather than fixed environments.

Volumes are created through sculptural forms, such as the distorted curving epoxy-resin wall enveloping the glassware; it emulates a micro version of the Guggenheim Museum in New York. Other graphic elements have been assembled from GOD merchandise, like the mosaic of ashtrays tiling a wall. Copious natural daylight and strategically placed openings offer visibility across the store to ensure that there is no danger of disorientation. From one area there are glimpses of other perspectives through unexpected openings or doors.

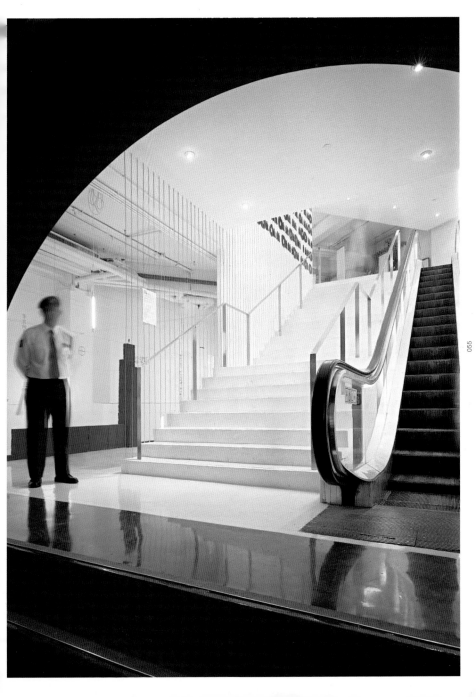

G G G G G G G G G G G G G G
好 好 好 好 好 好 好 好 好 好 好 好 好 好
D D D D D D D D D D D D D D

GoGo chair
Fabric Seat
Cushion Cover

3,640.-

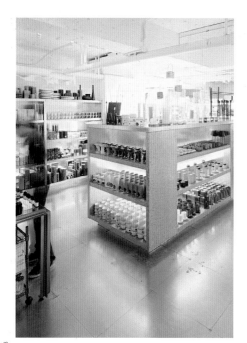

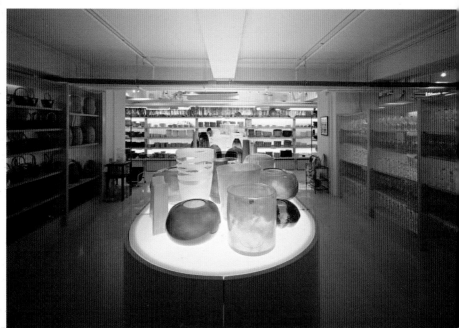

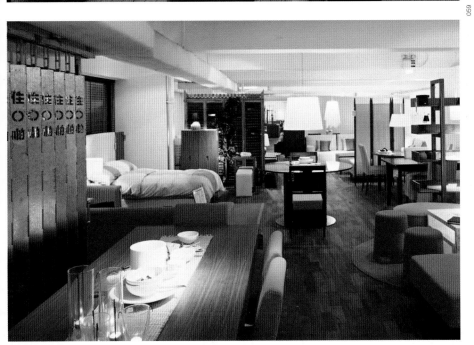

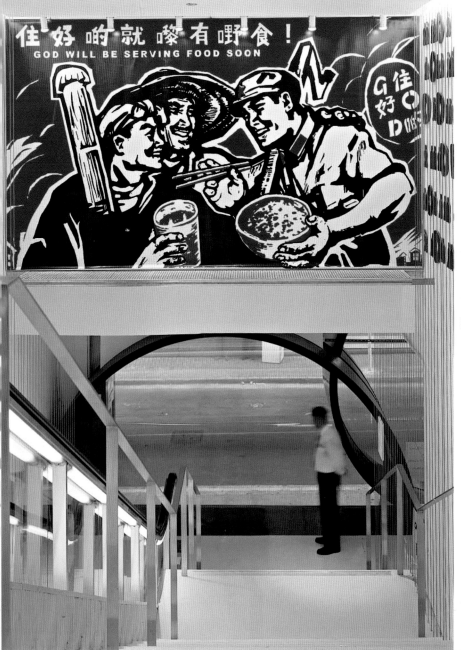

A NEW WASH OF SPACE

h2o pro

With fashion boutiques increasingly turning towards the soft sell in terms of visual merchandising, it comes as no surprise that the same marketing philosophy would eventually stretch to sanitary ware, as illustrated by H2O Pro.

NAME OF SHOP **H2O PRO**
OWNER/CLIENT **E BON GROUP**
ARCHITECT/DESIGNER **AB CONCEPT LTD**
PHOTOGRAPHER **ALMOND CHU**
TEXT **ANNA KOOR**
LOCATION **145 WONG NGAI CHUNG ROAD, HAPPY VALLEY, HONG KONG**
TEL (OF SHOP) (852) 2882 8136

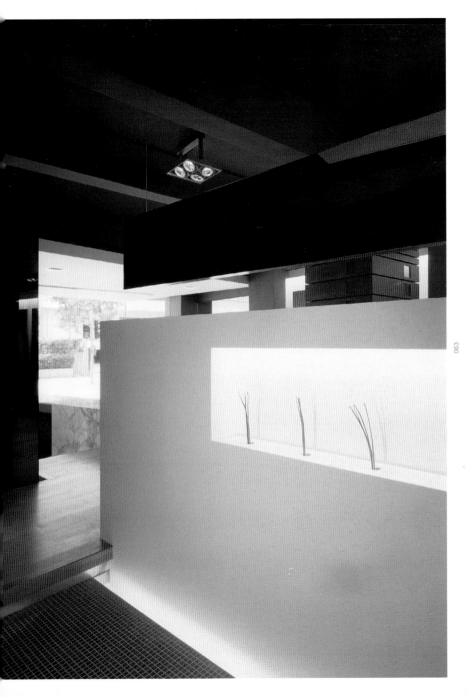

The H2O Pro shop intervenes on a stretch of home decor retail stores along
Wong Nai Chung Road in Happy Valley – an indication that the design of
one's washbasin or bath is becoming as important as the name on one's sofa.
The designers at AB Concepts had to tackle a long and narrow space with a
random smattering of structural columns and ceiling beams. The linear aspect
of the 1,200 square foot space lent itself to a series of successive layers and
a language of skewed surfaces.

Street presence is established through a clear composition of material forms
and the striking absence of product, save for a graphic wall and a single
sculptural ceramic piece – a combination that urges passers-by to enter. A
slab of Carrera marble greets customers, almost seeming to fight its way to
the pavement through the sliding glass doors. These penetrate a dazzling
white canopy. Rather than trying to organise the chaos inherited from the
structure, the designers decided that the only way to reconcile it was to
abandon the perpendicular, and subtly zig-zag the interior components. This
exercise was delicately manoeuvred so that even from the very beginning,
the rear glass wall is visible. The oblique angles create the necessary pull to
beckon customers further into the maze. The marble table is multi-functional
and is slowly consumed by the change in floor level.

Vertical panel walls add blocks of colour to backdrop the stark ceramics
mounted against them. The sporadic columns are utilised to support a flexible
display infrastructure. Horizontal bands of darkened oak, in different widths,
form a hanging surface. These can be removed or changed around easily,
thereby accommodating a diverse array of product.

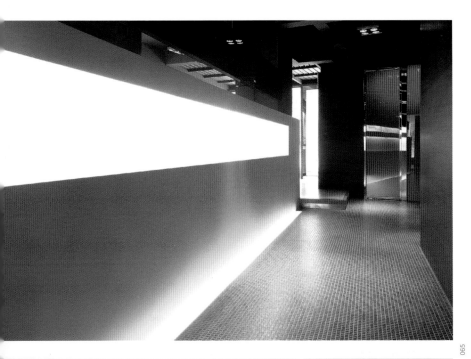

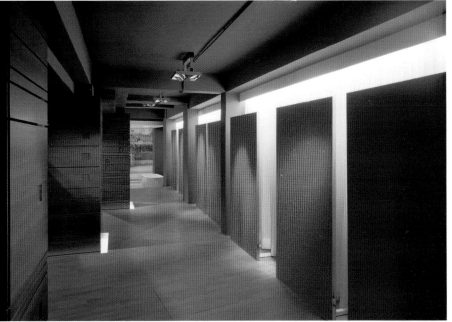

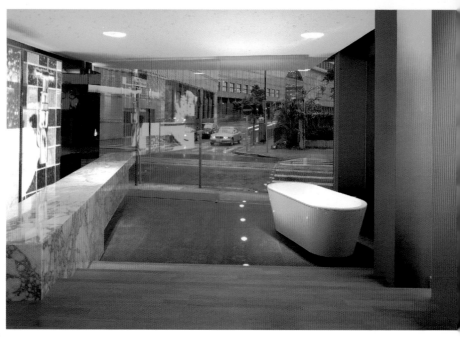

DISPLAYING ITSELF

Occupying a prime spot in the heart of the city, IT's concept store has twisted the traditions of retail design to the nth degree. Central to the design is the idea that the whole interior is the shop's showcase rather than just the window frontage.

NAME OF SHOP **IT**
OWNER/CLIENT **IT**
ARCHITECT/DESIGNER **AXIOM OVAL PARTNERSHIP**
PHOTOGRAPHER **ROGER HO**
TEXT **ANNA KOOR**
LOCATION **8 QUEEN'S ROAD, CENTRAL, HONG KONG**
TEL (OF SHOP) **(852) 2868 9448**

011
akira onozuka japan

He was born in 1950 and joined the Miyake Design Studio in
was first shown in Paris in 1989. He was awarded the 8th Mai
Editors Club Prize, both in 1990.

Masterminded by its visionary Managing Director Kar Wai Sham, the environment is a continuously evolving, 3-dimensional canvas. The question was posed, why invest in hulking fixtures and fittings that dictate how one uses the space? The designers treated the space like an exhibition hall with a similar sort of infrastructure. The architecture is therefore reduced to a neutral shell, expressed in grey walls and matt-black stone floors. Lighting is subdued, a signature trend of IT, and one of the key aspects of the design. Catering to a constantly morphing arrangement meant constructing a closely-knit ceiling grid with projected stage lights. As with all their outlets, everyday materials and finishes are skillfully applied in a way that elevates them beyond their origins.

High-profile and emerging labels such as Comme des Garcons and Alexander McQueen are presented within a temporary, thematic exhibition. The density of merchandise is low and the potential for enjoying the space as much as the product is heightened. Each changing installation is a piece of art that makes a bold statement, challenging the uninitiated to rethink the way that they perceive the merchandise and how they circulate round the space.

To this end, the rectilinear 5,380 square foot space is absent of the usual functions associated with fashion retailing – mirrors, changing rooms and sales points. These are all located well out of sight "backstage", adding to the air of exclusivity. One of the shop's first displays was a series of parallel graphic "walls" positioned in successive layers parallel to the street frontage. Patrons had to negotiate each aisle without any knowledge of what lay ahead.

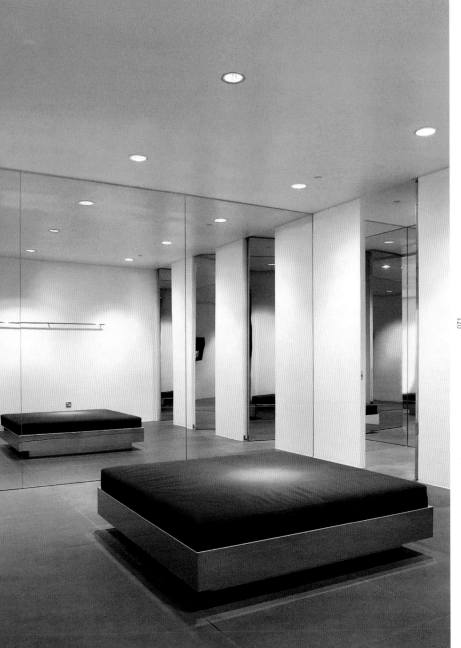

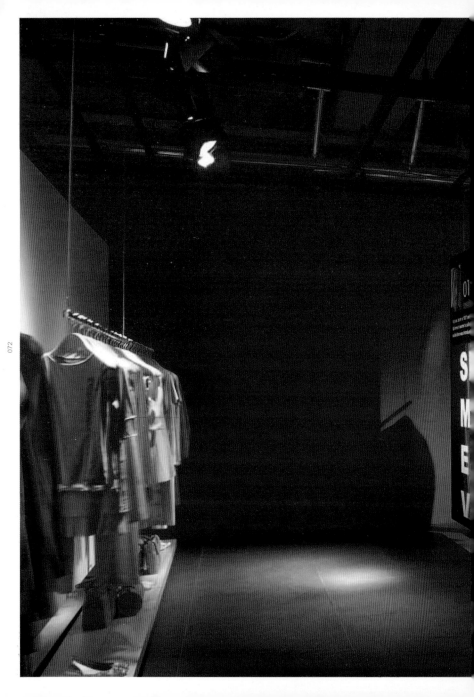

013
limi yamamoto japan

She, the eldest daughter of fashion guru Yohji Yamamoto, was born in Kyush
collection in March 2000, she inherited his father's talent with her own inter
collection that packed a punch. The mood is strong but relaxed: jackets of w

GOMME

G+SU
COLL
ION

COMME des GARÇONS
...d fine arts and literature, she worked in a textile company after
... own company, Comme des Garçons Co., Ltd in Tokyo. Starting

008
alexandre herence
This 28-year-old designer moved from London to Paris t...
the avant-garde yet wearable collection garnered him muc...
in the dark pushed a memorable climax to his Parisian debu...

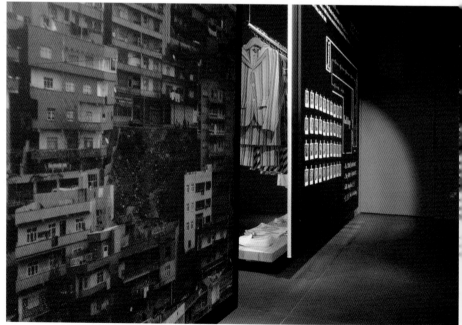

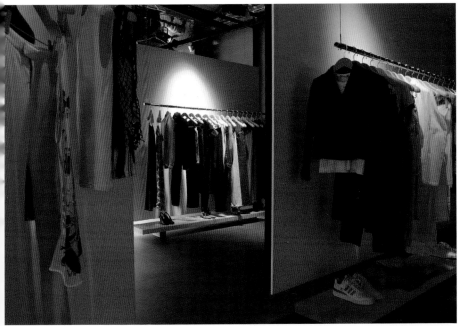

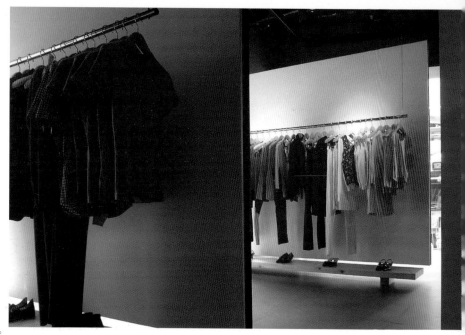

KOSUKE TSUMURA

...en Award in 1992 and joined the Miyake Design Office the following year. He started ...Week from 1998. In this season's collection entitled "Tissue Wear", basic items are ...e forms by making the fabric looks like tissues through cutting and tearing.

He was born in 1964 and gradua...
In this season's collection with...
coats. Pure white wedding dress...

006
vivienne westwood

She was 30 years old when she opened a boutique with Malcom McLaren in 1971. Her early de...
rooted in the 1970s, especially the punk youth subculture. Subversive, irreverent and definite...
she captured the essence of street wear during that era.

Vivienne
Westw...

MUSEOLOGICAL MARKET

louvre gallery

Louvre Gallery's furniture store occupies a prime space in the Designer's Showcase complex in the Central district of Hong Kong. Spacious and pared back, with an absence of natural light, it could be mistaken for a museum.

NAME OF SHOP **LOUVRE GALLERY**
OWNER/CLIENT **TONY LUK**
ARCHITECT/DESIGNER **JOSEPH SY AND ASSOCIATE LTD**
PHOTOGRAPHER **JOSEPH SY**
TEXT **ANNA KOOR**
LOCATION **SHOP B, LG/F RUTTONJEE CENTRE, 11 DUDDELL STREET, CENTRAL, HONG KONG**
TEL (OF SHOP) **(852) 2526 8400**

The layout of Louvre Gallery is defined by a series of portals framing dining, living and bedroom settings. The ambience and layout is reminiscent of a museum. Lowered tracks of downlights accurately pinpoint sculptural furniture pieces. The pieces have plenty of space around them so that customers can view the merchandise from all angles. To do this in Hong Kong, where commercial real estate costs are extremely high, is a surprising but clever move that many new-generation retailers are beginning to appreciate. The colour palette also has a museum quality – white walls meet matt-grey seamless floors. Together with the absence of natural daylight, one's focus remains fixed to the objects. Even the two sets of double-doors could represent the entrance and exit route of a museum.

There is little to determine where furniture, objects, lighting and artworks stop and start, and it is the owner's intention to blur those lines. However at some point, an inner reading of the space veers more towards a theatrical set. The central window has its star attraction perched centre-stage; a gauzy sheer textile hangs just halfway to the floor, giving the impression of a stage curtain rising on an important event. Sheer fabrics are often used to enhance transparency, as opposed to solid partitions, but here they also imply movement. Their softness contrasts with the harsh white walls and industrial matt-epoxy floor.

The drapes are run on a ceiling grid of tracks so that the layout can change to accommodate new stock. Customers are encouraged to linger within the intimate spaces, uninhibited by the prying eyes of sales assistants. A steel picture track encircles the perimeter walls, providing a horizontal juncture as the walls join the black-out ceiling. Suspended panels can be used as colour boards or graphic features, providing bookends to what otherwise would seem endlessly flowing space. Smaller pockets, constricted by ceiling bulkheads are set up as meeting areas where customers can sift through Louvre Gallery's expansive folio of ultra-modern European collections.

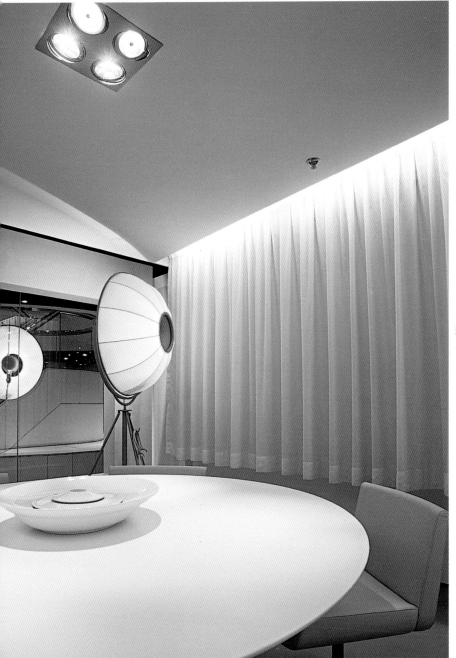

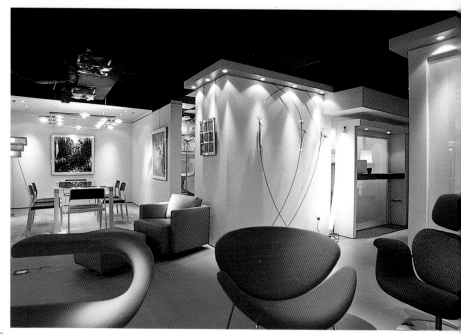

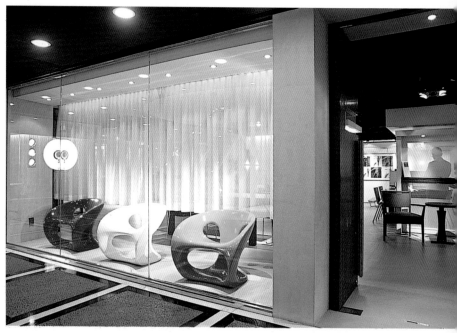

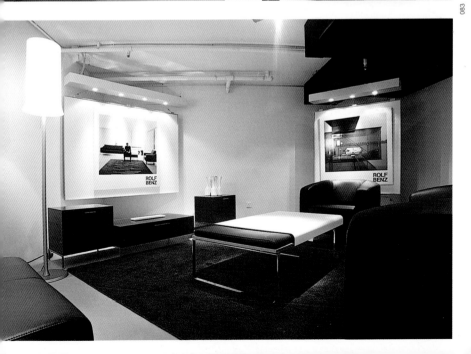

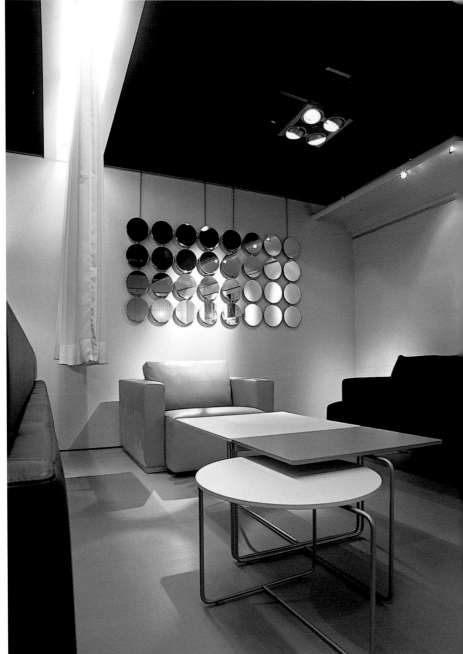

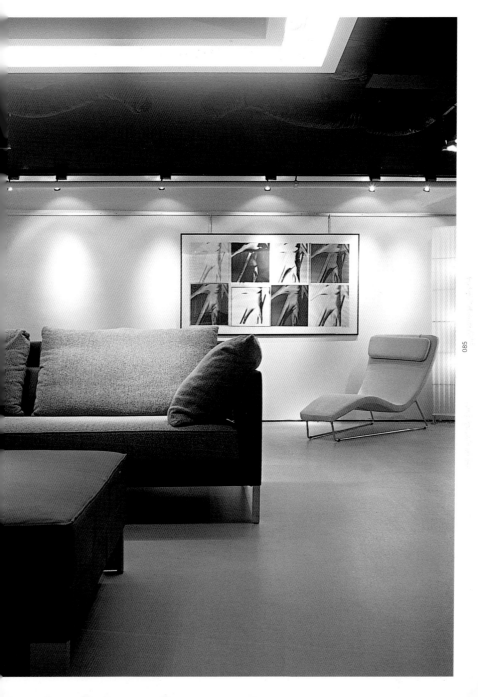

SEARCH AND RESCUE

chen mi ji

There is a little fantasyland inside Chen Mi Ji. Everything on sale in this Hong Kong curios store has its own story to tell. Raw and unpretentious, the store interior supports the "flea market" feel.

NAME OF SHOP **CHEN MI JI**
OWNER/CLIENT **MIKE CHEN**
ARCHITECT/DESIGNER **MIKE CHEN**
PHOTOGRAPHER **KELLEY CHENG**
TEXT **CATHERINE CHEUNG**
LOCATION **51 STAUNTON STREET, CENTRAL, SOHO, HONG KONG**
TEL (OF SHOP) **(852) 9499 1093**

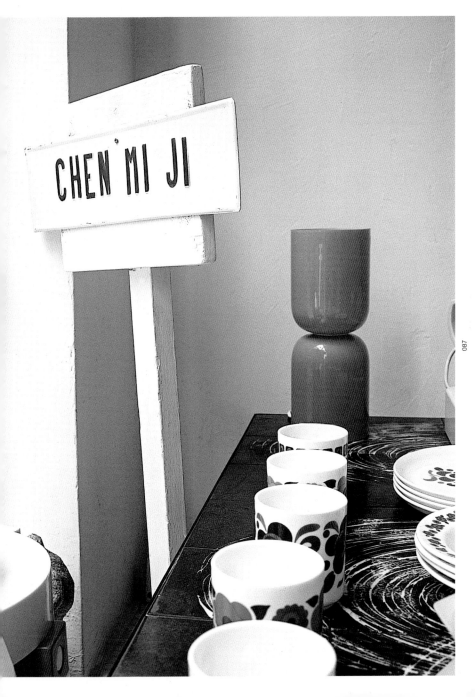

When Mike Chen opened the doors of Chen Mi Ji five years ago, only die-hard collectors frequented the store. This semed to be a period when nostalgia was but a forgotten word. Today, its collection of items from previous lives attracts movie art directors by the dozen.

The double-storey space is raw and unpretentious, with only a simple coat of plaster and white paint clinging lightly to the walls. Hooks and wires are candidly visible, acting as vivid reminders of where such things as pendants and chandeliers were once positioned. The display of goods is at its most random and spontaneous, requiring customers to rummage for hidden treasures.

The upstairs area, accessed via a seemingly ramshackle wooden staircase, is similarly stocked. This floor also serves as a studio/office for two cultural groups active in experimental and alternative performance. A mish-mash of shop, gallery, office and studio, it seems that all things are allowed to have their own place at Chen Mi Ji.

"The true value of an object only surfaces with the passage of time," Chen reminisces. Whether it be a sofa, table, chair, clock, flask, mug, piece of crockery, or record player, each piece on sale in Chen Mi Ji can be read like a narrative of a bygone era's glory. For Chen, one of the memory banks of any city lies within its flea markets. Sadly, these have never managed to flourish in Hong Kong. Chen Mi Ji, in the owner's words, is "an indoor flea market", beginning a quiet revolution against a city seemingly without memory.

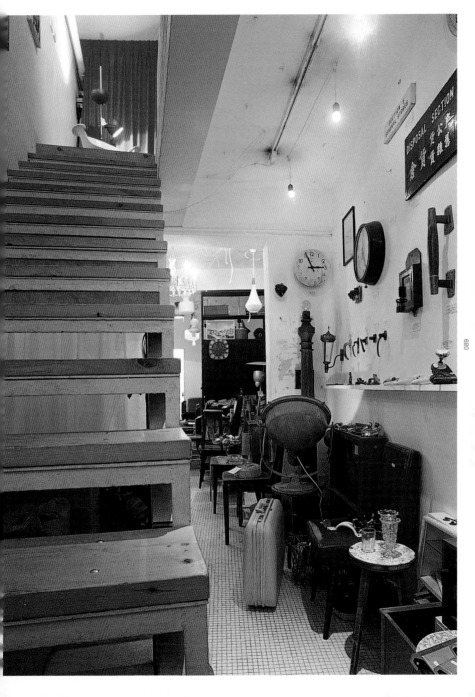

MORE upstairs!

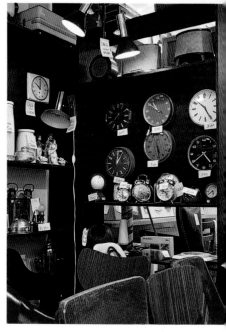

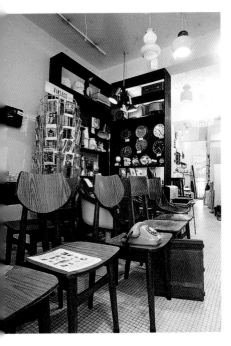

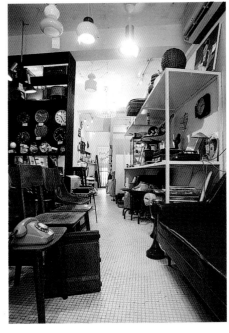

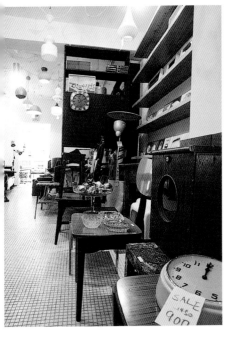

ANYTHING IS POSSIBLE

swank

This flagship store for Swank was designed as part of the re-launch of the brand. The intent was to expand Swank's customer base by attracting young, sophisticated and fashion conscious customers, while retaining existing clientele. The new environment can transform over time, constantly promoting new experiences in the store.

NAME OF SHOP **SWANK**
OWNER/CLIENT **THE SWANK SHOP LTD**
ARCHITECT/DESIGNER **ATELIER PACIFIC LTD**
PHOTOGRAPHER **VIRGILE SIMON BERTRAND OF RED DESERT LTD/COURTESY OF ATELIER PACIFIC LTD**
TEXT **ANNA KOOR**
LOCATION **NEW WORLD CENTRE, TSIM SHA TSUI, HONG KONG**
TEL (OF SHOP) **(852) 2736 8567**

Swank's dynamic, eclectic 14,000 square foot environment has the ability to change and transform over time, in an atmosphere that becomes a stage for the performance of the various labels. Walls, furniture, shelves, and hanging rails were conceived in the form of breakdown modules, so that the elements can be disassembled for easy handling and rearrangement. Itineraries, views and uses can be varied at will, giving form to the idea of "anything is possible", and marking out locations for relaxation in alternation with spaces for activity where anything can happen.

In the ladies-wear area, one is drawn to the display "theatre", which is illuminated by daylight. Customers are enticed to more fully experience the apparel by moving through the display. Returning into the sales area, one will come across a veiled view of the entire space through the *shoji* glass screens that divide the collections. Continuing the theme of the "space as theatre", the *shoji* glass panels run on concealed tracks, permitting them to be reconfigured in a variety of ways to create differing moods for the collections. Integrated through the store, a display of paintings and sculptures further enhance the evolving nature of the design.

The ceilings throughout the store are raised along the edges, drawing the eye into a brightly-lit zone that evokes the sky, and providing the sense of a larger space. Strengthening the reference to nature, stone gardens with "sculptural" planting wrap the perimeter of the lounges and fitting rooms for a more relaxing environment. Here, customers can be treated in style while sampling the latest fashions. Throughout, the customer is always visually connected with the next area, being drawn into a realm of discovery. With each visit a new experience will be had, as both the store and the collections evolve.

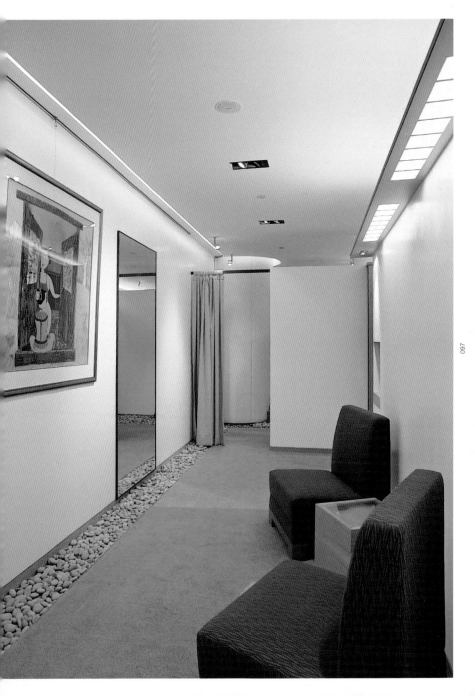

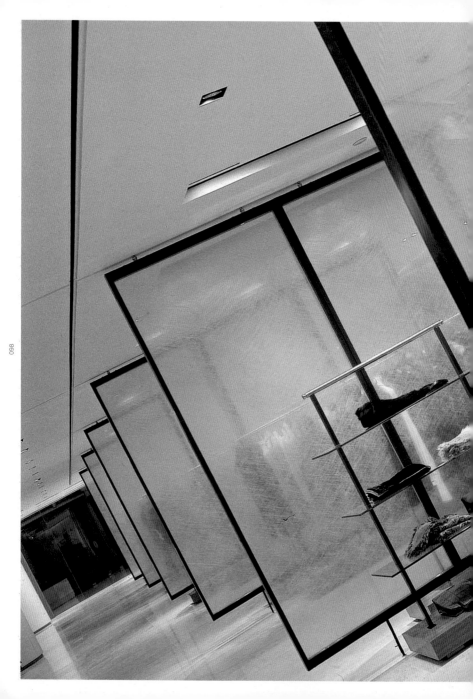

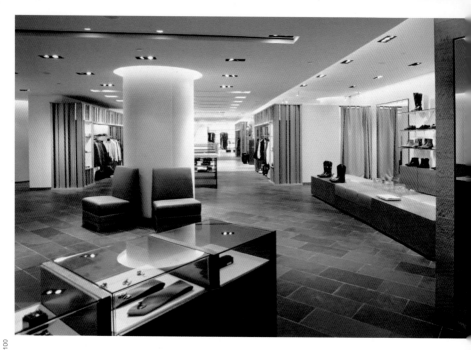

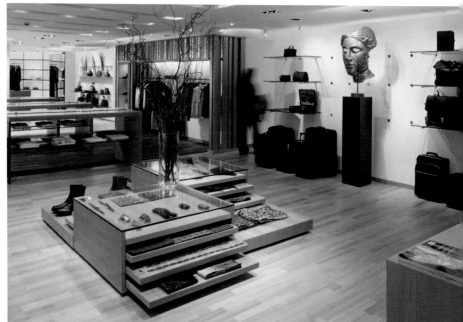

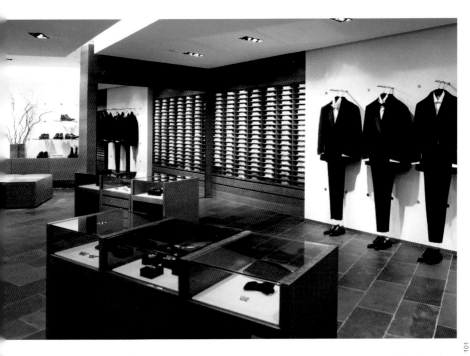

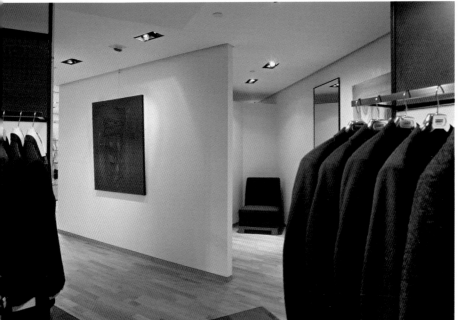

CLEAN CUT

vidal sassoon

Whereas a good proportion of the commercial offerings in the retail, entertainment and cultural neighbourhood of Xintiendi err on the cautionary in their architecture, the Vidal Sassoon Academy strikes a more daring pose.

NAME OF SHOP **VIDAL SASSOON ACADEMY**
OWNER/CLIENT **VIDAL SASSOON/PROCTER & GAMBLE**
ARCHITECT/DESIGNER **KPLUSK ASSOCIATES**
PHOTOGRAPHER **BUN HO, GREG GIRARD**
TEXT **ANNA KOOR**
LOCATION **LANE 181, TAI CANG LU, XINTIANDI, SHANGHAI, PEOPLES REPUBLIC OF CHINA**
TEL (OF SHOP) **(8621) 6311 2151**

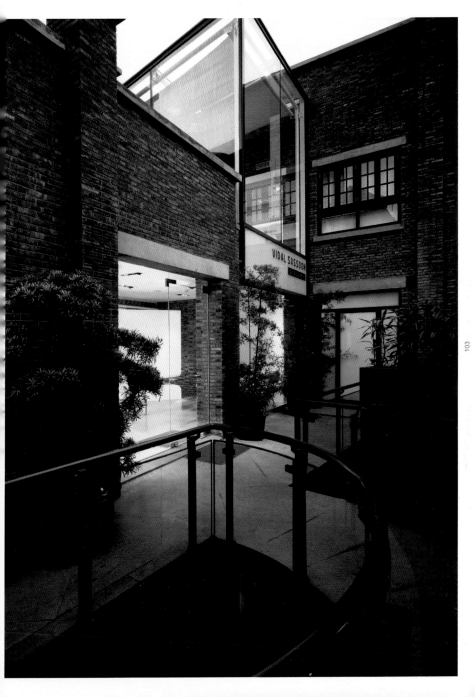

This 6,500 square foot hybrid retail space accommodates a teaching academy as well as a salon. Its street presence is very different from that exhibited by a typical shop window. The action lies on the inside, beginning with an entrance lobby, where smooth surfaces of maple and folded white Corian contrast with the rough-hewn brickwork that penetrates the space from the outside. Directly above this lies a comfortable lounge and locker area, which extends into an outdoor terrace where students can take a break. This space is twisted off the upper foyer where a drop-ceiling floats and an aluminium-sheath is draped over a column; these elements are cloaked over the structure without seeming to touch it, like hair that stands proud from the neck.

By the time one reaches the linear hall where the bulk of activities takes place, it becomes apparent that the more natural materials have disappeared, having been superseded by a distinctly synthetic palette that feels thoroughly cleansed. The salon is pierced with light from a number of skylights. Its semi-vaulted ceiling gives insiders a vague reminder of the sort of shell that this space occupies. The facilities were required to be flexible to cater to different numbers of student groups. The shampooing zone is a core element, enclosed by curved milky glass, which gives it an air of detachment from the foyer and other facilities. Folding glass panels separate the hall into smaller training rooms so that classes can simultaneously be taught or live demonstrations can be watched from the raised, movable stage at the far end.

The occasional kink in a vertical wall carries the sensation of crimping waves. These are aligned with absolute precision and attention to detail. Volume is shaped by crisp lacquer finishes and glossy treatments, which work harmoniously with the function of cutting and polishing hair.

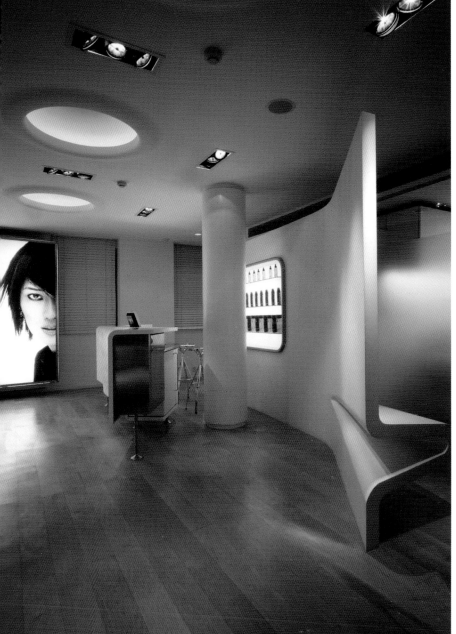

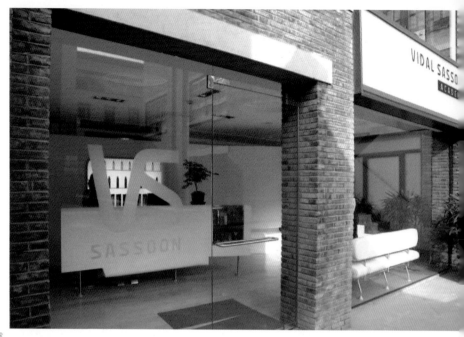

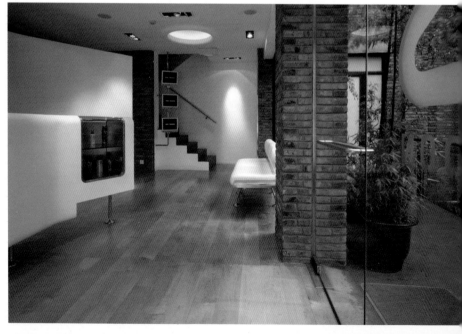

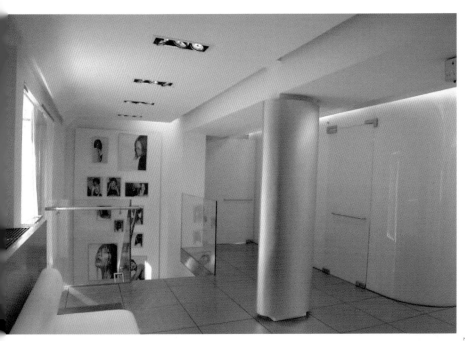

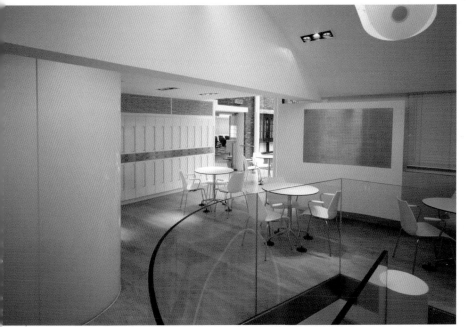

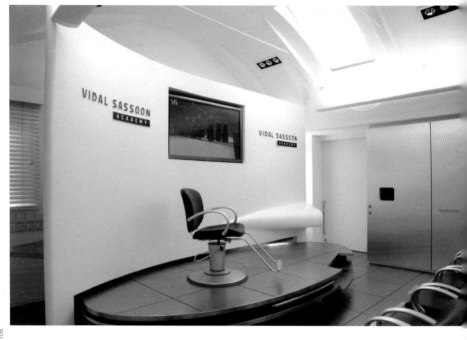

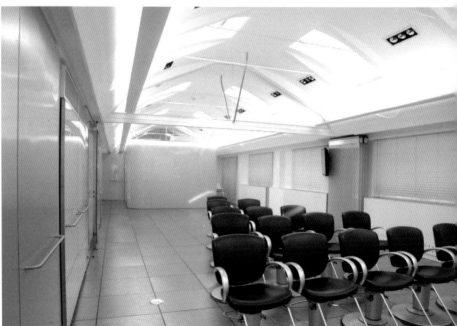

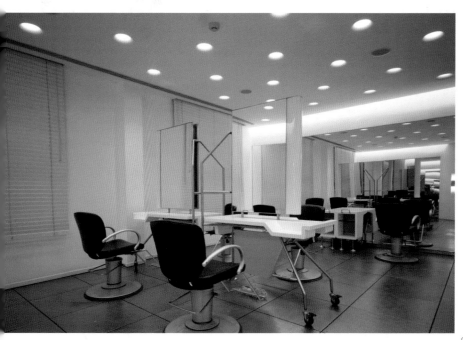

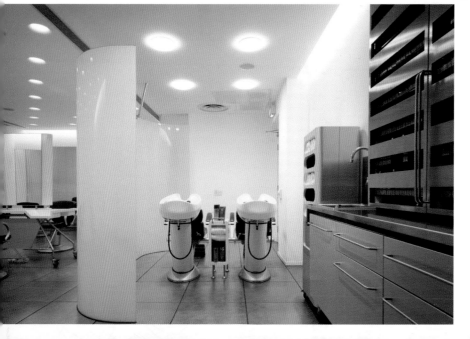

SCIENCE FICTION SHOPPING

a bathing ape "busy work shop"

Shoppers in this futuristic space might think that they have been transported to the set of a science fiction movie. They are ensured of a unique shopping experience.

NAME OF SHOP **A BATHING APE "BUSY WORK SHOP"**
OWNER/CLIENT **NIGO**
ARCHITECT/DESIGNER **MASAMICHI KATAYAMA/WONDER WALL INC**
PHOTOGRAPHER **KOZO TAKAYAMA**
TEXT **KWAH MENG CHING**
LOCATION **B1F, 4-28-22 JINGUMAE, SHIBUYA-KU, TOKYO, JAPAN**
TEL (OF SHOP) **(81) 3 5474 0204**

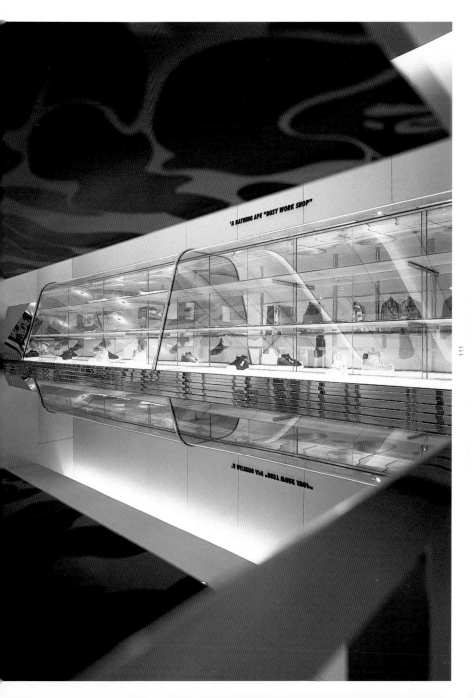

"A BATHING APE "BUSY WORK SHOP""

Masamichi Katayama first established his fame with his design of the first independent shop for "A Bathing Ape Busy Work Shop" in 1998. His continual collaboration with Nigo, owner of A Bathing Ape, has seen him design 15 shops since 1998. In 2001, Nigo felt the time was ripe for a renewal of the first A Bathing Ape boutique. The challenge to Katayama was then how to jump out from the shadow of the old work and create an entirely new concept shop within the same space.

Unlike other boutique owners, Nigo did not specify the amount of hanging space, shelving and fitting rooms required. To him, a shop is merely a box for selling. An attractive box is more important than packing a thousand and one items within the same space. In the space of 1,720 square feet, Katayama was only required to display 20 sets of clothes. With such an enlightened brief, Katayama set out to design an "attraction shop".

The ultimate result is a new boutique that is 180 degrees different from the old one in all aspects, be it circulation route, surface treatment or lighting. Yet, the most striking and eye-catching feature about this boutique is at the rear of the shop when one walks towards the T-shirt area. All of a sudden, decorative exposed ducts and pipe works underneath the toughened glass flooring come into view. Together with the illumination from below, the effect is that one seems to be floating on air. Shopping in this white washed space, with clothing on specially designed display systems with rollers, seems to transport the shopper to a futuristic scene in *2001: A Space Odyssey*. The whole design plays a serious but funny illusionary joke on the shopper, giving them a unique and different shopping experience. Such is one important characteristic of Katayama's work – that he is always having fun with his projects and there is no clear boundary between work and leisure.

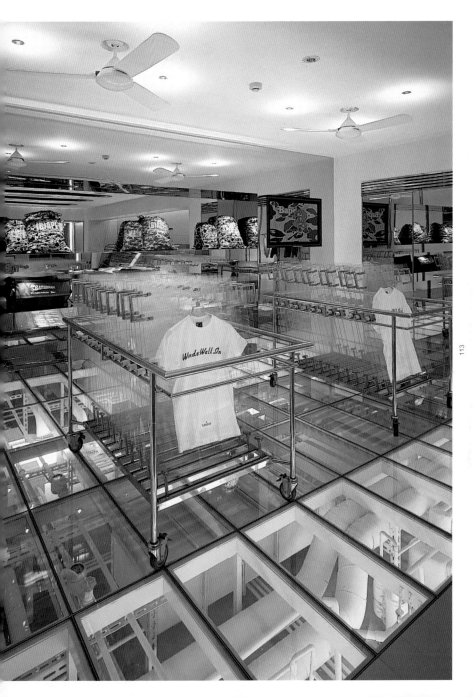

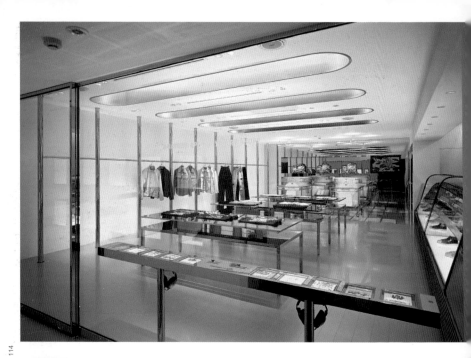

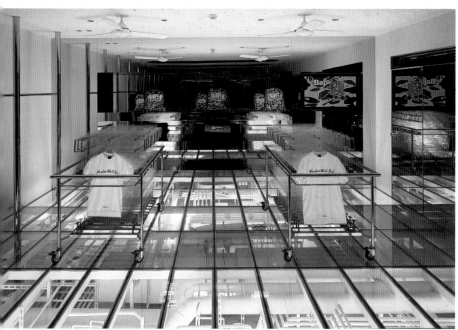

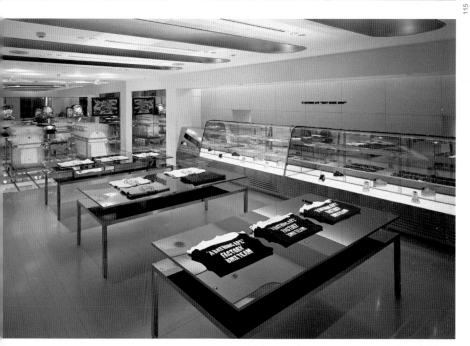

CLEVER CLIMBING

@home delux

This 4-storey concrete building, housing multiple casual wear boutiques, looks like just any other ordinary department store except for the large corner display window. A glance inside reveals a huge climbing frame, composed of zinc-coated square section steel tubes, that reaches to the ceiling.

NAME OF SHOP **@HOME DELUX**
OWNER/CLIENT **HOPS COMPANY**
ARCHITECT/DESIGNER **ALLGEMEINE ZUKUNFTIG BURO/AZB**
PHOTOGRAPHER **HARUHI FUJII**
TEXT **KWAH MENG CHING**
LOCATION **2-38, KAIUNBASHI-DORI, MORIOK CITY, IWATE PREFECTURE, JAPAN**
TEL (OF SHOP) **(81) 19 654 5039**

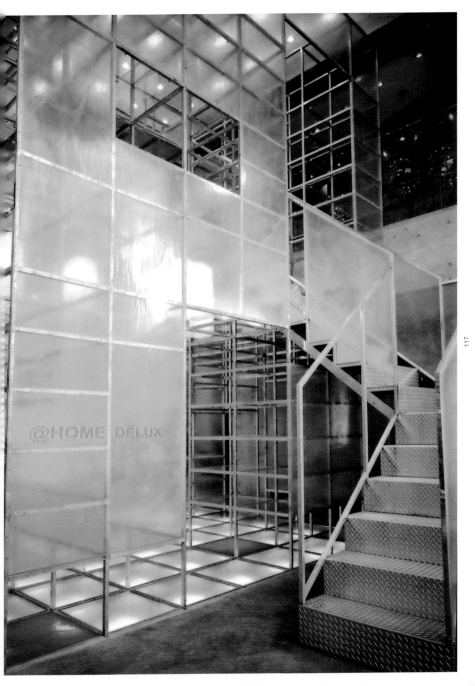

The climbing frame has small intervals of only 60 centimetres between the steel bars. Matte fiberglass infill screens provide a good backdrop for displaying fashion and accessories. This labyrinthine fashion display installation actually extends through two stores, one on the ground floor and the other above. Incorporated with clothes hangers, shelves, fitting rooms and showcases, this climbing structure is nicknamed "sukiya" which means "favourite house" in Japanese. Seats are incorporated into the frame to provide the adventurous "climbers" with a place to catch their breath.

The floor beneath this installation structure is illuminated – a gesture that theatrically presents the climbing frame as the main focus of the building. Light diffused from big jelly cans completes the last piece in the jigsaw of this dramatic installation, setting the playground for trend-conscious, adventurous urbanites. As if all of this is not enough, @home delux boasts another element of surprise on the first storey – the side entrance is a cube-form tunnel that "floats" 10 centimetres above the ground.

Every floor is divided into two parts, and every part is a different street/casual/fashion shop containing both national and international brands. Besides the double-storey atrium with the climbing frame on the first storey, there is also a small internal garden with a pond. The third storey in turn holds a bar/cafeteria with a terrace garden. @home delux is illustrative of AZB's pluralistic design that draws influences from many sources, particularly their own Japanese culture, most evident by the presence of a internal rock garden complete with a water feature.

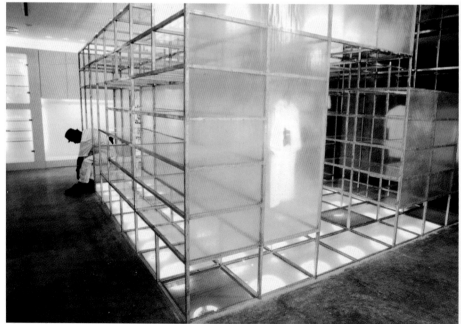

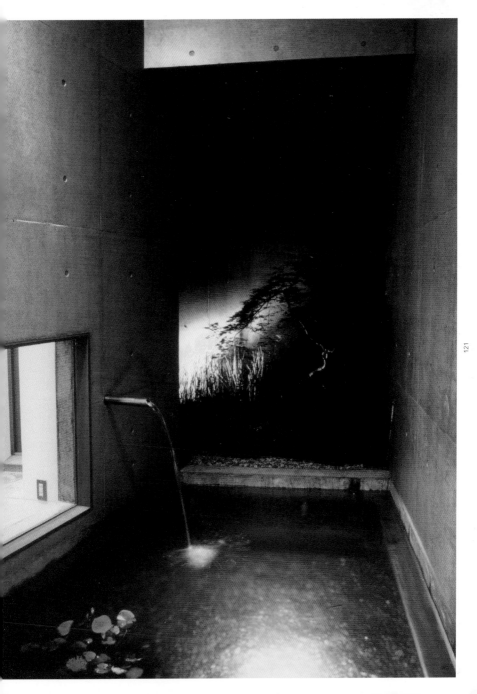

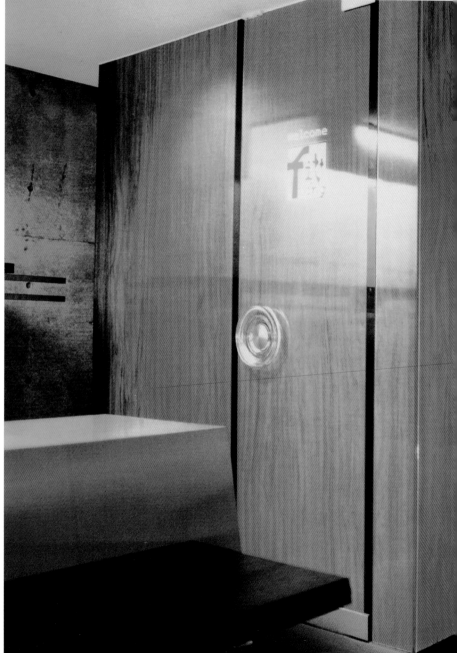

CHILD-LIKE BEAUTY

bape cuts

This is a beauty salon with a difference. Katayama has managed to create an interior of signatory playfulness and fun, with a graphic slant. Perhaps, most important of all, we can sense the child-like heart inside the designer.

NAME OF SHOP **BAPE CUTS**
OWNER/CLIENT **NIGO**
ARCHITECT/DESIGNER **MASAMICHI KATAYAMA/WONDER WALL INC**
PHOTOGRAPHER **KOZO TAKAYAMA**
TEXT **KWAH MENG CHING**
LOCATION **1F, 3-30-11 JINGUMAE, SHIBUYA-KU, TOKYO, JAPAN**

This is a beauty salon produced by Nigo, the director of A Bathing Ape. The concept of designer Masamichi Katayama, from Wonder Wall, is to make the salon like a hotel lobby, or a gallery; a place that is classy, soothing and comfortable, where one can come to relax, refresh, recharge and transform.

Looking from the street one sees a huge transparent glass window revealing the space where the real action of beauty treatment is carried out. This contrasts with the comparatively smaller glass door beside, which leads the customer to the reception area. Illuminated with ambient yellow light, this entrance foyer relaxes the customer and sets the atmosphere prior to beauty treatment.

Through another door one arrives at the main hall of the beauty salon. With a dark coloured timber floor, the brightly lit main treatment space is lined with two rows of individual booths at the centre. These booths are points at which the customers can receive a haircut and various other treatments. Designed as transparent glass boxes, the booths give each customer their individual privacy and yet at the same time allow them to maintain communication with the rest of the customers through visual transparency. Three circular light bands on the mirrored wall at the end of the main hall serve as a terminus to the axis. Together with strip-lighting on the ceiling, they set up a graphical rhythm to the space, complimenting the rectangular, sharp-edged glass booths. To complete the jigsaw, Katayama curated large portrait photographs of cute and innocent babies donning expensive jewellery. These were taken by Edward Mapplethorpe, the brother of the famous photographer Robert Mapplethorpe. Lining them up behind the booths on the wall added to the fun and relaxing atmosphere.

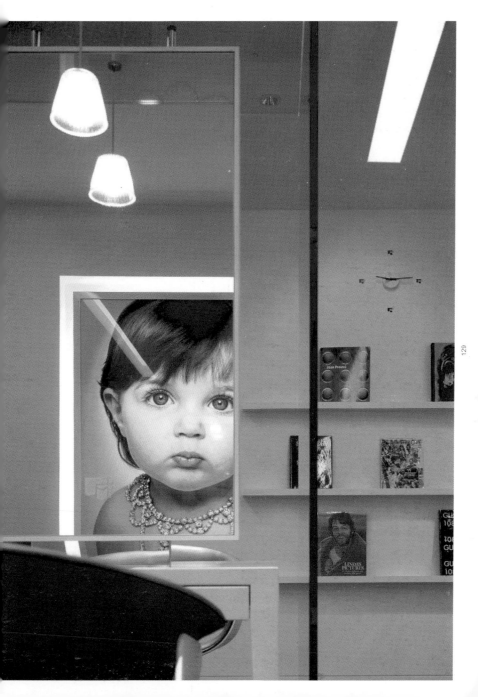

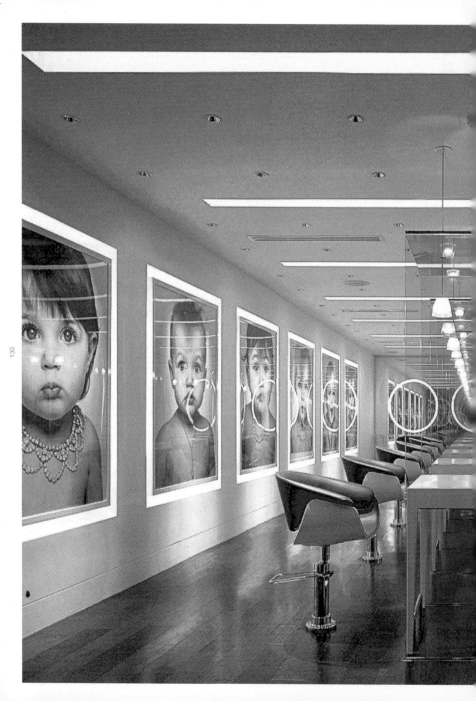

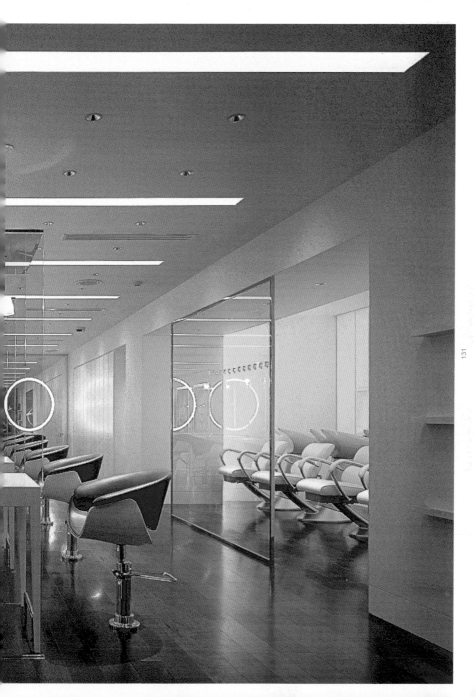

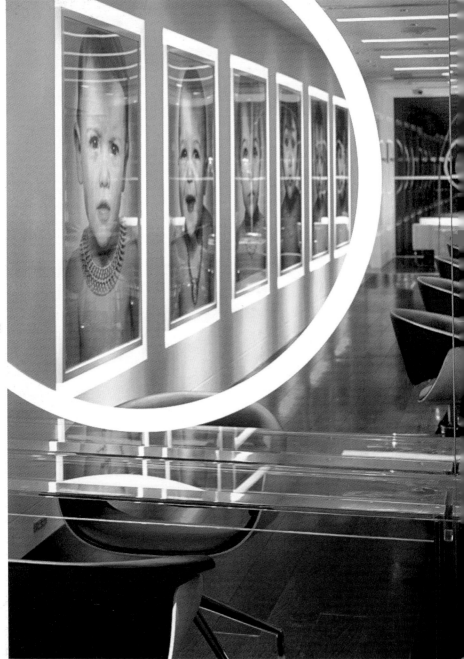

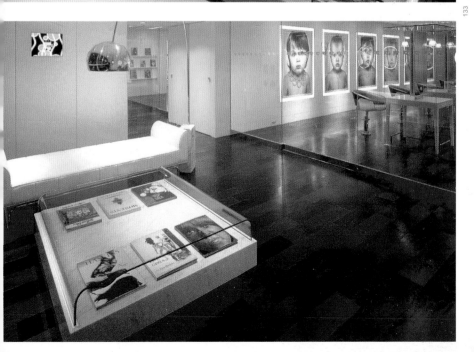

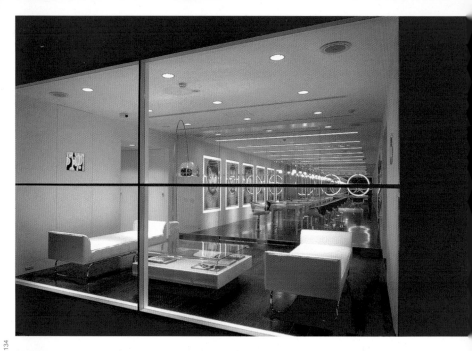

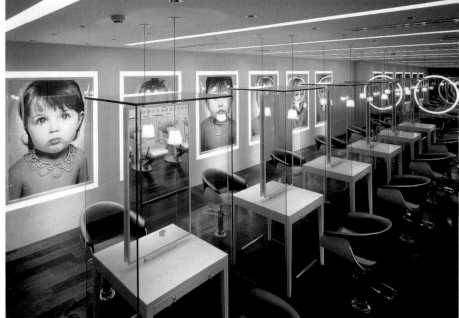

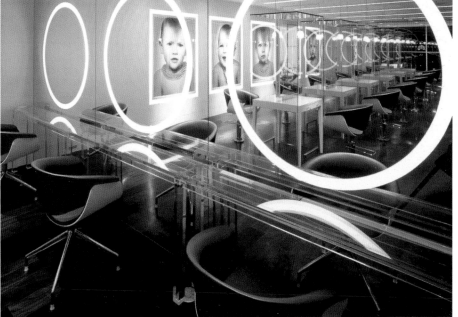

LIGHT-HEARTED ARCHITECTURE

bapy aoyama

Masamichi Katayama has designed not only the interior, but the whole building that houses BAPY AOYAMA; and he has used such humour and light-heartedness that it could easily be compared to the house of the famous Japanese doll, Rika-Chan.

NAME OF SHOP **BAPY AOYAMA**
ARCHITECT/DESIGNER **MASAMICHI KATAYAMA/WONDER WALL INC**
PHOTOGRAPHER **KOZO TAKAYAMA**
TEXT **KWAH MENG CHING**
LOCATION **3-8-5 KITA-AOYAMA, MINATO-KU, TOKYO, JAPAN**
TEL (OF SHOP) **(81) 3 576 9177**

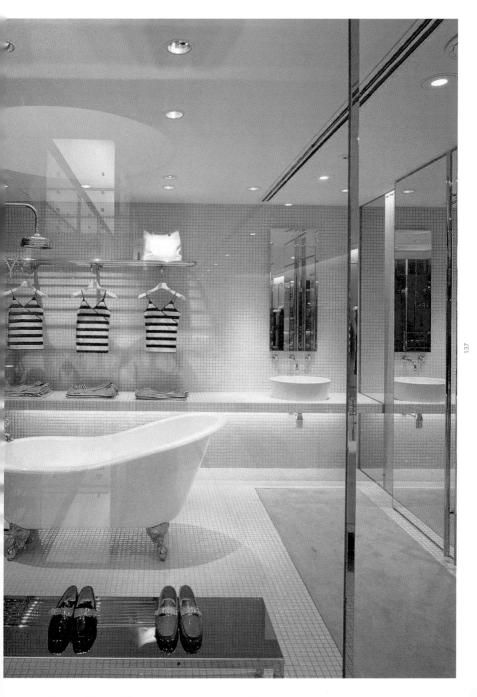

BAPY AOYAMA merchandises women's apparel. This was a collaborative project, for which Katayama worked with the client to devise the concept and identity for the whole boutique chain. In fact, within a year, Katayama had designed seven shops for the brand and maintained a consistent concept of a bathroom image.

Externally, the three storey high building has a glass front facade, with slim reflective stainless steel dividers between the glass panels, and a thick stainless steel edge wrapping around the building. From afar, the whole building looks like a dollhouse. Yet, the reflection of the surrounding landscape on the stainless steel reminds one that this simulacrum is in fact reality.

The whole building is designed as a huge bathroom with the different spaces taking on a different transformation of the main theme. For example, the fitting room adopts a shower booth image; it is actually a glass box fitted with curtains. The notion of bubbles from the bath is manifested in different ways, from pendent lights to sticker films on the glass partitions. On the third storey one will find the bath itself, basking under sunlight that is emitted through a circular skylight during the day, and highlighted by artificial light during the night.

The triviality of the treatment renders the design to be almost joke-like when compared to the usual seriousness found in architecture. Like a manga comic, this design does not try to be difficult. In fact, it is not difficult to understand the designer's intention here – to illustrate that life should be a form of enjoyment, and that shopping should be a kind of entertainment as well.

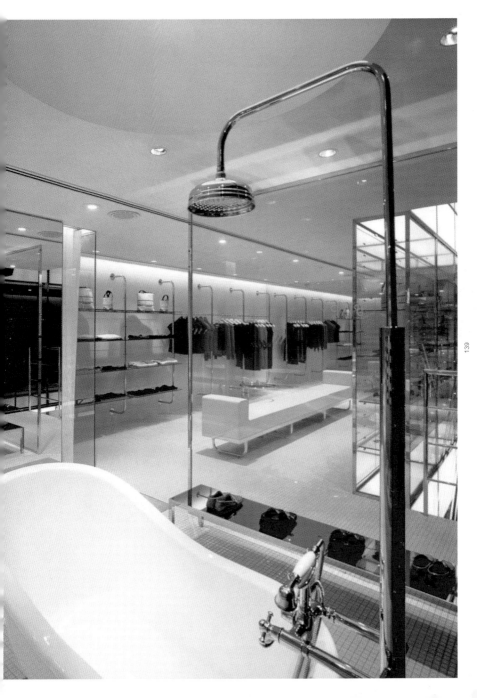

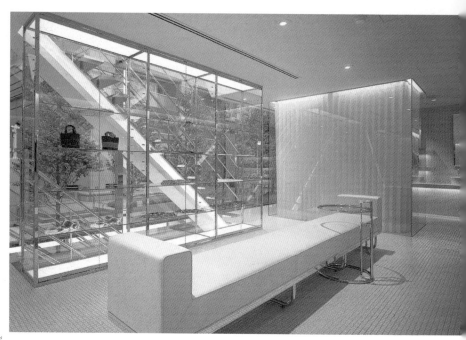

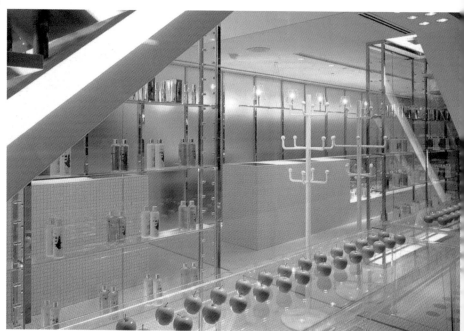

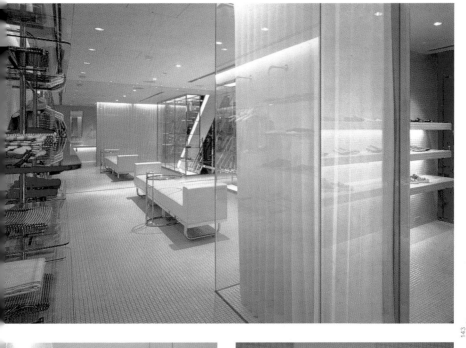

ART FOR EVERYDAY

beams t

Contrary to conventional shops that line the walls with T-shirt after T-shirt in a bid to show the variety of their collection, Beams T looks more like a gallery space or an artist's workshop, displaying works of T-shirt art. In fact the T-shirts on display here are all created under the theme of "Art for Everyday".

NAME OF SHOP **BEAMS T**
ARCHITECT/DESIGNER **MASAMICHI KATAYAMA/WONDER WALL INC**
PHOTOGRAPHER **KOZO TAKAYAMA**
TEXT **KWAH MENG CHING**
LOCATION **3-25-15 JINGUMAE, SHIBUYA-KU, TOKYO, JAPAN**
TEL (OF SHOP) **(81) 3 3470 8601**

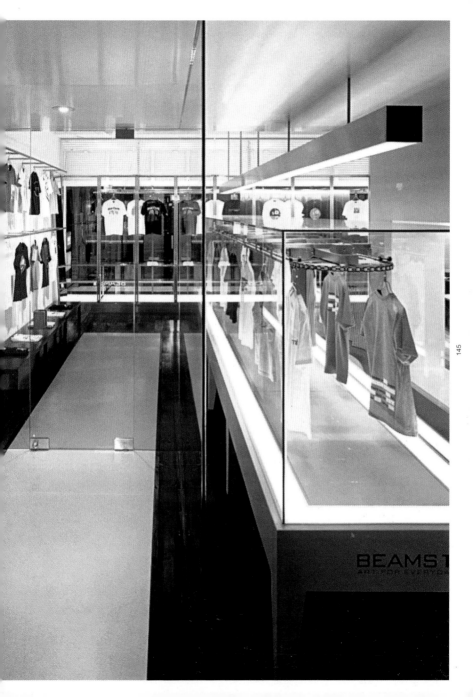

This is not your usual fashionable T-shirt store. Within the clean-cut and bright space, and against the background of the dark coloured timber floor, one's eyes are inevitably drawn to the central feature of the shop: an illuminated glass box containing a rotating troupe of T-shirts on a conveyor system, similar to the type used in a mass cleaning laundry. Katayama's design breaks away from the traditional static display and cleverly utilises a system that not only becomes the main focus of the shop; it also serves a functional purpose. It allows the customer to take a peek at the back of the T-shirts hands free, otherwise impossible with a conventional display system. The use of this display system, along with the encasement of the T-shirts inside glass cabinets, further elevates their status as pieces of art, befitting the theme of the store perfectly.

Besides the main illuminated box of rotating T-shirts, Katayama also devised other methods of display in a conventional but uncluttered manner. Folded T-shirts are placed on several tables, and others are hung on metal frameworks along the wall of the shop. Another set of rotating T-shirts is placed right in front of the shop display window. This creates a dialogue with the city and at the same time serves as an attraction to the numerous passersby on the street.

Beams T might be a small shop but it demonstrates Katayama's ability to innovate a merchandise presentation system that is new and refreshing. His system also cleverly strikes a close analogy with the haute couture industry, with the rotating T-shirts resembling models walking on the fashion runway, albeit with a mechanical sophistication.

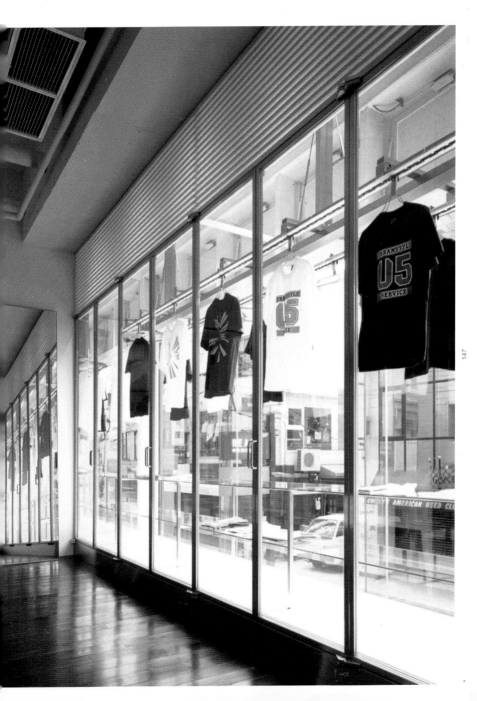

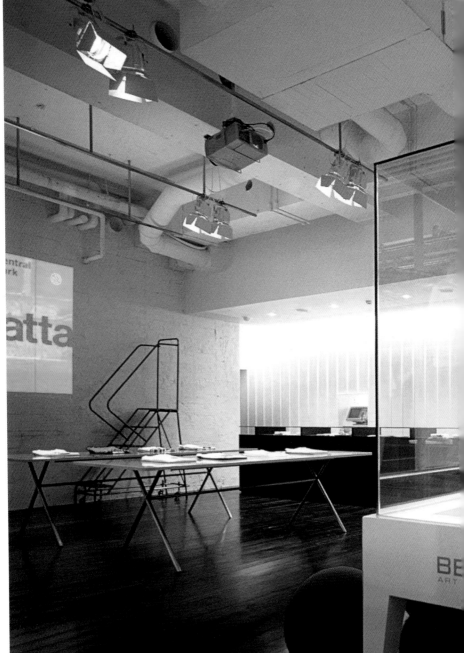

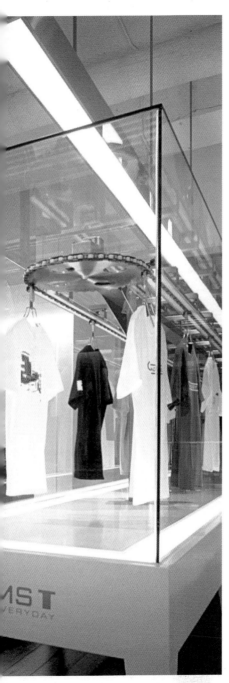

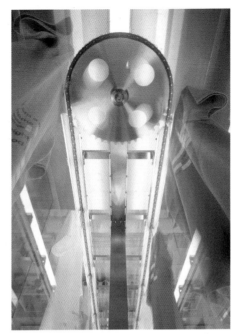

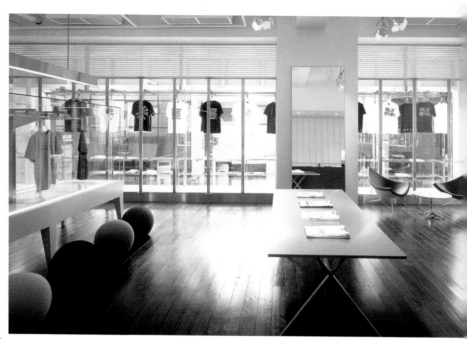

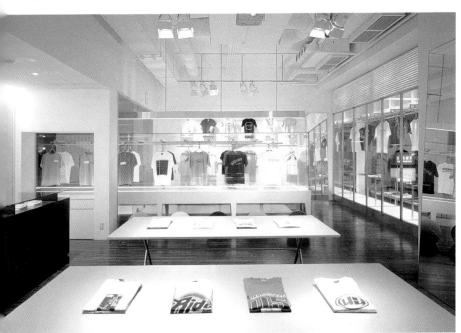

STREETWEAR OR SPACESHIP?

α-compiler

Fascinated by the future and a love of the traditional elements found in Japanese aesthetics and design, AZB's work is characterised by the skilful combination of seemingly incompatible styles, and is filled with fun and surprise. The menswear store α-Compiler does not fall short of this description.

NAME OF SHOP α-COMPILER
OWNER/CLIENT BELLNALD INTERNATIONAL
ARCHITECT/DESIGNER ALLGEMEINE ZUKUNFTIG BURO/AZB
PHOTOGRAPHER NACASA & PARTNERS
TEXT KWAH MENG CHING
LOCATION 7-7-4 HIGASHI-DORI, AKITA CITY, AKITA PREFECTURE, JAPAN
TEL (OF SHOP) (81) 18 884 7866

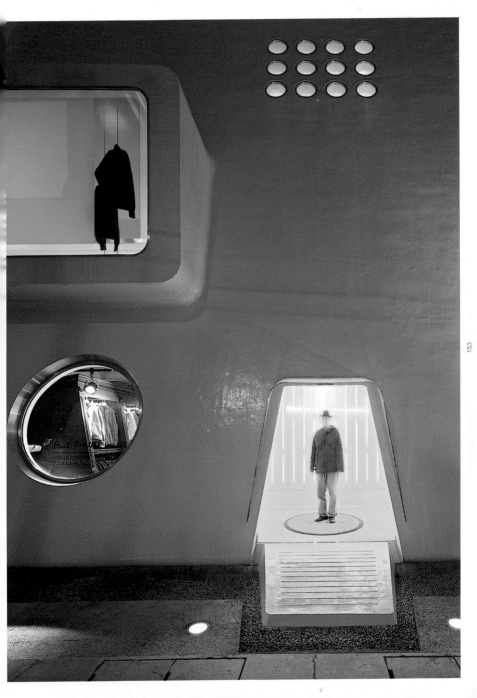

Allgemeine Zukunftig Buro's (AZB's) name may sound German, but it is only a reflection of their passion for German culture. Comprised of three Japanese core members, an over-riding sense of "confusion" seems to be a recurring theme in their work. α-Compiler is a steel structured, 3-storey shop selling menswear. Austere, cool and futuristic, the shop looks like a space ship that has just landed from the pages of a Japanese science fiction manga: Clad in easy-maintenance fiber-reinforced-plastic (FRP), the off-white building steals the show in downtown Akita. Using the traditional culture of Japan as a point of departure, AZB want to sketch an image of the future with their work. Here, they created a simple form with no superfluous details but yet one that inevitably catches the eye.

An automatic sliding entrance door that slants backwards leads the customer into the belly of this amorphous form; a step into the future. Every floor has a different concept. On the first floor there is a pebbled Zen garden with one Japanese pine tree rising all the way up through the atrium right to the second floor. Contrasting with this majestic strength is a tea ceremony room called "The Lux-Command-Chashitsu", also located on the first floor, with a very low ceiling. Most display units are made of stainless steel, including the honeycomb shelves. In addition, certain units are incorporated into the floor surface while others that resemble large illuminated refrigerators line the walls. Everything is rounded and soft.

A stainless steel staircase, suspended in space, leads to the second floor. Here, hangers are fixed to robust steel wires that are tensioned between the floor and ceiling. Customers can choose to sit on a low bench – AZB's reference to a "super low life" – and view images projected on a large window overlaid with a special film, similar to the appreciation of traditional Japanese calligraphy scrolls, the kakejiku. The incorporation of traditional Japanese elements interpreted in a modern way characterises the approach of AZB. Once inside, one could almost forget that this is a streetwear boutique.

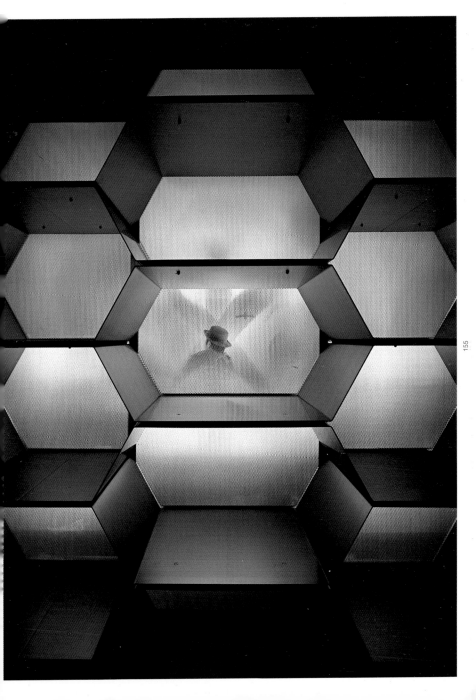

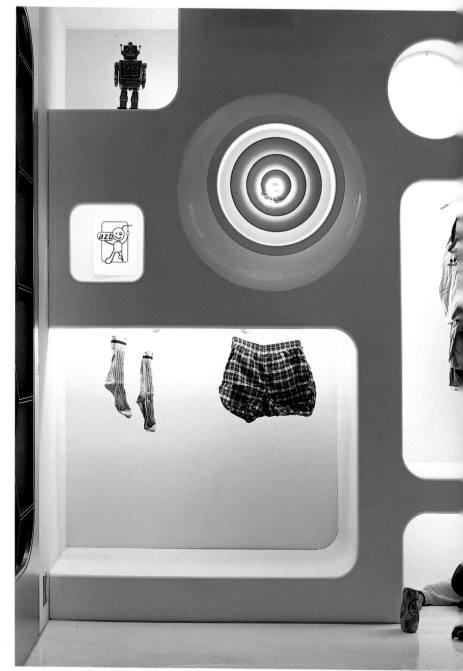

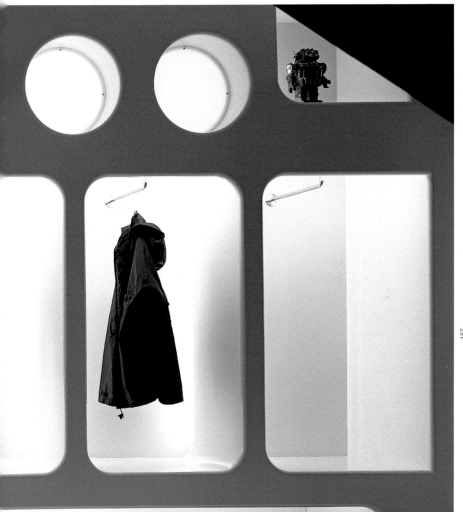

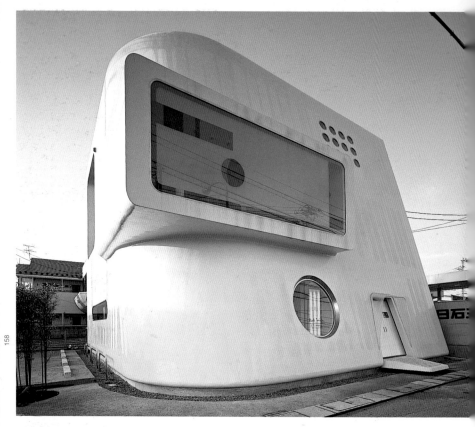

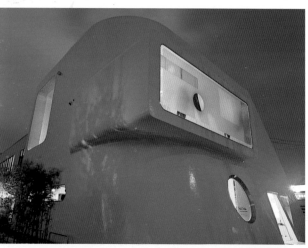

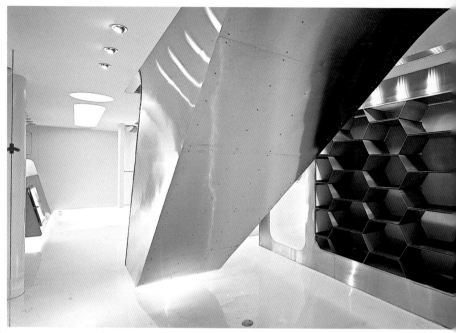

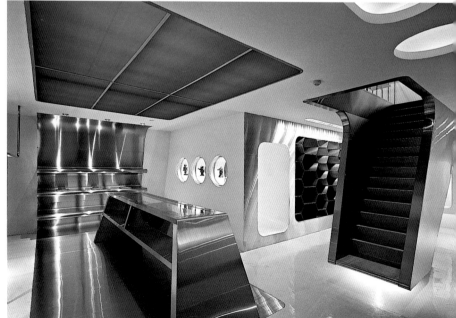

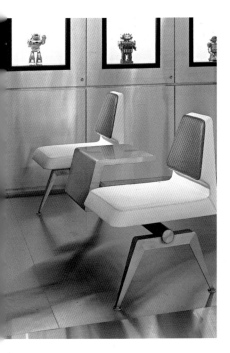

MODERNITY, LUXURY AND TECHNOLOGY

espace tag heuer

The concept of the new Tag Heuer "experience" is a space that expresses modernity, luxury and technology. The designers aimed to translate the movement of time and the precision of watches into an architectural experience.

NAME OF SHOP **ESPACE TAG HEUER**
OWNER/CLIENT **LVMH WATCH & JEWERLY JAPAN K. K.**
ARCHITECT/DESIGNER **GWENAEL NICOLAS/CURIOSITY**
PHOTOGRAPHER **NACASA & PARTNERS/DAICHI ANO**
TEXT **KWAH MENG CHING**
LOCATION **5-8-1 JINGUMAE, SHIBUYA-KU, TOKYO, JAPAN**
TEL (OF SHOP) **(81) 3 5467 4881**

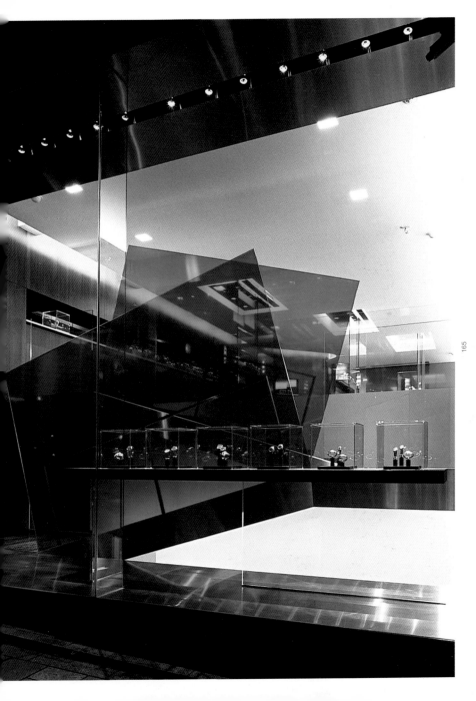

The starting point of the design was a redefinition of both how watches are displayed, and the way that customers interact with the products. Each display has been designed to respond to a specific interaction and to create a different in-store experience. Contrary to the usual static display, movement, surprise, tension, opacity and transparency are integrated into the displays to arouse the curiosity of the customers. The scale of space is especially manipulated so that attention can be focused on the watches.

Bordering the space on one side is a large curved walnut wall. A long window in it receives acrylic cubes whereby the watches can be displayed at different heights. On the other side sits a black glass visual wall. The designers developed a special system that allows the glass to change from black to transparent on demand. The interchanging opacity and transparency causes the products placed behind the wall to appear and disappear, creating a subtle presentation which expresses the passage of time, day and night.

To further express the theme of technology in space, the designers (whose firm is aptly named "Curiosity") looked for reference and materials from other fields, and transferred technology to create an architecture that expresses innovation without direct reference to the watches. They designed special floor tiles made of alcilite, a material combination of glass and aluminium. When laid in a large area, they created a sense of movement and dynamism that is a good compliment to the adjacent walnut flooring.

The integrity of the shop identity is a subtle contrast between tradition (walnut) and avant-garde (visual wall), luxury (silence) and performance (tension). What resulted is a classy and integrated space that befits the image of Tag Heuer – an integration of modernity, luxury and technology.

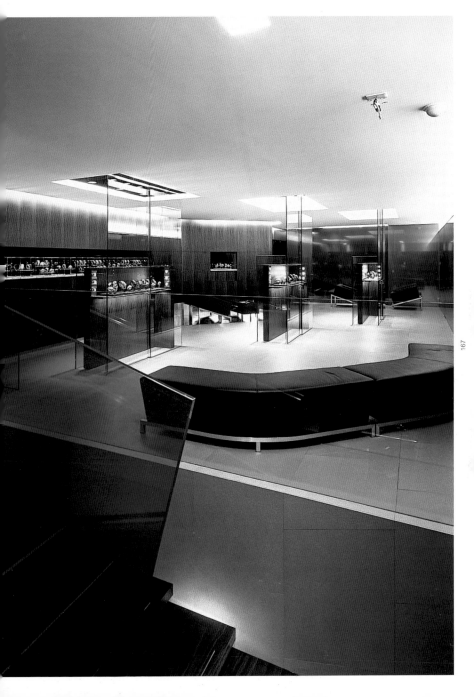

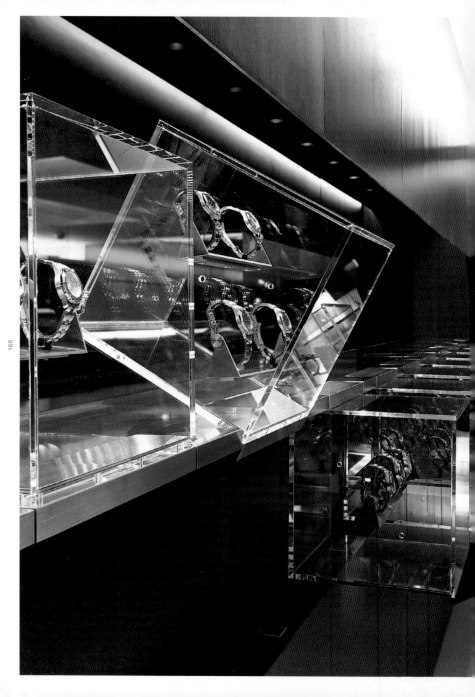

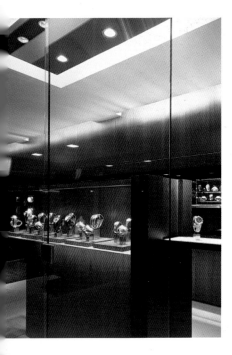
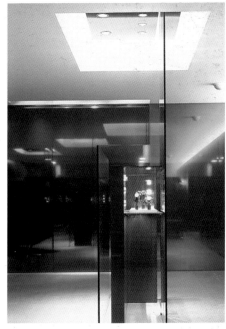

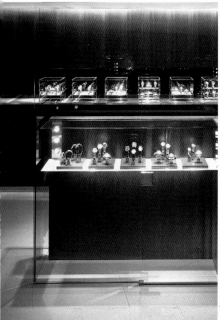
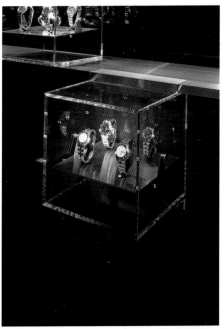

DESTINATION MARNI

marni aoyama

This flagship store for Marni in Japan is located in a fashionable area, where numerous other fashion brands fight for the consumer's attention. Against all conventional sense of having a window display that allows for an easy and clear view of the merchandise within, Sybarite decided to do otherwise.

NAME OF SHOP **MARNI AOYAMA**
OWNER/CLIENT **MARNI JAPAN**
ARCHITECT/DESIGNER **SYBARITE**
PHOTOGRAPHER **NACASA & PARTNERS INC**
TEXT **KWAH MENG CHING**
LOCATION **6-2-11 MINAMI AOYAMA, MINATO-KU, TOKYO, JAPAN**
TEL (OF SHOP) **(81) 3 5468 6301**

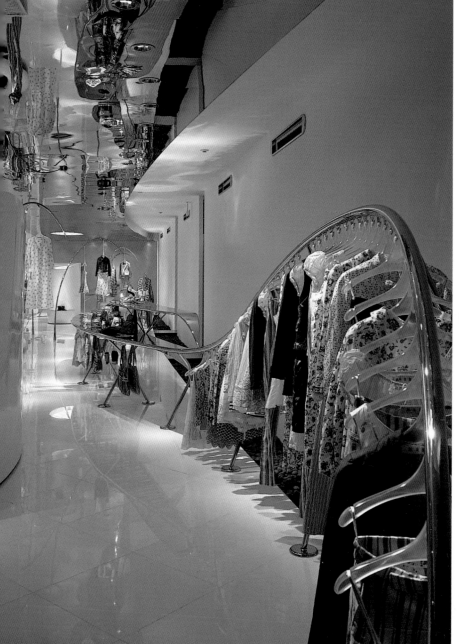

The shop has two terminuses. At the end that faces the main thoroughfare, the designers created a giant stainless steel "breast" that pushes onto the street, gently upsetting the flushed shop fronts that line the street. On it they created a small binocular style "peep hole" from which curious passers-by can take a peek at the shop interior. It is only through close examination that one will discover the entrance to the shop is actually on the opposite end.

Sybarite has adopted the concept of direction and perspective here. On entering, a crimson glass wall diffuses colour along the flanking side before fading to clear at the furthest end of the shop. Such subtle strokes are contrasted and complimented with the sinuous curves of the stainless steel rails that form the unique display system for clothes and shoes. The white marble floor is gently sloped to make up for the disparity between differing street levels at either end of the shop. The shopping experience is further enhanced by the theatrical stage that is set up by the sloped floor; at one point, the floor rises and falls with exaggerated cantilevers, and swoops down to create an opening for a seating area and shoe display. The whole floor is moated by traditional Japanese stones with the fitting room pods like giant rocks amidst a sea of white sand.

Closing off the main street entrance, leaving no visual access but the small "peep hole", and forcing the customer to walk around and find the entrance themselves, has contributed to a sense of discovery and also emphasised Marni as a "destination store". In addition, the breakaway from the traditional method of bunched clothes hanging on a rail has allowed each individual item to be displayed and viewed properly. The end product is undoubtedly a manifestation of the initial intentions to make shopping in Marni a unique and satisfying experience.

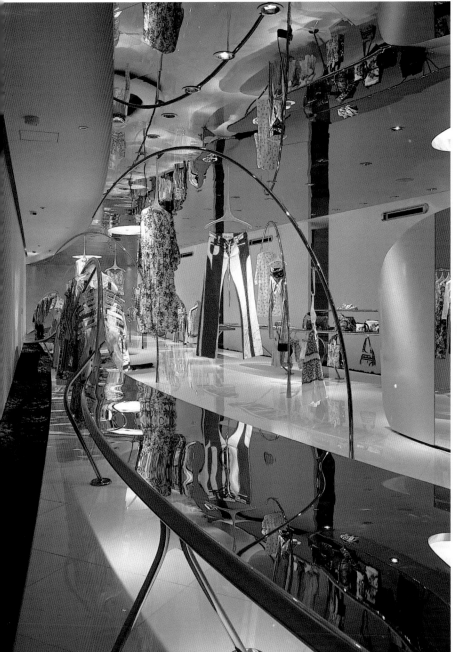

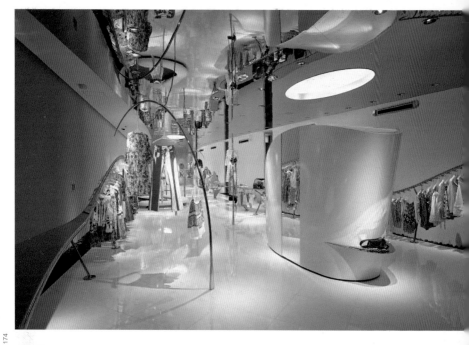

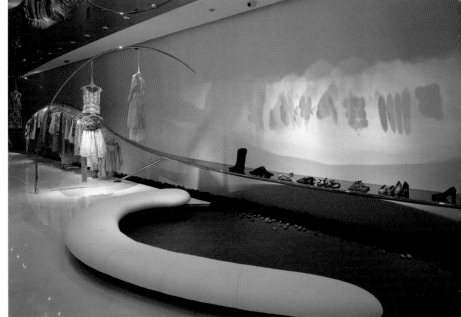

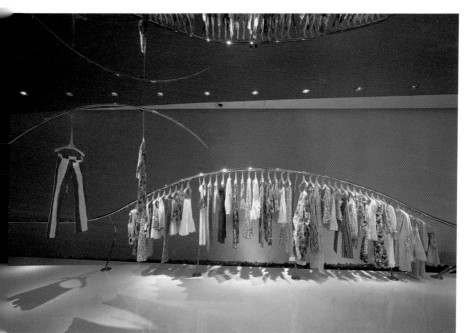

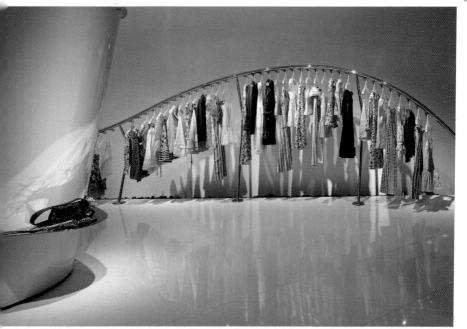

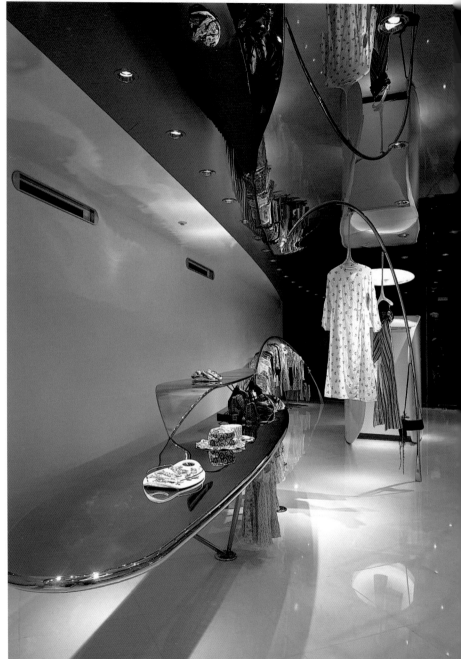

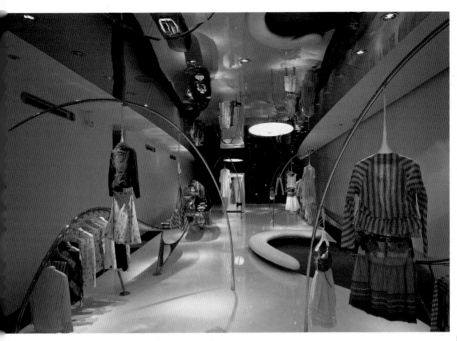

HAUTE PRODUCTION

me issey miyake

me Issey Miyake is a humorous meeting point of high-end branded product with mass consumer culture technology that befits Japan's country image so well.

NAME OF SHOP **ME ISSEY MIYAKE**
OWNER/CLIENT **ISSEY MIYAKE**
ARCHITECT/DESIGNER **GWENAEL NICOLAS/CURIOSITY**
PHOTOGRAPHER **YASUAKI YOSHINAGA**
TEXT **KWAH MENG CHING**
LOCATION **MATSUYA GINZA 3F, 3-6-1 GINZA, CHUO-KU, TOKYO, JAPAN**
TEL (OF SHOP) (81) 3 5159 0797

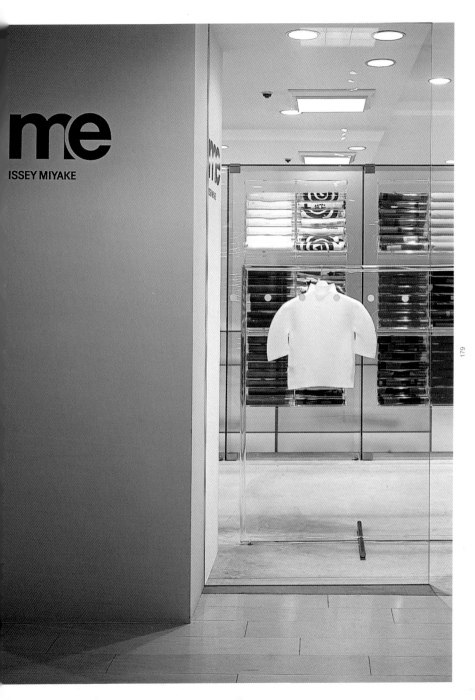

"me" is a new brand from Issey Miyake. It exclusively carries only tops that all come in one free size. Each garment is engineered with the characteristic ability to stretch a great degree so that it can fit every body. This one-sized, unique product gave Gwenael Nicolas of Curiosity the opportunity to develop a new concept for the shop – that of clothes displayed in the ever familiar "vending machine".

Whilst still in the factory, the "me" tops are packed into transparent tubes that were specially designed by Curiosity. In the shop, the tubes are displayed in a transparent acrylic "vending machine". First, the customers can check the shapes of the tops on a hanger and then select the preferred colour and texture from the vending machine. After removing the tube from the front of the vending machine, the next tube will automatically appear. This reusable transparent plastic tube is fitted with a large screw that it can be opened on one side, like a mineral water bottle. Once the merchandise is sold, no extra packaging is required.

Japan is known the for the number of vending machines in the country, selling all kinds of mass consumer goods from canned drink, beer, cigarettes, packets of rice, snacks, film, instant cameras, even bouquets of fresh flowers, and condoms. To display a high-end fashion product in a vending machine is indeed a fresh approach to interior design, but it also redefines the process of shopping in a brand boutique. The shop space may be small, but Curiosity have demonstrated their full understanding of the product and devised an innovative merchandising method whereby the product is really the main element of the interior.

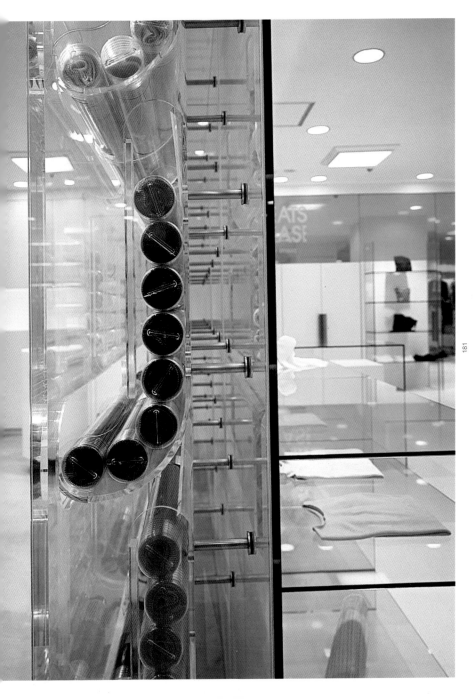

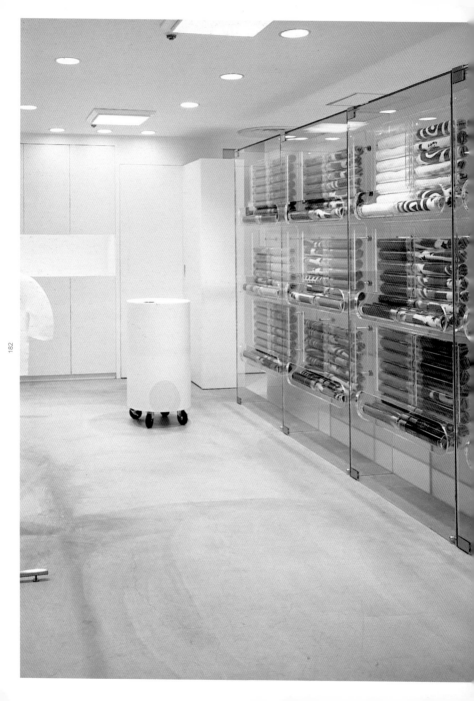

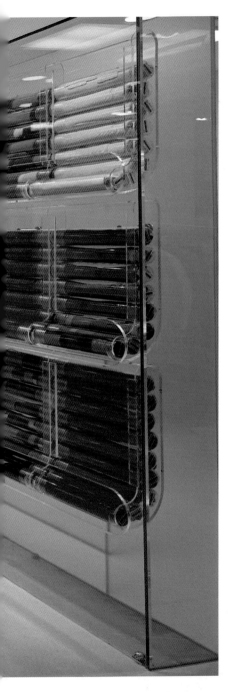

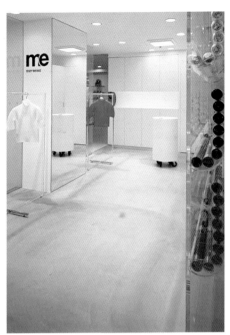

STANDING OUT IN THE CROWD

sage de cret boutique

Sage de Cret is located in an area that is full of international boutiques, most of which have similarly designed interiors. Since it would be easy for a shop to slip into insignificance, the question for Tsutomu Kurokawa was how to stand out among the rest.

NAME OF SHOP **SAGE DE CRET**
OWNER/CLIENT **GALERIE DE POP CO LTD**
ARCHITECT/DESIGNER **TSUTOMU KUROKAWA/OUT.DESIGN CO LTD**
PHOTOGRAPHER **KOZO TAKAYAMA/TANK CO LTD**
TEXT **REIKO KASAI**
LOCATION **6-4-14 MINAMIAOYAMA MINATO-KU, TOKYO, JAPAN 107-0062**
TEL (OF SHOP) **(81) 3 5778 2580**

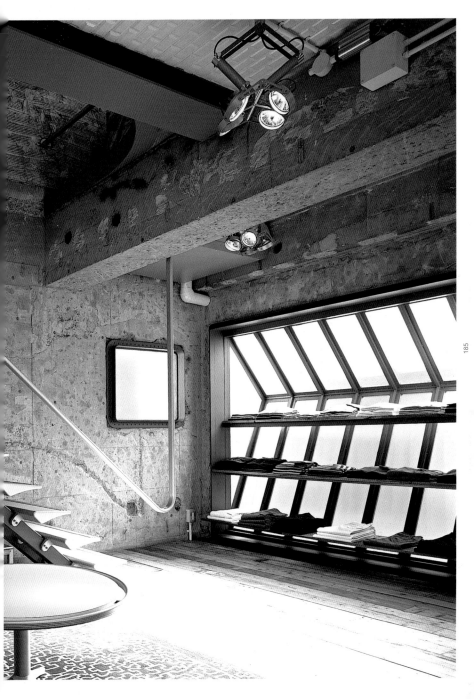

In order not to have an interior design that would become outdated too quickly, or one that is too futuristic, the decision was made to highlight individuality by working with the original look of the existing building. The designer stripped back this once residential structure to its concrete skeleton, then worked with the revealed surfaces and made insertions. The interior is a mix of old and new – layers of history juxtaposed with futuristic declarations. The existing concrete walls are rough and scarred, with holes from ventilation fans and windows. Recycled timber, equally rough with screw holes and paint marks, has been employed to cover some of the concrete walls, while others are left bare. Plumbing pipes are visible, and electrical conduits are exposed, contributing to the industrial aesthetic.

Round-edged window frames and moulded metal stair treads lend a futuristic aspect to the design. The starfish-shape of the clothes rack wall clasp evokes the concept of parasitism, reminding one that this shop is actually located inside an old building itself. The clean, smooth white wall on which it hangs strikes a contrast with the rough concrete and timber cladding. Modern, industrial-feel lighting further extends the contradiction of the new inhabiting the old. A sofa, rug and coffee table coyly recall the past domestic use of the building. A marble counter makes a bold expression of the lavish against these more industrial materials.

The juxtapositions in the design of Sage de Cret give the shop a level of interest and integrity to its existing building fabric that customers are sure to find refreshing. The contrast of warm timber to cold concrete and metal, and of rough, old and marked surfaces to smooth, new, futuristic and clean ones, creates a rich interior that makes an interesting backdrop to the clothing inside.

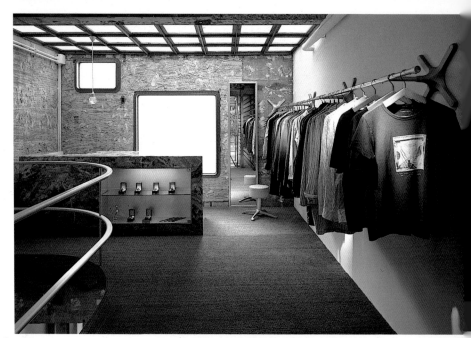

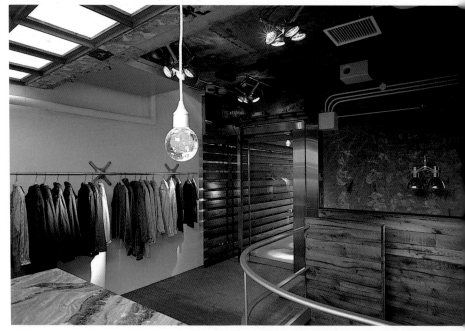

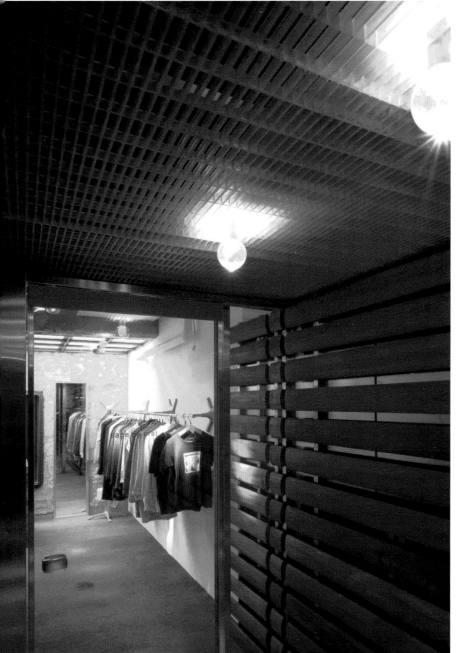

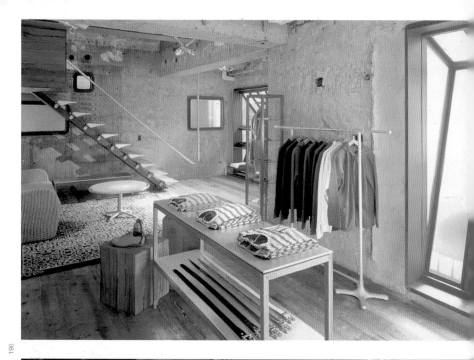

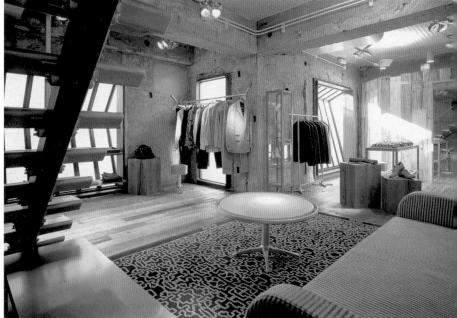

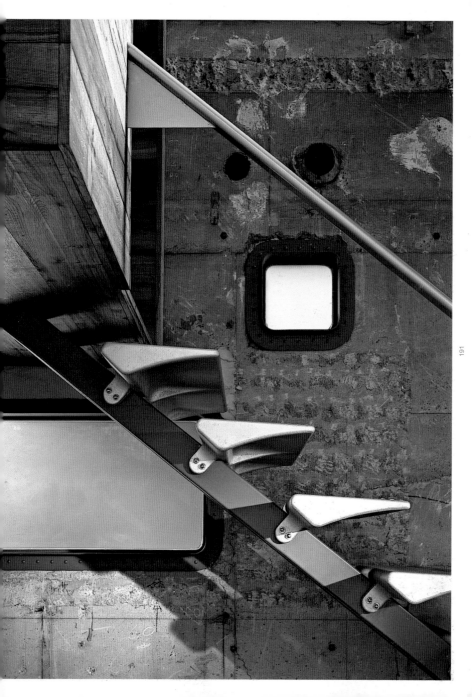

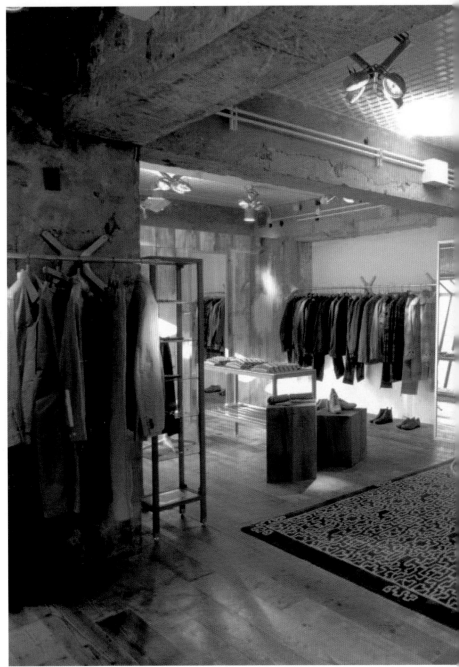

SHIFTING PLANES

Yohji
Yamamoto 1

Yasuo Kondo is known for his boutique design for the brand Yohji Yamamoto. One can even say that his name is synonymous to Yohji Yamamoto's boutiques. Through the years, he has done numerous boutiques and stores for Yohji Yamamoto, all with a different design. Yet, all of them exhibit a consistency of design language in the choice of material, colour and the simple, streamline, pristine design befitting Yohji Yamamoto's haute couture.

NAME OF SHOP YOHJI YAMAMOTO KOBE BAL
OWNER/CLIENT YOHJI YAMAMOTO INC
ARCHITECT/DESIGNER YASUO KONDO/YASUO KONDO DESIGN OFFICE
PHOTOGRAPHER NACASA & PARTNERS INC
TEXT KWAH MENG CHING
LOCATION 3-6-1 KOBE BAL 6F, SANNOMIYA, CHUO-KU, KOBE-SHI, HYOGO PREFECTURE, JAPAN
TEL (OF SHOP) (81) 3 5463 1501 (YOHJI YAMAMOTO HEAD OFFICE)

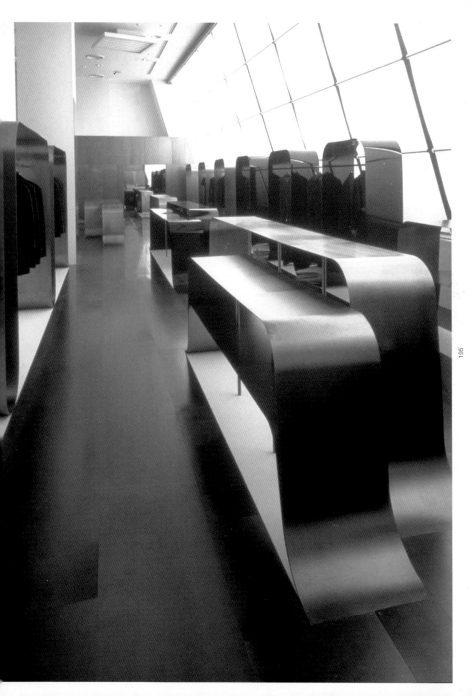

In YOHJI YAMAMOTO Kobe Bal, one encounters a shop where the relationship between space and functions is integrated by a series of folded metal plates. The shop space is long and linear with a 6 metre high ceiling. One of the longitudinal elevations of the space is a series of huge glass windows while the other side fronts the passageway. Yasuo Kondo sought to reconstruct this space just by working on the flat surface of the floor alone. The floor is first covered with continuous bands of 500 millimetre wide, 3.2 millimetre thick metal plate. Out of the numerous bands, some of them located at the central axis of the shop pop up and become low tables for displaying clothes. Those along the periphery assume a higher profile for clothes hanging. On the whole, this design boasts a simple composition of "flying carpets" where both spatial and functional requirements are integrated.

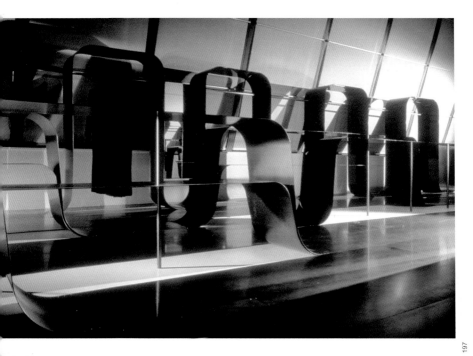

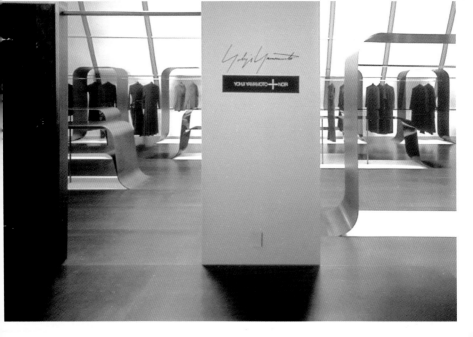

SHIFTING PLANES

yohji
yamamoto 2

NAME OF SHOP YOHJI YAMAMOTO POUR HOMME & Y'S FOR MEN
OWNER/CLIENT YOHJI YAMAMOTO INC
ARCHITECT/DESIGNER YASUO KONDO/YASUO KONDO DESIGN OFFICE
PHOTOGRAPHER NACASA & PARTNERS INC
TEXT KWAH MENG CHING
LOCATION 3-6-1 KYOTO BAL 2F, YAMAZAKI-CHO, KAWARAMACHI-DORI, NAKAKYO-KU, KYOTO, JAPAN
TEL (OF SHOP) (81) 3 5463 1501 (YOHJI YAMAMOTO HEAD OFFICE)

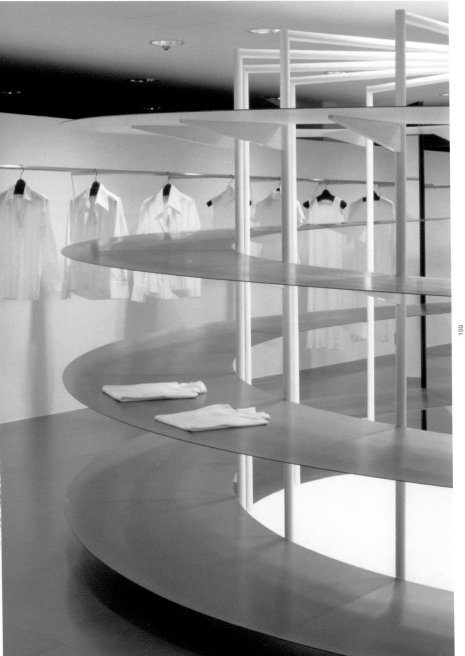

In YOHJI YAMAMOTO POUR HOMME & Y's for men, Yasuo Kondo adopted another approach. Still using the 3.2 millimetre thick metal plate, but 700 millimetres wide now, he created a spiral that spins up from the floor towards the ceiling at a gentle inclination of 3 degrees. Supported on steel pipe, this 4 metre diameter spiral thus becomes the shelving and hangers for the clothes, besides being the central focus and symbol of the shop.

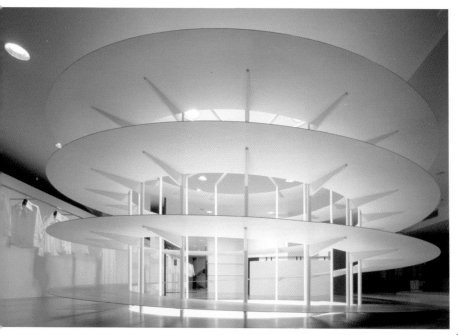

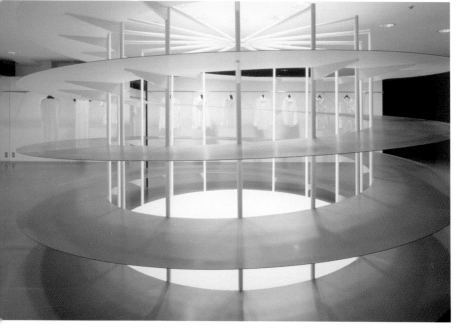

SHIFTING PLANES

yohji
yamamoto 3

NAME OF SHOP **YOHJI YAMAMOTO MATSUYA GINZA**
OWNER/CLIENT **YOHJI YAMAMOTO INC**
ARCHITECT/DESIGNER **YASUO KONDO/YASUO KONDO DESIGN OFFICE**
PHOTOGRAPHER **NACASA & PARTNERS INC**
TEXT **KWAH MENG CHING**
LOCATION **3-6-1 MATSUYA GINZA 3F, GINZA, CHUO-KU, TOKYO, JAPAN**
TEL (OF SHOP) **(81) 3 5463 1501 (YOHJI YAMAMOTO HEAD OFFICE)**

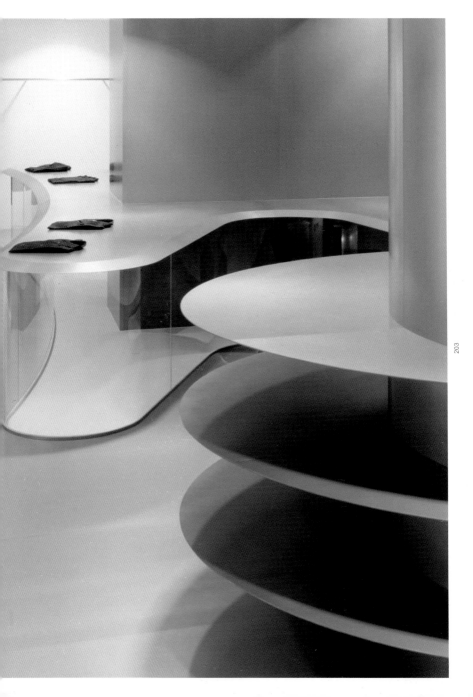

YOHJI YAMAMOTO Matsuya Ginza is the eighth shop of the metal plate series. Yasuo Kondo composed this shop with two simple elements, a metal and glass cabinet with a unique shape and metal display shelving. The plan of the metal and glass cabinet resembles that of a four armed starfish, and the 2.3 millimetre thick metal plate top acts as a display area for clothes. Precision glass lines the curved perimeter of the metal top. The metal top seems to float on air, casting cloud-like shadows on the floor. The metal display shelving is a successful way to neutralise the imposing column at the front of the shop. The designer has turned it into an elliptical sculptural piece by wrapping it with metal plate. In addition, part of the metal plate whirls out horizontally, as if under the act of centrifugal force, to provide additional display shelving, whilst also acting as the symbol for the shop.

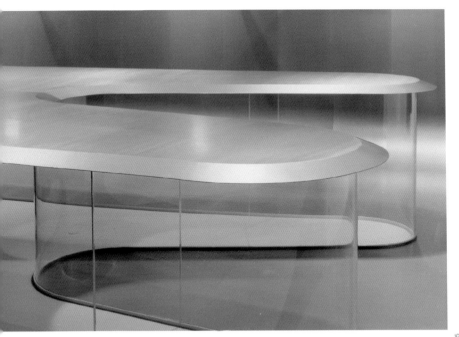

VERY VERSATILE

gudang
showroom

Spatial versatility allows controlled and flexible retail presentations in this up-market furniture and homewares store.

NAME OF SHOP **GUDANG SHOWROOM**
OWNER/CLIENT **GUDANG DAMANSARA SDN BHD**
ARCHITECT/DESIGNER **JOHN DING, KEN WONG, YIK SWOFINTY**
PHOTOGRAPHER **HILTON PHOTOGRAPHERS SDN BHD**
TEXT **RICHARD SE**
LOCATION **BANGSAR SHOPPING CENTRE, KUALA LUMPUR, MALAYSIA**

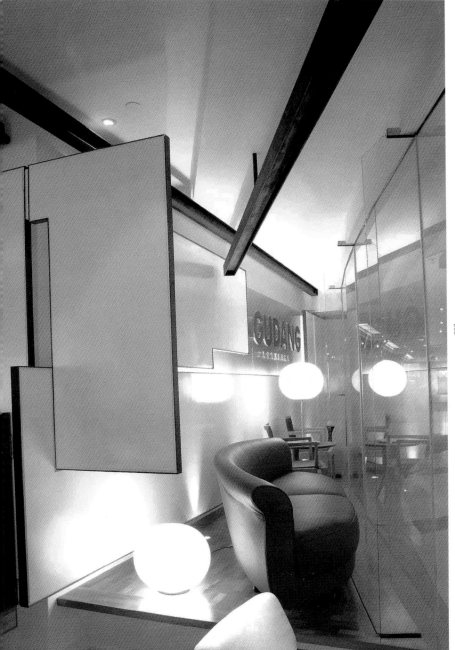

Gudang Showroom is a space for displaying furniture and homewares in an up-market Kuala Lumpur shopping centre. The client had requested that there be a high level of flexibility in the main display space, and that its ambience could be altered depending on the display conditions adopted.

The designers have succeeded in providing a flexible and contemporary gallery ambience. They have created different levels in the space, identifying two major spaces for display – the retail gallery and the chair gallery. The main retail gallery space affords further flexibility with moveable screens that are set at regular centres. These allow the retailers to further divide the space into smaller, more intimate pockets, or to exhibit in the main open gallery as a single, expansive space. The screens are also used to frame objects and work as backdrops for various room settings.

The entrance is emphasised with a steel I-beam structure on which the main doors are top-hung to slide effortlessly along its length. A long cantilevered counter identifies the check-out area and also acts as a display shelf for home accessories. The spaces are further distinguished by different lighting solutions, with the main focus in the shop being the brightly-lit accessory space. With an overall palette of neutral cream and fawn tones, the design is an exercise in expression and veiling, spatial versatility and controlled retail presentations.

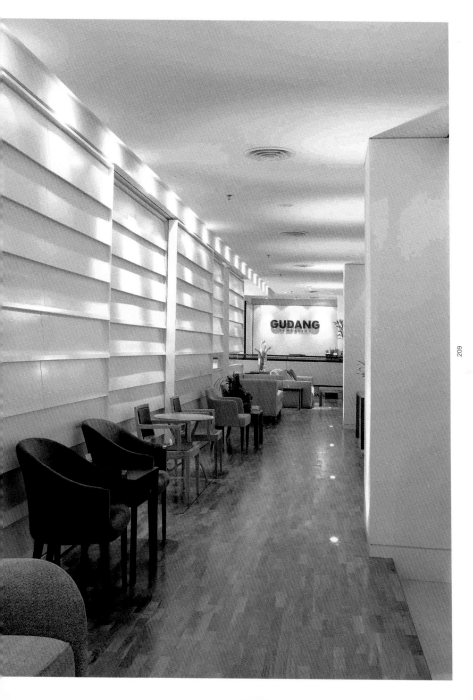

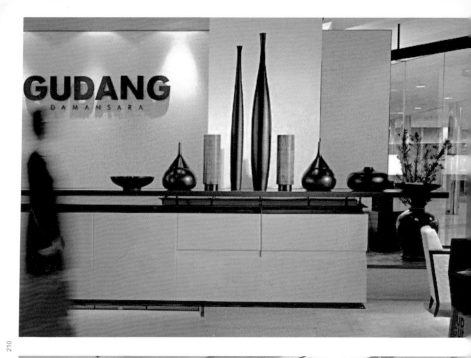

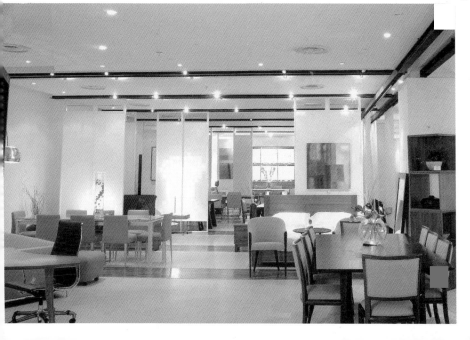

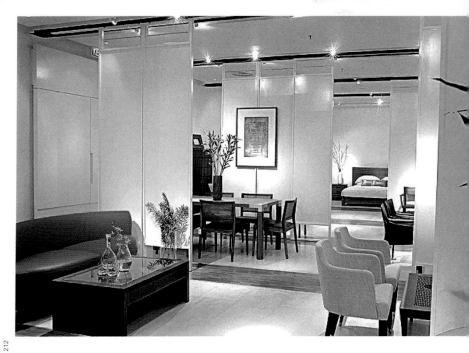

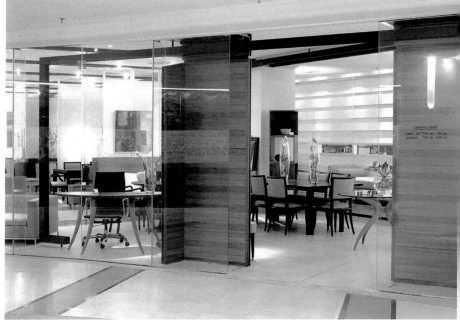

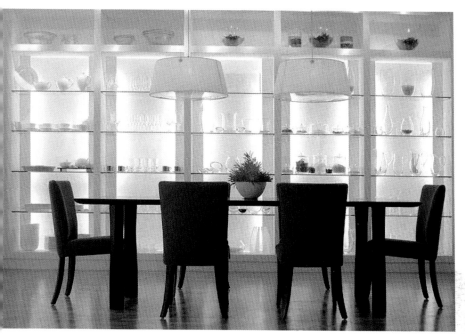

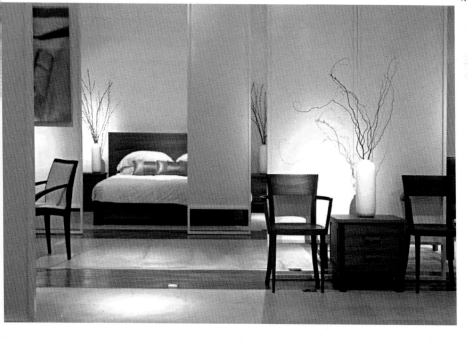

ENERGETIC ENCLAVE

shuz sports

The design concept for this sport and casual shoes store projects an upbeat image aimed at a select market.

NAME OF SHOP **SHUZ SPORTS**
ARCHITECT/DESIGNER **RICHARD SE/PH+D DESIGN**
PHOTOGRAPHER **RICHARD SE**
TEXT **RICHARD SE**
LOCATION **111D SURIA SHOPPING MALL, KUALA LUMPUR, MALAYSIA**
TEL (OF SHOP) **(60)3 3820737**

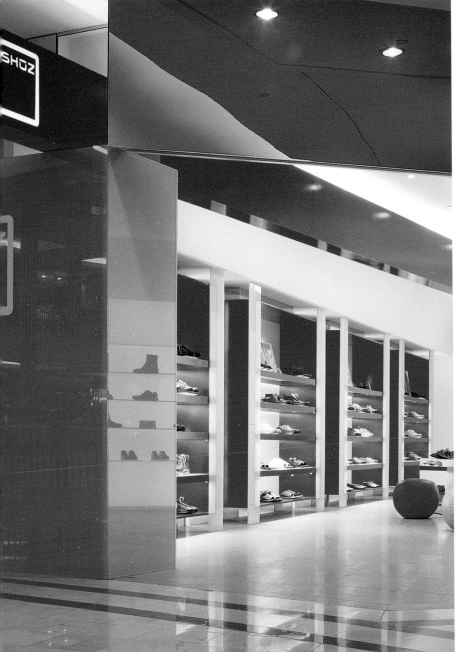

Shuz Sports is a sporty counterpart to Shuz boutique, also located at Suria, Kuala Lumpur city centre. Shuz Sports focuses mainly on men's shoes and also has a selection of female casual shoes, with Camper as its main draw card. Red is chosen as the chief colour for the shop's interior design, supported by white and grey. Red is associated with Camper shoes stores around the world, and the designers felt that it also promotes an energetic, sporty image.

Several contrasting design elements were mapped out on the funnel-shaped floor plan. These elements are the display shop front, the display shelves on the selling floor and the storage area. The unusual and rather difficult geometry of the floor plan was creatively resolved by placing the shelves and displays at non-perpendicular angles.

Two important design elements are the fragmented shop front and the "red beam" that spans across the space. This beam serves to hold the signage and the general lighting for the store. Contrasting elements such as glowing translucent glass shelving and back-lit red shelving create a lively and casual atmosphere. The island display units, finished with mirrored surfaces, also serve as mirrors for customers trying on shoes while sitting on funky egg shaped seats. The grey natural limestone floor creates a contrast with the smooth and polished surfaces in the store. The store features a gigantic sliding door that, when fully utilised, forms a wall and a full-height mirror.

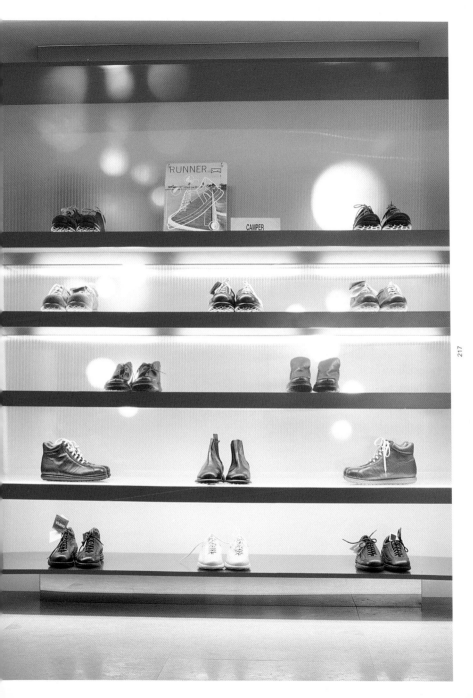

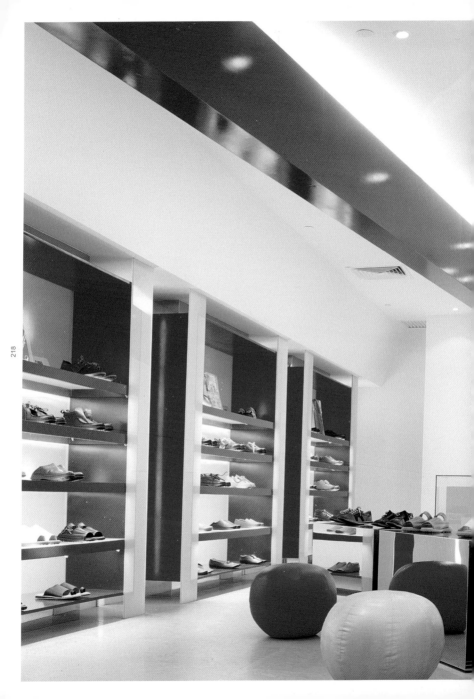

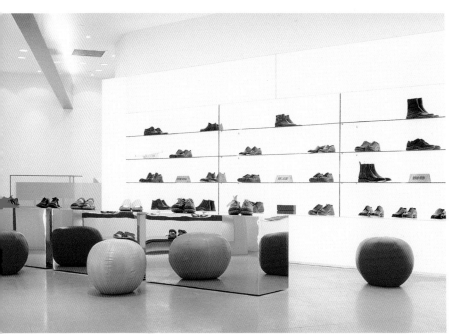

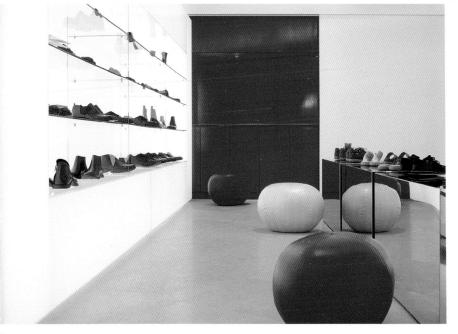

TRANQUIL OASIS

cairnhill gallery

The interior of this shophouse was retrofitted for an art dealer so that he could house his private collection of paintings and sculpture, and accommodate visiting artists. The intention was to create a tranquil oasis for the contemplation of contemporary prints and sculpture.

NAME OF SHOP **CAIRNHILL GALLERY**
OWNER/CLIENT **GLASTECH INVESTMENT PTE LTD**
ARCHITECT/DESIGNER **SOO CHAN/SCDA ARCHITECTS**
PHOTOGRAPHER **PETER MEALIN**
TEXT **ANG HWEE CHUIN**
LOCATION **72 CAIRNHILL ROAD, SINGAPORE**

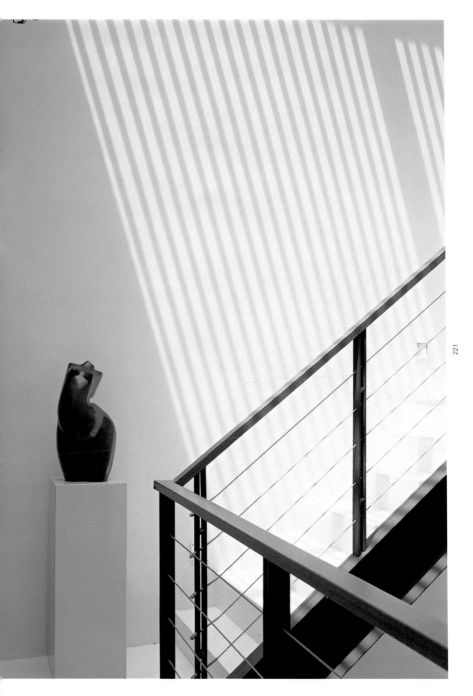

Workplace and residence merge in this retrofitted shophouse. The front portion of the building was gutted internally and simultaneously a rear extension was added, sunken by half a level, in order to conceal the kitchen and service areas. From the entrance, the first gallery space retains the original light and air-well of the shophouse. The route is carefully choreographed, shifting from a central axis to the left. Crossing a solid timber bridge over a black granite reflective pool and ascending granite steps to the second gallery space, one regains the centre. A timber screen separates the two spaces. The heart of the house is a soaring light-filled water-court with a timber and granite "floating" platform. A timber pergola casts delicate shadows on the walls while filtering sunlight. From the sculpture court, one ascends to the final gallery space with views of the verdant green space beyond.

The gallery owner's suite is also located at the rear overlooking dense foliage – while the guest rooms are located facing Cairnhill Road. Access to these upper rooms is via a solid wood staircase, which is cantilevered from the wall. A restrained palette of bush-hammered grey granite, white oak strips and travertine marble is used.

There is a feeling of immense calm and stillness, which supports the contemplation of the exhibited artwork. Each piece is accorded a generous amount of space and a specific setting in relation to the choreographed movement. The detachment of each object and the lack of distractions enable an intense engagement between the viewer and the sculptural object from a variety of angles.

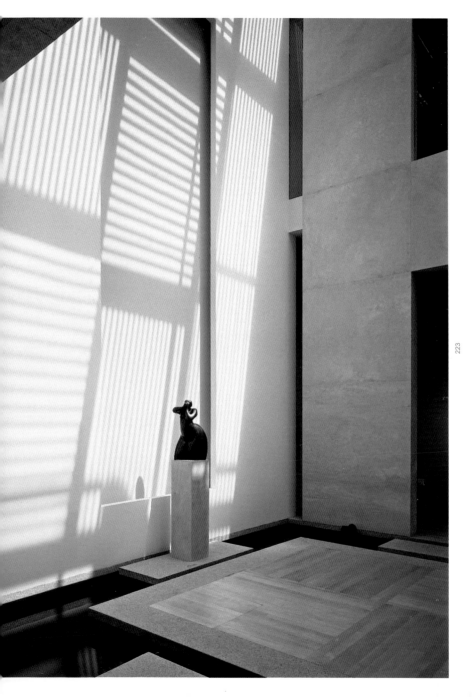

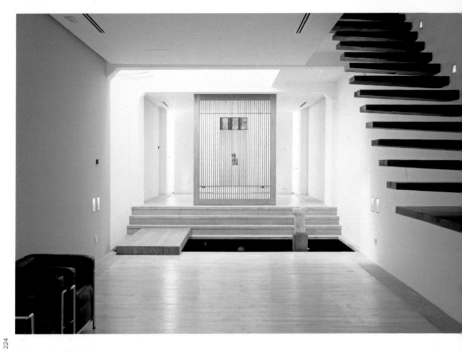

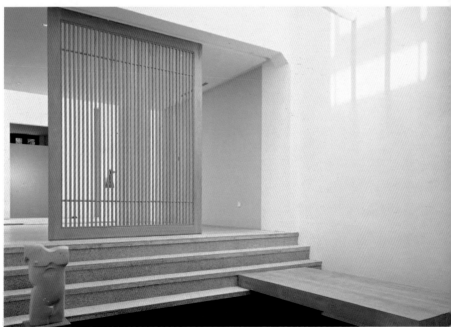

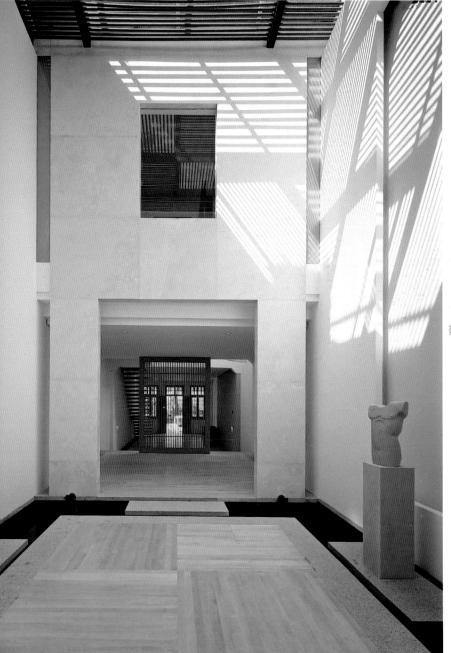

FRESH PRODUCE

camper

Sweeping rows of shoes, lined up on low horizontal platforms, give this Camper outlet the feel of a fresh produce market—an effect that suitably reflects the free spirited nature of the Camper brand.

NAME OF SHOP **CAMPER (RAFFLES CITY)**
OWNER/CLIENT **F. YAMING INTERNATIONAL PTE LTD**
ARCHITECT/DESIGNER **SONG YIH**
PHOTOGRAPHER **KELLEY CHENG**
TEXT **ANG HWEE CHUIN**
LOCATION **252 NORTH BRIDGE ROAD, #01-30 RAFFLES CITY SHOPPING CENTRE, SINGAPORE**
TEL (OF SHOP) **(65) 6333 9603**

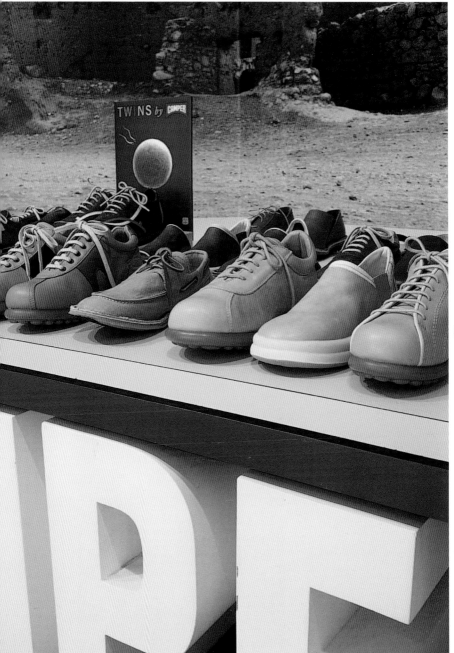

The design of Singapore's Camper flagship store is based on the concept of freshness and vibrancy, expressing the free and passionate spirit of the Camper brand. The vivid red and white of the Camper logo, along with other earthy tones, are manifested on volumes and planes, and cover the entire space of the shop. As such, the shop is undeniably branded. Low, curving display shelves negotiate the many awkward angles inherent in the space, and promote a casual circulatory flow through the shop. Dissolving the traditional barriers of shop displays, the design aims to encourage free browsing and trying.

To create the inviting environment that supports such active interaction, the store adopts an open concept, whereby minimal glass lines the shop front, and the entrance takes the form of a concave shape, drawing people into the store in a natural course of motion. The single-tiered display platforms encourage people to pick up the shoes. The way that the shoes are lined up in rows on horizontal planes, rather being than stacked up vertically on shelving, gives the shop the feel of a fresh produce market.

A circular pod, where shoppers may sit and try on their shoes in front of a succinct strip of mirror forms a spatial focal point in the store. This single, major vertical element contrasts greatly with the surrounding sweeping horizontal planes, and as such, its functional role as the only place to sit is highlighted. Configured neatly behind this platform are the service counter and stock rooms. The store interior is dressed with eclectic wall prints, expressing the natural spirit that ties with the Camper brand.

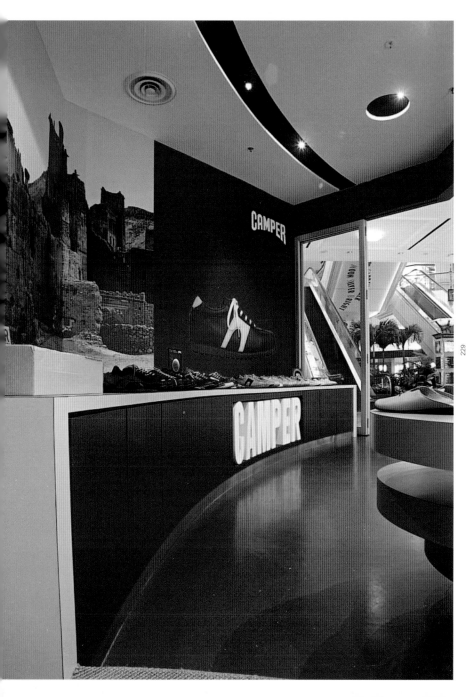

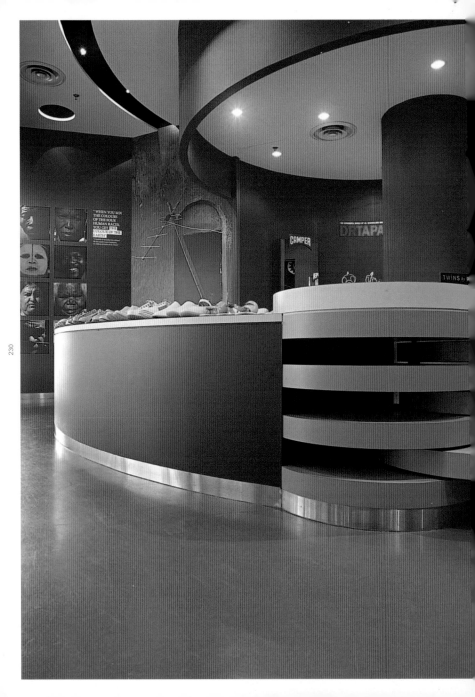

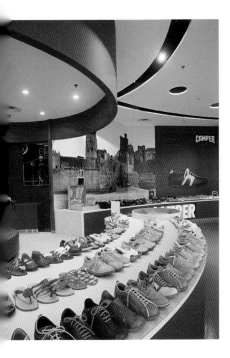
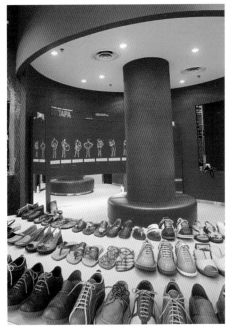

A TIMELY DIMENSION

emotus

Targeted at a hip, young clientele, this watch shop retails sophisticated designer timepieces in a shop space that will completely erase any conception that you may hold of watch shops being old, cramped and dingy.

NAME OF SHOP **EMOTUS**
OWNER/CLIENT **SINCERE WATCH LTD**
ARCHITECT/DESIGNER **ECO-ID ARCHITECTS & DESIGN CONSULTANCY PTE LTD, SINGAPORE**
PHOTOGRAPHER **KELLEY CHENG**
TEXT **ANG HWEE CHUIN**
LOCATION **391B ORCHARD ROAD, #B1-36 NGEE ANN CITY, SINGAPORE**
TEL (OF SHOP) **(65) 6835 2690**

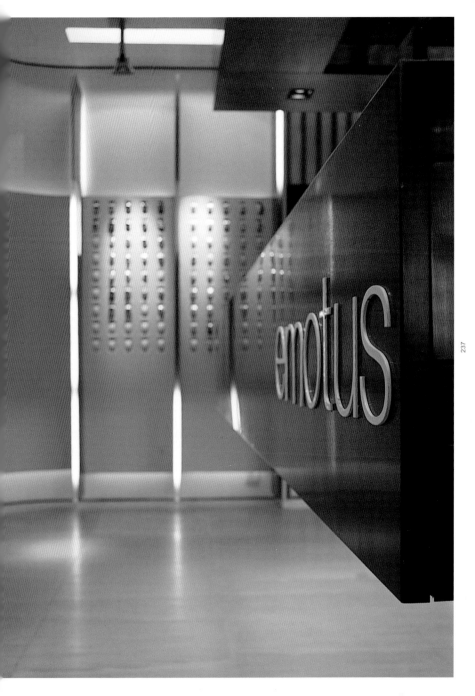

Aimed at introducing a whole new concept to the design of watch shops, Emotus has been highly successful in projecting the stylish and sublime image of sophisticated consumer culture. As a shop that carries multiple brands, the chief design challenge came in giving each brand sufficient space for showcasing individual identity, without overshadowing the Emotus brand name. As such, a programmable shop front that allows displays dedicated to different featured brands every season, offers an opportunity for a regular change in shop flavour. This shop front is clad in white metal and sports a hound's-tooth-shaped glass display, which is designed to capture shoppers' attention from afar.

Within the shop, a floating island counter in the centre, bearing the signature mark of Emotus, forms a visual and spatial focus in the space. Suspended from the ceiling by steel ties, it is clad in anodised bronze sheet to imbue the design with a sense of luxury. A drop-ceiling, clad in walnut, provides this space with the intimate dimension required for the trying on and contemplation of a watch.

Vertical walnut timber strips line the wall displays to create a louvre appearance. These louvres give a shifting visual effect when one browses around the shop, and gather the customer's focus on one row of watches at any one time. Complemented by padded white leather upholstery (into which watches are inserted for display), the wall display system further portrays the chic-luxurious theme. The vertical strips of cladding, and the vertical ties suspending the counter, are reminiscent of the strip of a watchband. The horizontal band of the counter's front edge breaks the monotony of the vertical dimension, and is the point on which the customer will focus upon entering the shop.

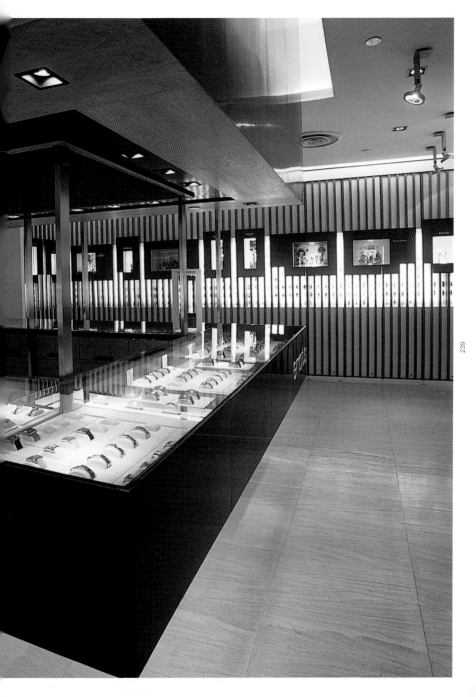

RELIGIOUS RETAILING

loang & noi

This exclusive jewellery shop shuns the usual attention grabbing form of shop fronts, and inside, it expresses qualities that are decidedly holy.

NAME OF SHOP **LOANG & NOI**
OWNER/CLIENT **LOANG & NOI PTE LTD**
ARCHITECT/DESIGNER **ROBIN TAN, CECIL CHEE/WALLFLOWER ARCHITECTURE + DESIGN**
PHOTOGRAPHER **KELLEY CHENG**
TEXT **ANG HWEE CHUIN**
LOCATION **290 ORCHARD ROAD, #01-23 PARAGON SHOPPING CENTRE, SINGAPORE**
TEL (OF SHOP) **(65) 6732 7218**

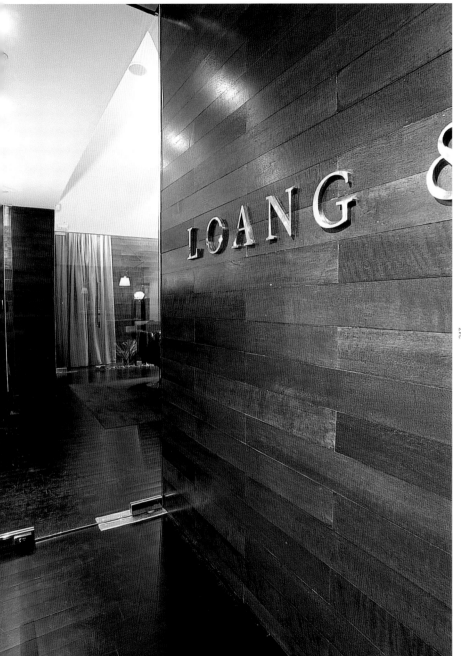

This atypical shop, specialising in custom-designed jewellery, makes a quiet statement along the row of neighbouring designer stores. The shop space is divided into three sections: the retail space, with a flanking display area and pantry on the left, and offices and a meeting room on the right. This configuration elongates the retail space, imbuing a nave-like, classical quality, which is exaggerated by a mirror placed at the end.

A strip of black carpet demarcates an aisle along the centre of the space, terminating with a counter that converges this perspective. Coffee tables placed along the black carpet allow for interaction and informal discussions between clients and designers, which is unlike the setup in most jewellery shops. Dark timber flooring runs up midway along the wall to give spatial and material continuity to the lower half of the room. Capping this space is a vaulted drop ceiling, from which a series of circular panels are suspended to support lamps and adjustable spotlights that highlight different areas of the room. Freestanding display columns are cleverly lit to bring out the sparkle and exquisiteness of the jewellery, which is all displayed at eye-level. A window display space clad in natural stone is suggestive of space beyond the confines of the shop.

With its shop front shrouded by translucent curtains, and its minimal methods of display, Loang & Noi expresses essence, rather than shouting out with loud visuals. In this way, it is more like a chapel than a shop. It encourages movement through and experience of the space, and shuns reliance on visual communication. It is a delicate, alternative way of selling, that is suitable to its one-off, customised designs.

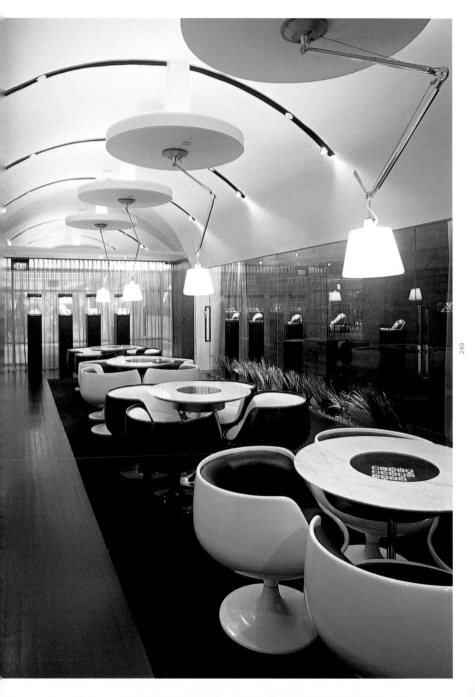

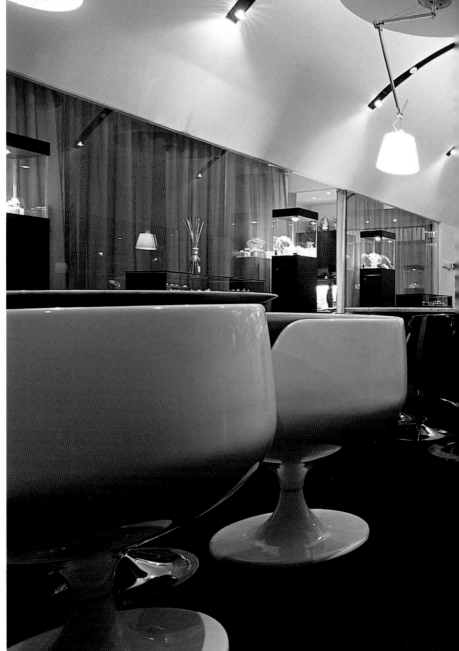

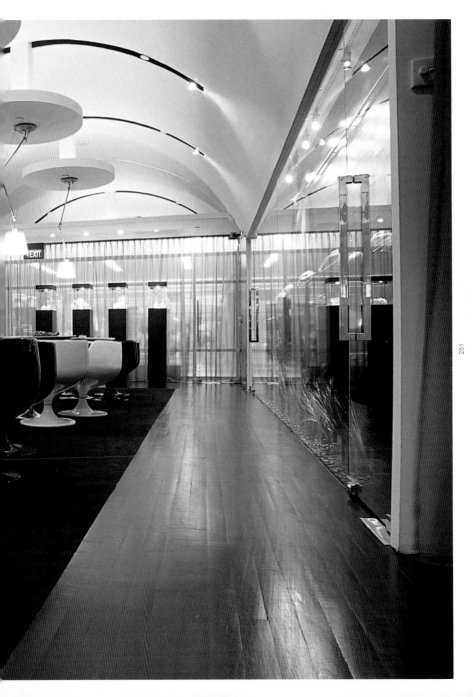

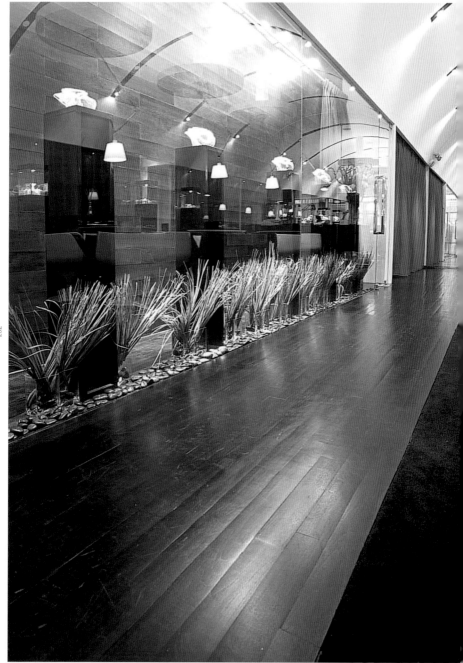

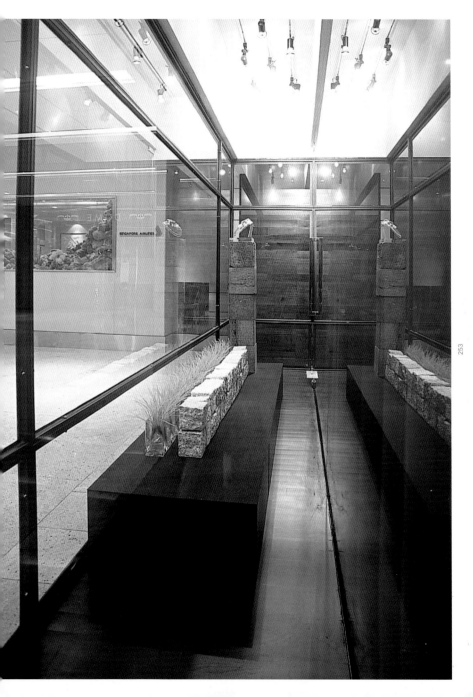

DRAMATIC CUT

passion hair salon

This pristine salon space is focused on the creation of dramatic views from various vantage points, such that the user is treated to an interesting view with every turn.

NAME OF SHOP **PASSION HAIR SALON**
OWNER/CLIENT **DAVID GAN/PASSION**
ARCHITECT/DESIGNER **PETER TAY**
PHOTOGRAPHER **FRANCIS NG TECK YONG & ELAINE KHOO**
TEXT **ANG HWEE CHUIN**
LOCATION **390 ORCHARD ROAD, #01-01/02 PALAIS RENAISSANCE, SINGAPORE**
TEL (OF SHOP) **(65) 6733 5638**

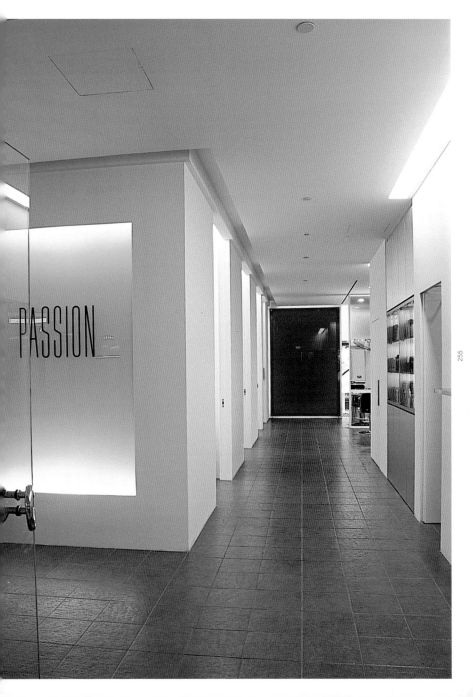

Situated in the upmarket Palais Renaissance shopping mall, this salon is designed to present a pristine and chic image. Segregated into a reception, a cutting area and a washing area, the salon is generously proportioned and seats 21 people at one time. The treatment of the space focuses on the creation of dramatic views from various vantage points around the salon, such that the user is treated to an interesting view with every turn. As such, a strongly planar language fused with expanses of coloured films applied onto acrylic, characterise the pockets of spaces within the salon. These films are easily changeable according to moods and needs, and sculpt a new atmosphere each time a different colour is applied.

Lighting and furniture details are heavily concealed here to maintain a design that does not reveal complex mechanisms. To cater to its rich and famous clientele, four VIP rooms have been included in the premises. These rooms are partitioned off by full-height sliding doors with concealed tracks that, when closed, appear like walls rather than doors, thereby preserving the visual cleanliness of the wall plane. When viewed from the street, the salon's facade appears as a clear expanse of glass, which transforms the salon into a moving showcase of activities.

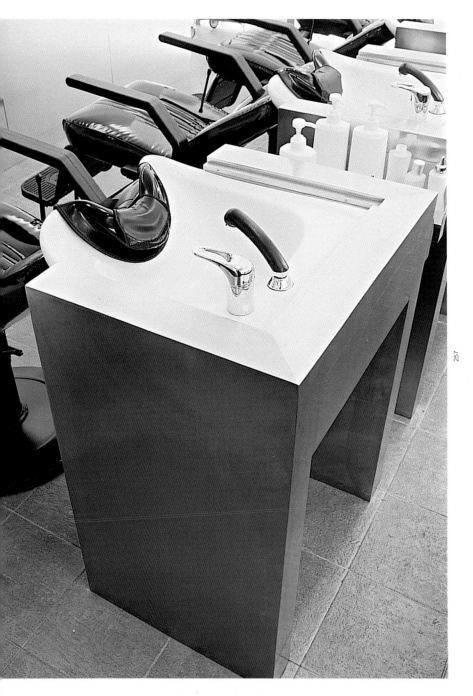

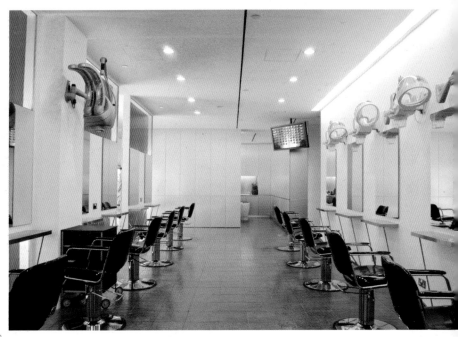

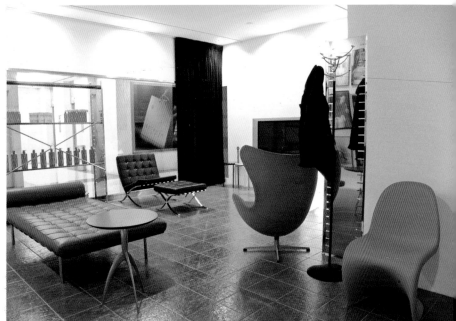

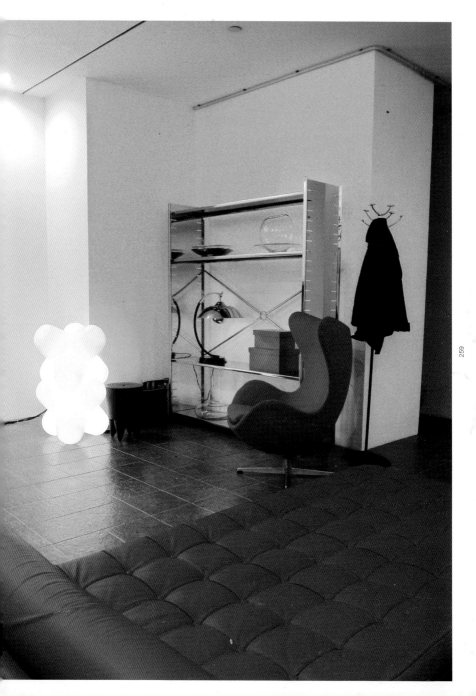

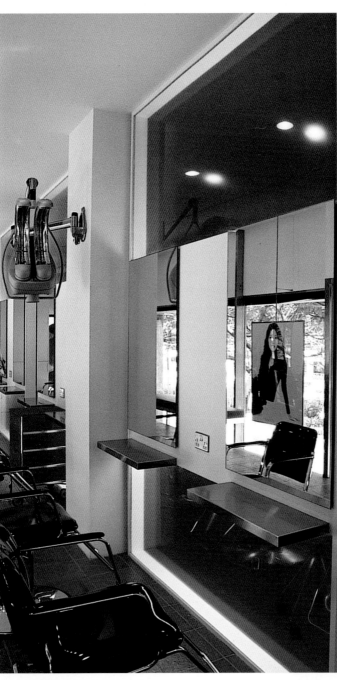

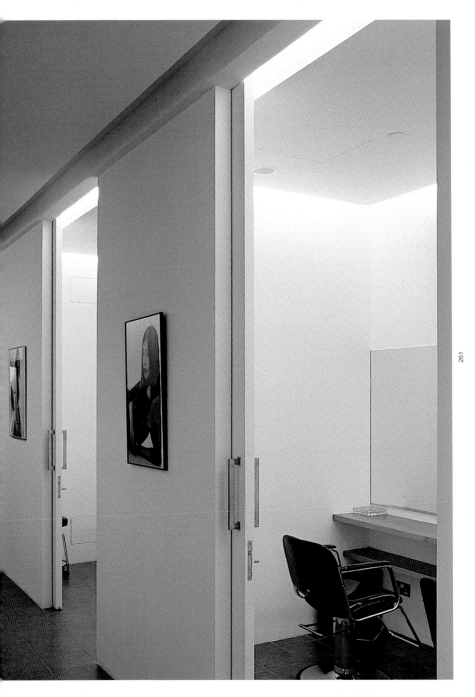

SCI-FI FLAVOUR

pod @ wisma atria

With an organically shaped three-dimensional insertion into its rectilinear space, this telecommunications store takes on a science-fiction edge that speaks of our detached state of existence when speaking on the phone.

NAME OF SHOP **POD @ WISMA ATRIA**
OWNER/CLIENT **SINGAPORE TELECOMMUNICATIONS LTD**
ARCHITECT/DESIGNER **ECO-ID ARCHITECTS & DESIGN CONSULTANCY PTE LTD**
PHOTOGRAPHER **AMIR SULTAN**
TEXT **ANG HWEE CHUIN**
LOCATION **435 ORCHARD ROAD, #B1-38 WISMA ATRIA SHOPPING CENTRE, SINGAPORE**
TEL (OF SHOP) **(65) 6481 8181 (SINGTEL ENQUIRIES)**

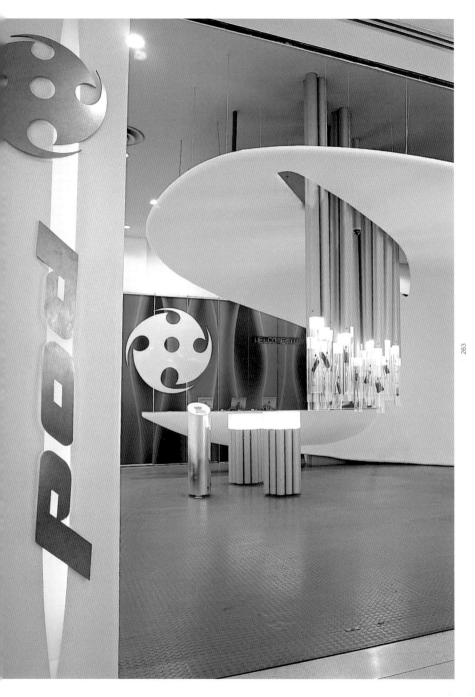

pod @ Wisma Atria was developed in a re-branding exercise for Singtel – Singapore's largest mobile service provider – in a bid to attract younger customers. Offering mobile phones, services and various technological gadgets, the brand aims at marketing future lifestyles to its clientele.

The store has a club-like fit-out that shapes an exciting and futuristic retail environment. In a rare departure from conservative local shop designs, the designer has inserted an intuitively-shaped element into the rectilinear shop space to capture peoples' attention from afar. Constructed from a metal sub-frame with timber armature and plaster applied, the organic shape resembles a clasped hand, which seems to capture human traffic and suggests – on an abstract note – a removal from reality. In this way it is suggestive of how we are detached, in a way, from our immediate surroundings when we talk on the phone.

The small and loose nature of the products has prompted the designer to devise innovative and theatrical display cases fashioned from aluminium tubes and perspex. These are suspended from the ceiling. Glowing with inbuilt lighting, the cases appear to defy gravity, adding a sci-fi edge to the feel of the store. These displays are supplemented by mini flat screen LCDs that project moving images and videos to rouse visual attraction, drawing people's attention to the merchandise.

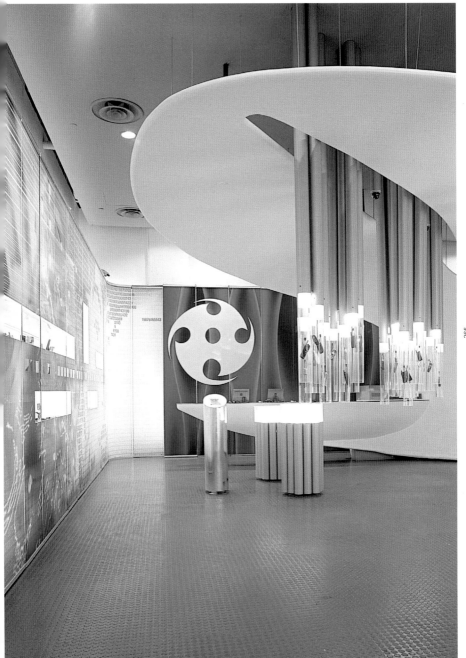

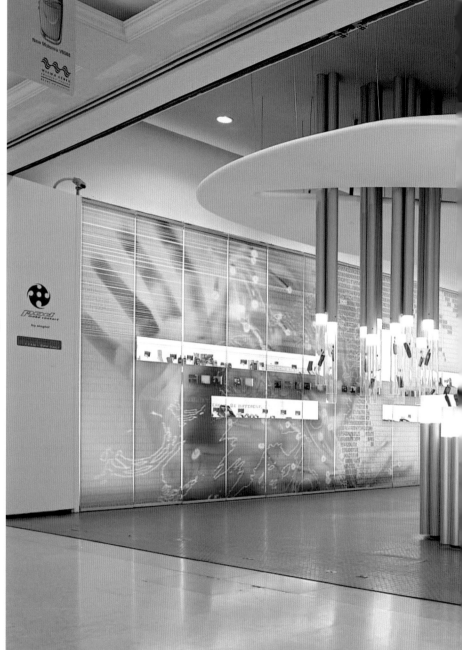

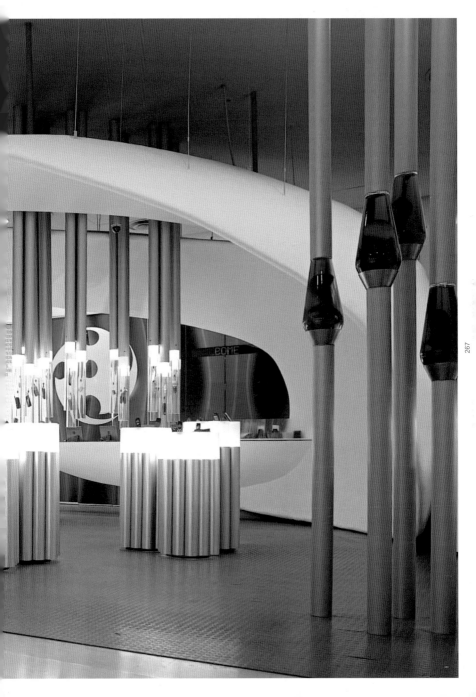

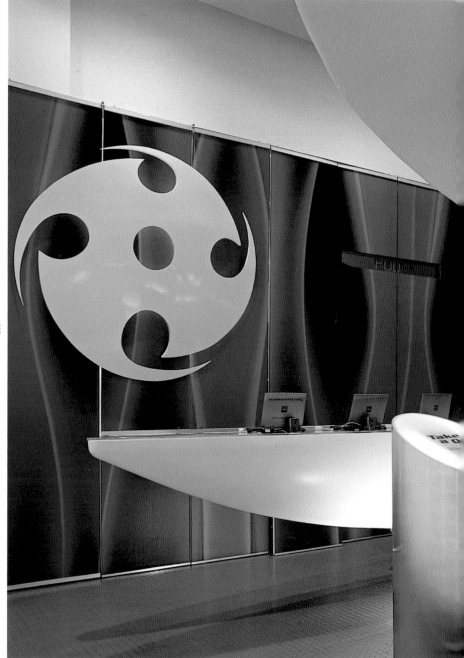

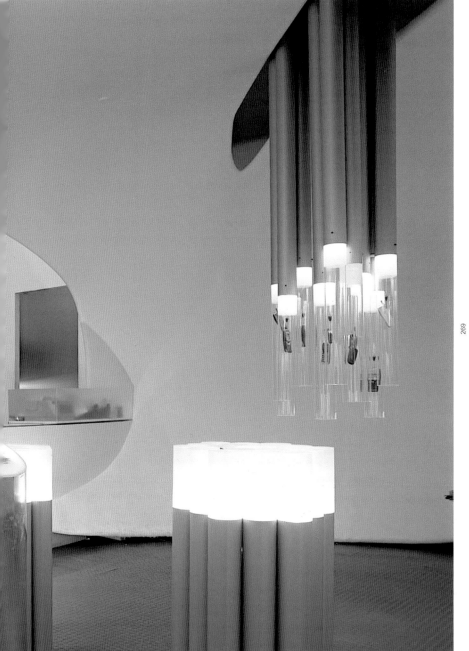

ECLECTIC COOL

projectshop
bloodbros

Customers are encouraged to rummage around and make discoveries in this eclectic clothing store, which contains its own café.

NAME OF SHOP **PROJECTSHOPBLOODBROS (PARAGON)**
OWNER/CLIENT **PROJECTSHOPBLOODBROS**
ARCHITECT/DESIGNER **DESIGN AND CONCEPT: PROJECTSHOPBLOODBROS; PROJECT TEAM: RICHARD CHAMBERLAIN, PETER TEO, PHILIP CHIN;**
INTERIOR CONSULTANT: **AAMER TAHER STUDIO**

PHOTOGRAPHER **KELLEY CHENG**
TEXT **ANG HWEE CHUIN**
LOCATION **290 ORCHARD ROAD, #02-20 PARAGON SHOPPING CENTRE, SINGAPORE**
TEL (OF SHOP) **(65) 6734 7209**

Driven by the desire to create a less commercial and more casual shopping environment, the designers drew inspiration from the idea of a home, fusing it with the aesthetics of industry and retro themes. Aimed at creating a shopping experience that lets customers rummage around and make discoveries for themselves, the displays are deliberately crowded and visually abundant. Over time, this shop morphs with the addition of different elements and new methods of display.

Custom-designed racks and an eclectic collection of loose furniture is scattered across the shop space, adding to the laidback air. Metal clothing racks climb up the walls, displaying clothing arranged in a seemingly casual manner. Metal grilles and framed glass panes typical of 1970s design forge a characteristic language. Concrete block walls are painted white, but are left unrendered. Oxidised steel sheets line the floor to provide an element of contrast against the white walls and grilles. Air conditioning ducts, electrical conduits and other services are left exposed, clinging to the white-painted ceiling.

A café is tucked in the deepest end of the shop, marked as a separate area by a threshold of a raised timber floor. Delineated from the retail space by framed glass panes and grilles, the café maintains visual transparency and entices shoppers to enjoy a quick break. A curving metal grille serves as both a magazine rack, and an enclosing device. Attractive views are available from the café to the street below.

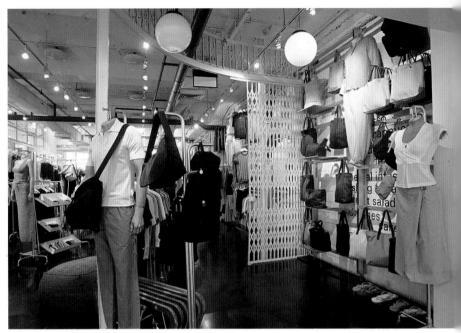

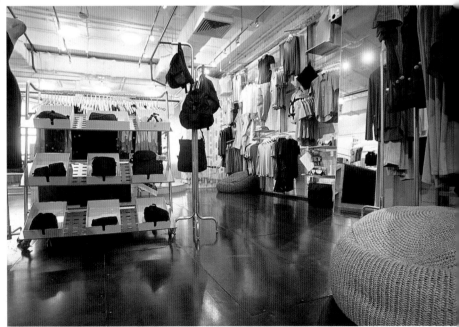

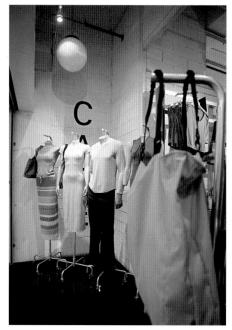

bloodcafe

Specials

POTATO AND LEEK SOUP @7.00

CHEF'S SALAD
SALAD OF TUNA NISCOISE,
CHERRY TOMATO, BABY POTATO,
BLACK OLIVES, GREEN BEANS
AND ROASTED CAPSICUM TOPPED
WITH FRESH HERBS @15.00

HOMEMADE TASTY CREPES
SERVED WITH BRAISED VEAL,
LENTIL AND POTATO CURRY
 @16.00

DESSERT

BANANA CREAM PIE @10.00

BANANA MANGO CRUMBLE
SERVED WITH A SCOOP OF
ICE CREAM @10.00
(ALLOW 10 MINS)

Red
Valdiv
Caberr

Bel Ar
Califor
Caber

Scarpe
Shira
Bethar

Whit
Hasel

Ames
Sauv

Scar
'inus

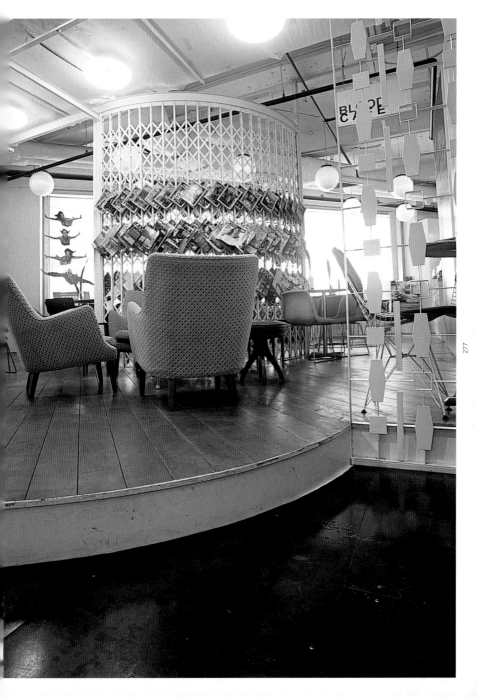

TECHNOLOGICAL TERRAIN

reebok concept store

This concept store for Reebok employs a futuristic and innovative theme to showcase the technological proliferation behind the design of Reebok products.

NAME OF SHOP **REEBOK CONCEPT STORE**
OWNER/CLIENT **REEBOK PTE LTD**
ARCHITECT/DESIGNER **ECO-ID ARCHITECTS & DESIGN CONSULTANCY PTE LTD (WITH GRAPHIC DESIGN BY WORKS ADVERTISING)**
PHOTOGRAPHER **AMIR SULTAN**
TEXT **ANG HWEE CHUIN**
LOCATION **3 TEMASEK BOULEVARD, #01-157 SUNTEC CITY, SINGAPORE**
TEL (OF SHOP) **(65) 6332 1495**

The Reebok Concept Store has been selected as the design prototype for Reebok retail environments throughout the world. Highly differentiated from conventional sports goods stores, the store design emphasises the showcasing of the technological proliferation behind the design of Reebok products. The futuristic and innovative theme employed for the interior gels with the experimental spirit behind the brand. Consequentially, the store is conceived to echo a laboratory environment, employing a language of organic and cellular forms.

Instead of the usual window displays, a giant video wall greets the customer at the shop facade. Travelling through a vestibule of back-lit glass walls, one enters the main retail space – the "Launch Pad" – where biomorphic plastic forms dominate the visual setting. A "Shoe Wall" composed of perspex cells holds displays of various shoe models. Sensors detecting human movement near the wall activate tech panels that provide descriptions of the technological features of the products. A pod-shaped structure erected in one end of the store and termed "The Hub" forms an enigmatic spatial and visual focus. Transporting the shopper into an extraordinary cocoon-like realm, it communicates Reebok's corporate messages with a subtle but powerful persuasiveness.

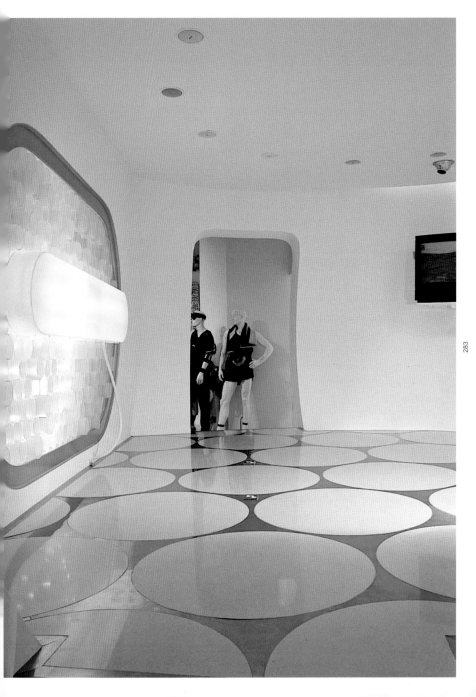

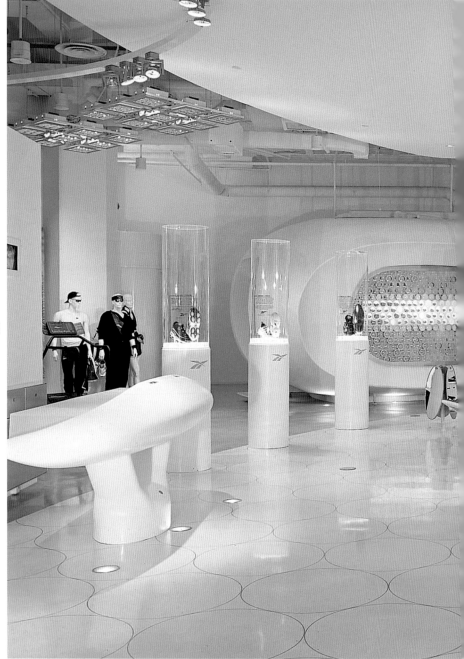

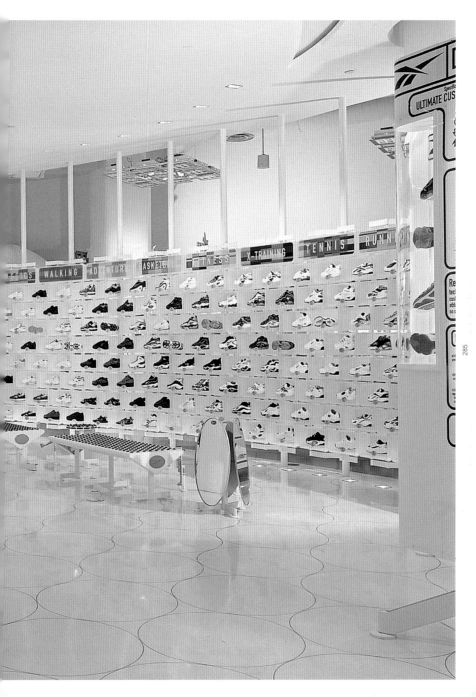

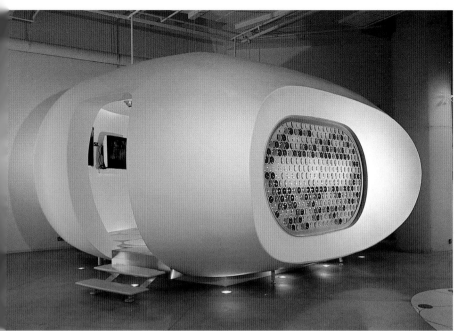

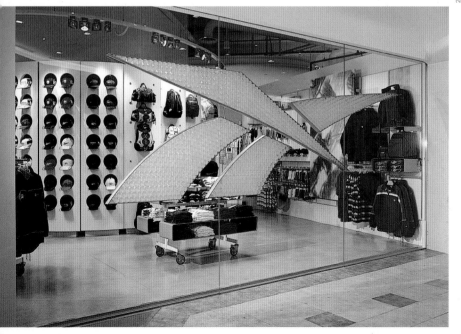

A SOPHISTICATED NAIL SPA

snails

The fundamental agenda of Snails is to elevate basic manicure and pedicure procedures from their usually mundane method of delivery, to a finer, more gratifying experience of sensuality via the option of rich and varied treatments. The design for the Snails nail spa thus hinges on the idea of levels of sensual experience.

NAME OF SHOP **SNAILS**
OWNER/CLIENT **SARAH LAM & MILLIE TAY**
ARCHITECT/DESIGNER **CECIL CHEE, ROBIN TAN/WALLFLOWER ARCHITECTURE + DESIGN**
PHOTOGRAPHER **THE PRESS ROOM**
TEXT **AYS TAN**
LOCATION **501 ORCHARD ROAD, #03-01 WHEELOCK PLACE, SINGAPORE**
TEL (OF SHOP) **(65) 6738 0100**

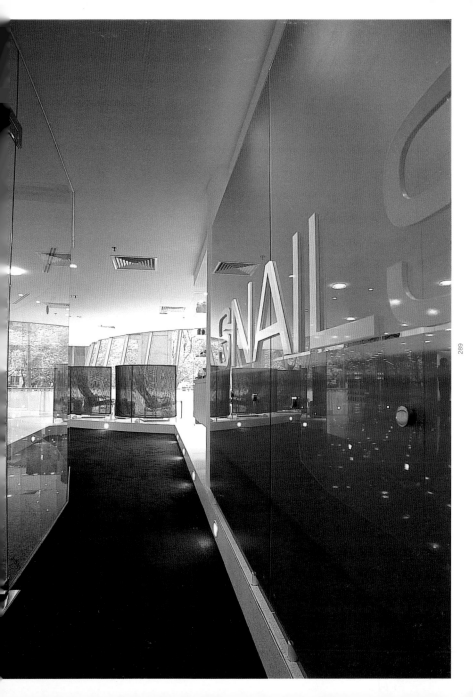

In their quest for a more sophisticated nail spa, the owners of Snails had insisted on a relaxed environment that should be contemporary and refined in outlook, but not overtly clinical or elitist. The resulting interior, with its fully-glazed curving front, is clean, clear and light. Pristine and elegant, it is a predominantly white-based interior muted by instances of purple. Aside from its elegance, purple was selected for its more unisex or "less girlish" quality, and also due to its hedonistic suggestion of sensual indulgence.

Most of the Snails experience takes place in very comfortable reclining bent wood chairs, which are enveloped by curved purple screens that make booths. The low, curved structure of the booths lends a more private and enclosed experience. The textured and tactile sheers of the curved booth screens, the warmth of the suede-like upholstery and armrests on the bent wood chairs, and the soft steps of purple wool carpet at the entry bring home the notion of different levels of sensual indulgence. The experience of a nail spa treatment is enhanced further by the solace offered by views of calming greenery through the glass façade. An added perk of the glass skin is the provision of daylight for more accurate nail colour render.

The spatial orientation of Snails is incidentally snail-like, with the booth screens and chairs set gracefully on a raised platform that follows the curvature of the glass shop front, but that is strategically set back about one metre from it to skillfully negotiate for a hierarchy of spatial function. Amidst its atmosphere of pristine elegance, composed by very simple white and purple against an intriguing system of spatial configuration, the design culmination of Snails has managed to afford a tranquil environment for some much needed languid indulgence and escapist therapy.

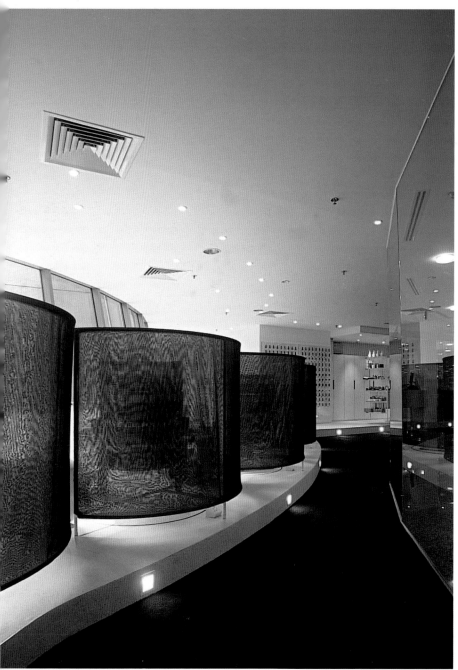

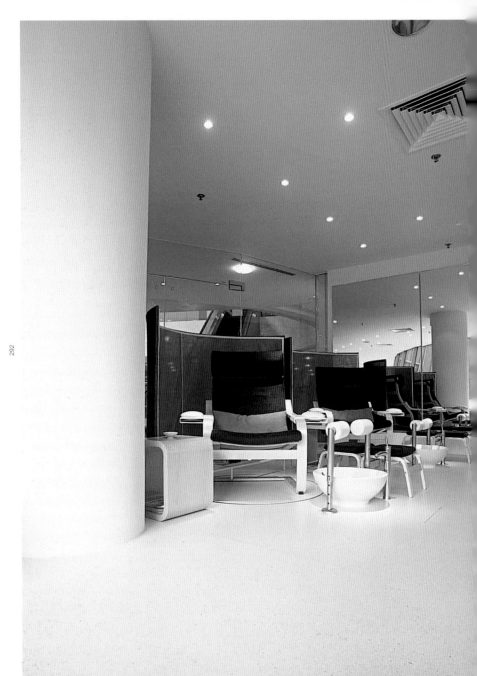

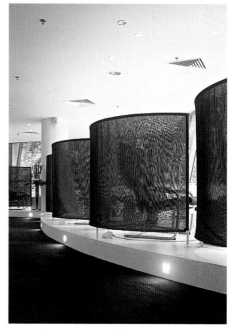

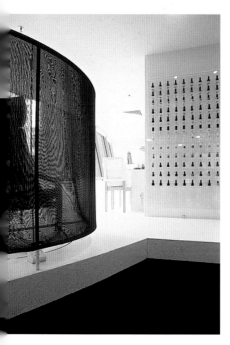

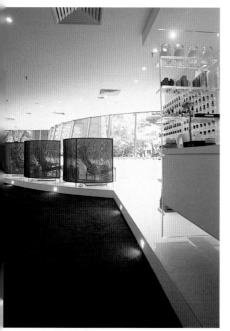

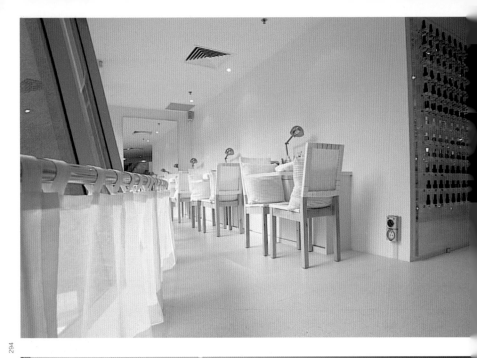

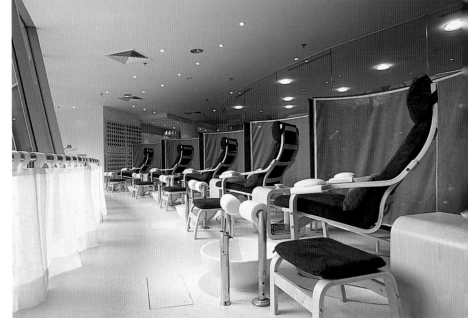

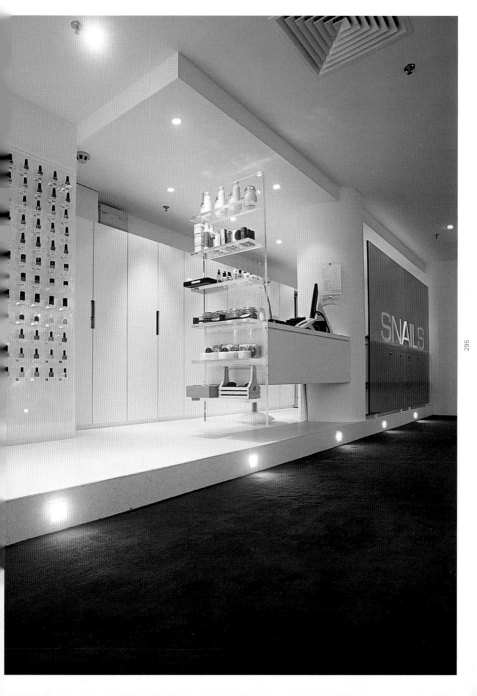

SHADOW PLAYS

song & kelly

This boutique marked Song & Kelly's leap onto the Singapore retail fashion runway. Song Wykidd is a Singaporean, trained in fashion design in London and Milan. Ann Kelly studied graphic design in the UK prior to relocating to Singapore. Coming together in 1993, they have built up a considerable reputation in the fashion capitals of the world.

NAME OF SHOP **SONG & KELLY**
OWNER/CLIENT **SONG & KELLY**
ARCHITECT/DESIGNER **SOO CHAN/SCDA ARCHITECTS**
PHOTOGRAPHER **PETER MEALIN**
TEXT **ANG HWEE CHUIN**
LOCATION **391 ORCHARD ROAD, #03-02 NGEE ANN CITY, SINGAPORE**

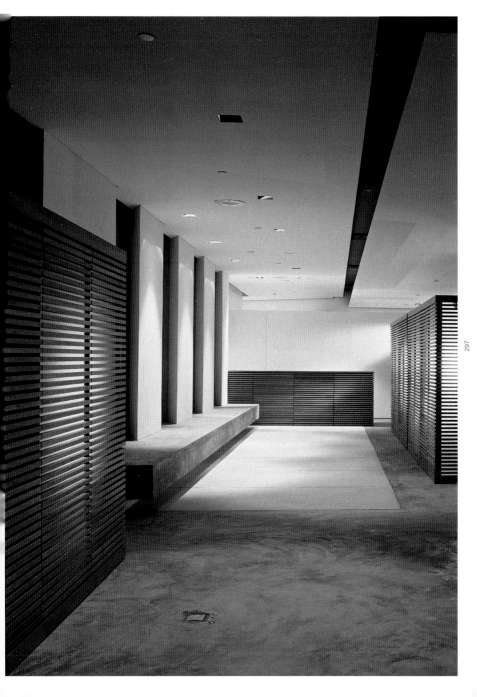

The brief for the shop unit was to use a minimalist language; the client required flexibility for different uses such as readings, shows and exhibitions, but there must be no excess and there should be precision in detailing. The resulting design from SCDA is a monochromatic, almost Spartan, interior, yet there is a sensuous quality that hovers behind the cool, controlled, almost austere image that verges on the erotic.

The garment display consists of four elegantly crafted clothing racks, which can be arranged in a number of configurations. Each rack is framed in mild steel with horizontal timber slats on the two ends, the rear and the top. There is an opaque sandblasted glass surface behind the horizontal slats so that shadows are cast and silhouettes projected as customers examine the clothes. There is something sensual and mysterious about the louvred screen, concealing the faint, unidentifiable silhouette of a human form. This can be read as an allusion to the traditional wayang kulit (shadow plays) of the Indonesian and Malay archipelagoes.

The racks are mounted on castors and their orientation can be manipulated into several permutations pivoting around pre-determined steel markers on the floor, thereby changing the spaces that enclose and are enclosed by them. There is no doorway or glass display window at the front of the shop unit and the boundary between public and private is ambiguous. The display units "float" in this indeterminate space in a surreal manner.

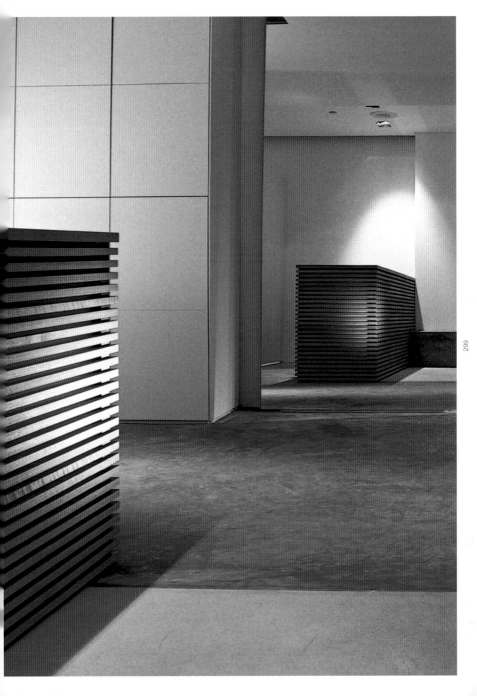

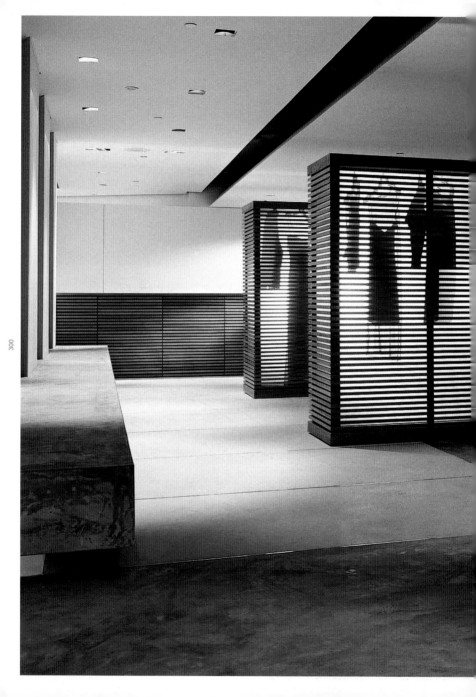

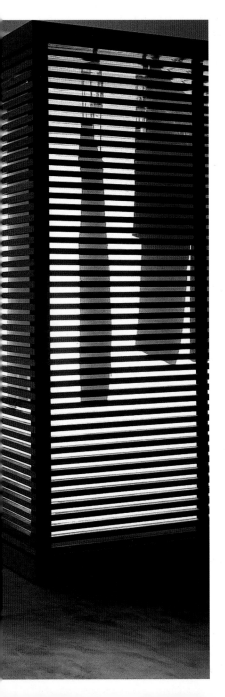

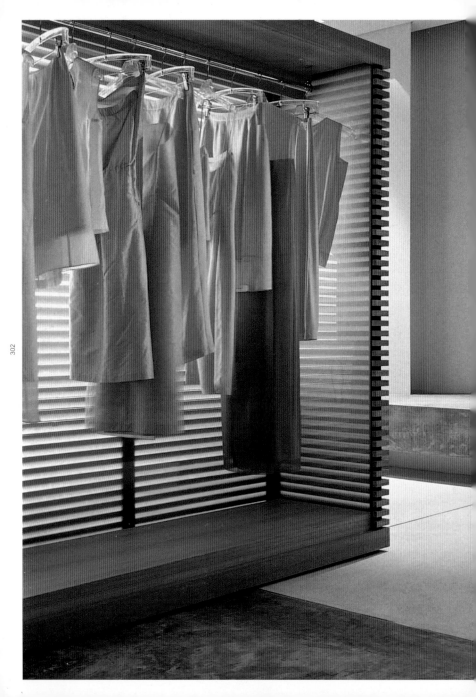

CONGENIAL CHOREOGRAPHY

song & kelly 21

This new boutique for Song & Kelly occupies back-to-back units, so it fronts both internal and external malls at Forum Galleria. Like the earlier Song + Kelly boutique in Ngee Ann City, this is a minimalist design, though it is softer than its predecessor.

NAME OF SHOP **SONG & KELLY 21**
OWNER/CLIENT **SK 21 PTE LTD**
ARCHITECT/DESIGNER **SOO CHAN/SCDA ARCHITECTS**
PHOTOGRAPHER **PETER MEALIN**
TEXT **ANG HWEE CHUIN**
LOCATION **583 ORCHARD ROAD, #01-38 FORUM GALLERIA, SINGAPORE**

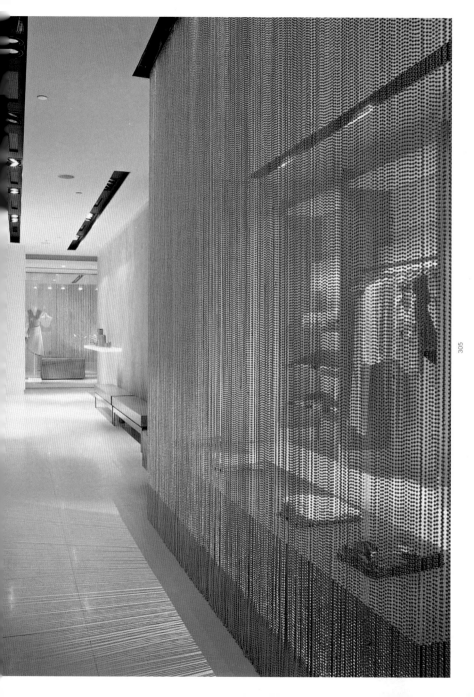

Most of the perimeter wall space in the shop is occupied by conventional hanging rails. The strongly articulated and detailed display units, employing vertical, bleached timber panels and etched glass, give a rhythm to the design and focus the customer's eye in on the exquisite cut of the clothing. The wall surfaces are unpainted plastered panels, with large mirrors placed in strategic locations. The former gives a neutral backdrop for the colour and texture of the garments on display. The mirrors visually connect the front and rear of the shop, and laterally expand its narrow cross section. The floor surface is likewise a neutral off-white, and the ceiling is white painted plaster expressed as floating planes.

An unusual feature is the use of silver-beaded curtains in parallel rows, 10 centimetres apart, to create ephemeral "walls" in four locations. Blue lighting is arranged between these "veils" to highlight the reflective beads. They choreograph a route through the shop, reorienting and directing the browsing customer in a non-intrusive manner. There is an element of transparency; a glimpse of something beyond. The "walls" are dematerialised and are analogous to a vertical wall of water descending from the eaves of a building during a tropical monsoon – a simultaneously soft and yet severe plane.

The use of the beaded curtains, which both conceal and reveal, is an appropriate backdrop to the essentially feminine attire. The beaded "walls" are lightly secured by Velcro so that they can be removed or have their position adjusted. Solid mahogany display stands contrast with the diaphanous materiality of these "walls".

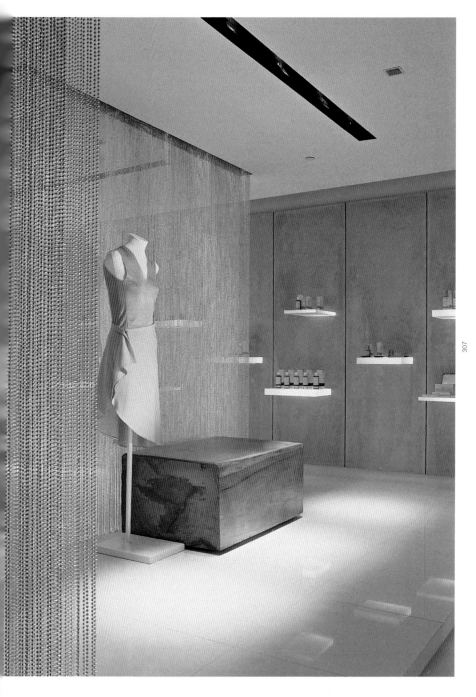

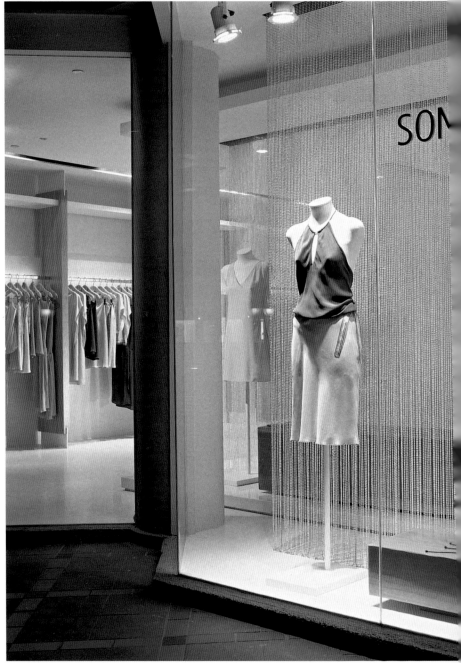

SON

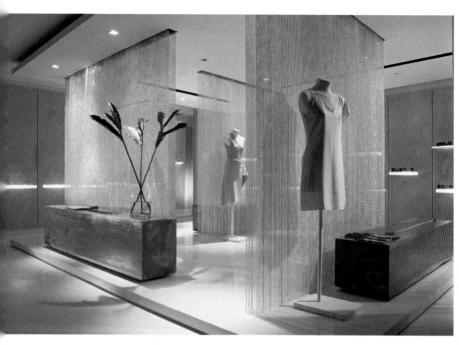

SERIOUS LISTENING

that cd shop

The extension of an existing CD shop allowed the opportunity for a complete redesign of the space, and a slick new look against which CDs stand out like colourful gems.

NAME OF SHOP **THAT CD SHOP**
OWNER/CLIENT **THAT CD SHOP PTE LTD**
ARCHITECT/DESIGNER **KOZI INTERIORS PTE LTD**
PHOTOGRAPHER **KELLEY CHENG**
TEXT **ANG HWEE CHUIN**
LOCATION **1 KIM SENG PROMENADE, #B1-01 GREAT WORLD CITY SHOPPING CENTRE, SINGAPORE**
TEL (OF SHOP) **(65) 6734 2276**

This project involved the extension and renovation of a music CD shop situated in the basement of a shopping mall. Originally occupying less than half of its present floor space, the design of the old shop was inconsiderable beyond its space planning. The extension works enlarged the shop space along its length, such that it now overlooks a travellator connecting the basement with the carpark. The high floor of the extended space was, upon the client's suggestion, played up and designed as a listening platform for customers to try out discs. A full expanse of glass fronts the listening stations, offering total visual transparency and showcasing the shop's interests to passers by. It also provides the listeners with visual engagement with the outside activity of the travellator.

The main retail space has retained the original layout so as to not effect drastic changes. Instead, the displays and cabinetry are redesigned in a palette of stainless steel, glass, dark wood stains and nyatoh veneer, to inject a new feel. Cement screed finishes and granite tiles used for the flooring complement this material scheme. The darkness of the CD cabinets is complemented by black sofas and black audio speakers. The colourful CD covers stand out impressively against this dark background palette. To complete the industrial urban look of the space, services are left exposed. Creating interest in the generous interiors, the designers have employed track-lights to develop light patterns on the floor, as well as provide strategic illumination on the products and displays.

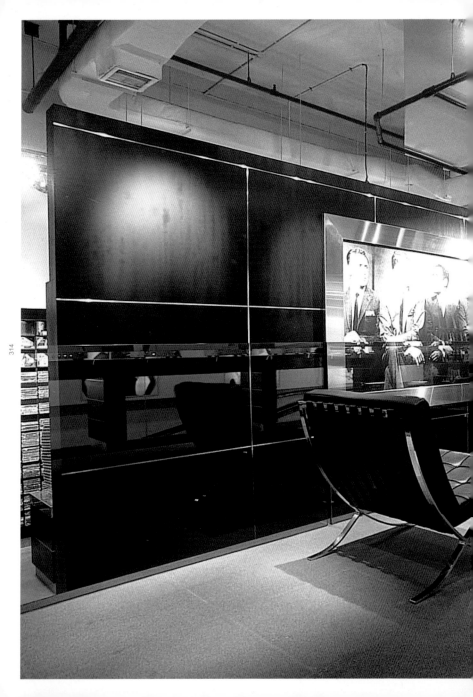

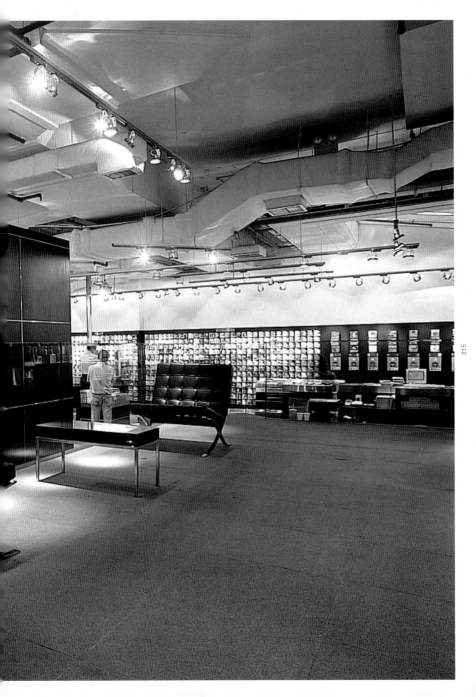

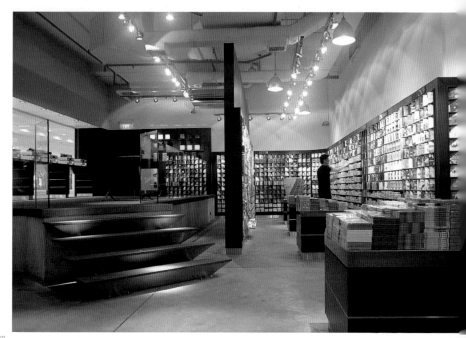

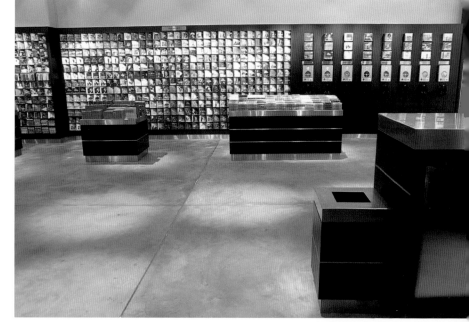

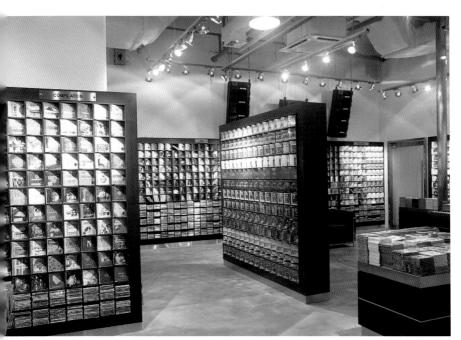

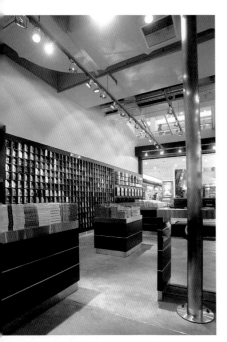

LIGHT FOR LUSCIOUS LOCKS

toni&guy

This Toni&Guy salon utilises full glass facades to maximise exposure to the street from its upstairs position, and to flood the shop with light.

NAME OF SHOP **TONI&GUY (HOLLAND VILLAGE)**
OWNER/CLIENT **TONI&GUY SINGAPORE PTE LTD**
ARCHITECT/DESIGNER **CLEAR CONSULTANTS WITH HENNE MERCER**
PHOTOGRAPHER **KELLEY CHENG**
TEXT **ANG HWEE CHUIN**
LOCATION **24B LORONG MAMBONG, SINGAPORE**
TEL (OF SHOP) **(65) 6466 2660**

As Toni&Guy's first franchise salon in Singapore, the design of this salon has set a design prototype, which is to be applied to other Toni&Guy salons in the region. Previously a residence, the space was subsequently overhauled, and a thorough demolition of internal walls was carried out. Without the usual ground-level commercial advantage of exposure to passers by, the designers had to create the salon's presence in an indirect manner. A full glass facade addresses this; it allows good views into the space from the street, as well as infiltrating the deep shop space with plenty of light.

A visual continuity is maintained along the axis of the shop, offering views into the lush foliage and street scenes in front of and behind the shop. Further illuminating the interiors, a light beam runs depth-wise through the shop along the ceiling, providing a soft source of illumination, whilst enhancing the linear qualities of the space. This beam terminates with a TV column set just behind the glass facade that projects videos to the street as well as to the salon interior. Full height mirrors break the horizontality of the space by emphasising the vertical dimension.

Besides the need to create a more relaxed environment in which patrons would be comfortable spending time, Toni&Guy also desired a stylish, rather than a trendy and momentarily fashionable design. As such, a soothing palette of bleached limestone, glass, maple wood and white epoxy paint was employed to create the visual and spatial components needed to fulfill this aim. The neutral white background of the store allows full visual focus to be placed on the customer.

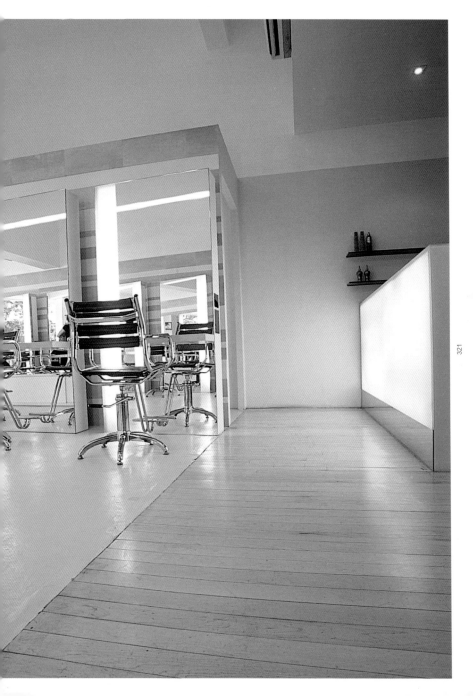

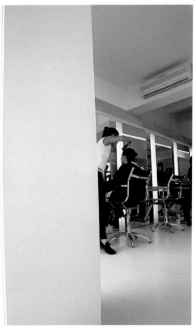

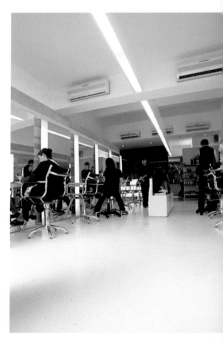

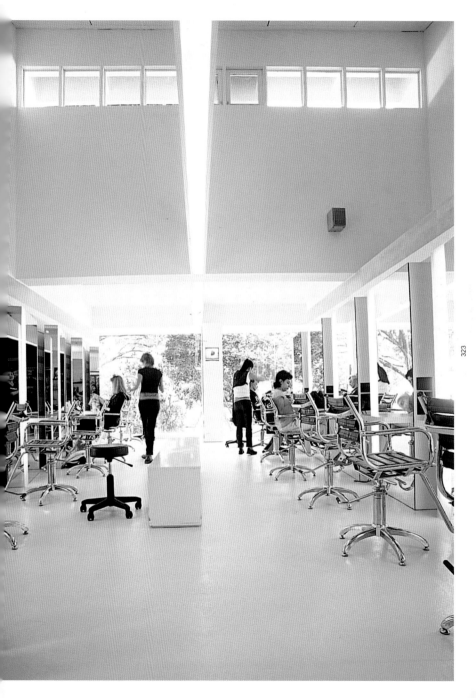

WORK IN PROGRESS

woods
& woods

The austerity of the interior design of Woods & Woods in Pacific Plaza, Singapore, sees the clothes on display stand out like art installations within a gallery.

NAME OF SHOP **WOODS & WOODS**
OWNER/CLIENT **WOODS & WOODS**
ARCHITECT/DESIGNER **LAWRENCE LING**
PHOTOGRAPHER **KELLEY CHENG**
TEXT **ANG HWEE CHUIN**
LOCATION **9 SCOTTS ROAD, #02-16 PACIFIC PLAZA, SINGAPORE**

Formerly a shoe store, the space was reworked into a sleek boutique that resonates with a hip, raw, industrial aesthetic. The mix of cement and paint finishes that are applied onto the walls, ceiling and partition board, foster an unfinished, "work-in-progress" appearance. The expansive use of cement as the chief texture has resulted in an austere feel that allows the clothes on display to stand out like art installations within a gallery. Opportunely, this captures the design spirit of this fashion label.

Unlike many typical boutiques, the display concept here is minimal in nature. Wall-mounted tubular steel clothes rails sprout form the subdued walls in simple L-shaped configurations. A single timber display shelf, centred on the shop floor, flaunts just one garment. The only splashes of colour come on the fitting room doors, which are pivoting full-height doors finished in cement on one side and painted red on the other. When closed, the fitting rooms appear to assimilate into the walls, enhancing the pure, stark quality of the interior space. When the rooms are in use, the doors are swung the other way, displaying the red panels. Large format graphic prints of models dressed in Woods & Woods clothing will replace these red panels subsequently, creating a changing internal landscape within the shop.

The hard, unrelenting surfaces in the shop are softened by the light projected from recessed downlights. These cast voluptuous arcs of light on the cement wall behind the main hanging space and play visually against the various swirling and linear textures of the concrete. Furthermore, this wall is actually suspended away from the boundary wall, and is backlit to frame the clothes in a field of light. The minimal treatment of this space reflects the simple, stylish cutting of Woods & Woods clothing, which becomes the single element of focus in the shop.

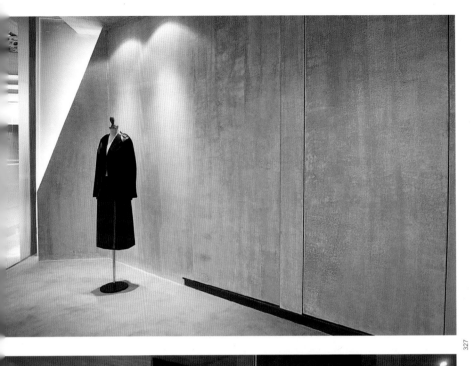

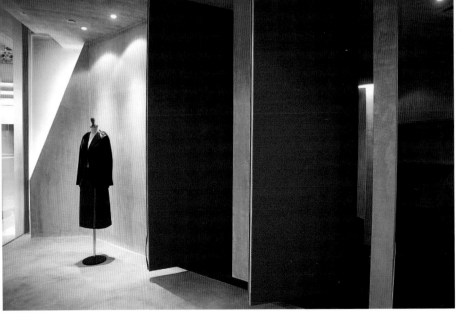

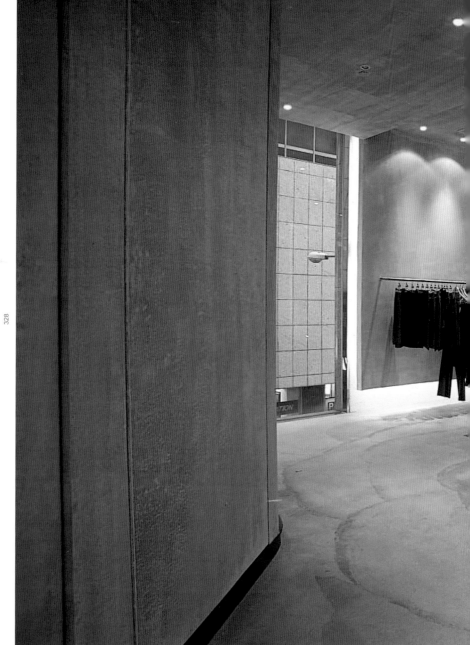

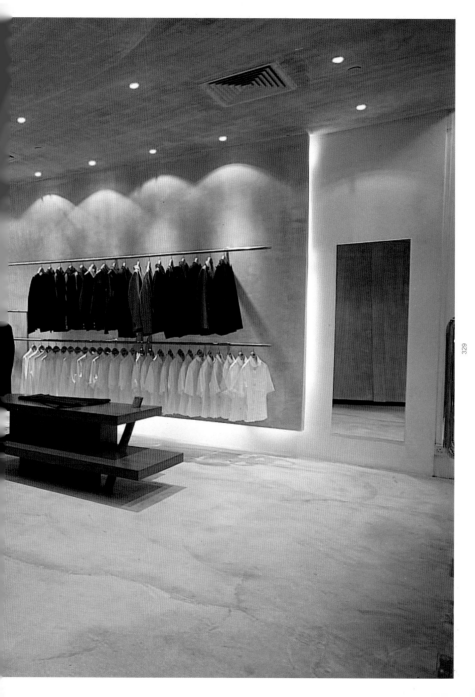

A SUBTLE SPACE FOR SELLING

anyroom

Material subtlety and modernist spatial lessons have informed the interior design of this room in which designer homewares are sold.

NAME OF SHOP **ANYROOM**
OWNER/CLIENT **MINISTRY OF SPACE CO LTD**
ARCHITECT/DESIGNER **ARCHANART BUNNAG**
PHOTOGRAPHER **PIRAK ANURAKYAWACHON**
TEXT **SAVINEE BURANASILAPIN & THOMAS DANNECKER**
LOCATION **4TH FLOOR, SIAM DISCOVERY CENTRE, BANGKOK, THAILAND**
TEL (OF SHOP) **(66) 2 658 0481**

anyroom

here design is really the matter

From a mall corridor's banal neutrality, a ponderously-wide swiveling glass panel gives way to a sophisticated, memorable designer neutrality; a single large room that could be any room. It is, in fact, anyroom, a store that sells imported designer objects for the home, especially objects of the serious, reserved, modern variety.

Clean, but not quite clinical in its austerity, anyroom walks a delicate line down the centre of minimalism. It cannot afford to be a generic white box (easily the death of a design-oriented store), yet it cannot overpower its wares with in-your-face severity. A range of designed objects needs to be accommodated. Most could easily stand on their own; several can only stand on their own. The resulting environment is an exercise in material subtlety. Surfaces of several shades of white (walls, shelves, countertops) float on sea of blonde wood punctuated by the occasional stab of green glass. Lighting, mechanical systems, even the inventory computers and cash register, are cleverly concealed, performing their functions in the service of a clean, efficient atmosphere without interfering with the design on display.

The store's functional elements are neatly condensed into a solid white volume that sits in the centre of anyroom. This allows for a group of spaces (not quite rooms, but spaces defined by the arrangement of furniture being sold) to flow smoothly around it, without breaking up the formal clarity of a single large room. The perimeter is freed for circulation and display. As an organising principle, the solid central core in a rectangular plan counts such iconic modernists as Mies van der Rohe among its ancestors. The reference is especially appropriate, given the modernist sophistication of anyroom's clientele.

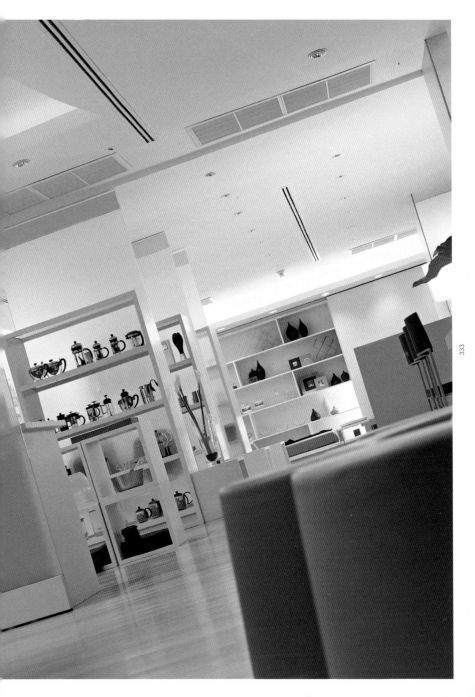

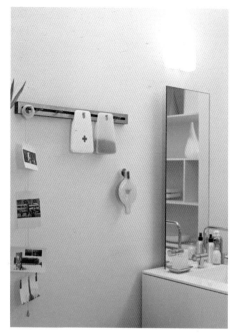

COMMERCIAL BASILICA

cocoon

At Cocoon, a congregation of interior furnishings fill a space that is less like a shop than a basilica for exuberant minimal decor.

NAME OF SHOP COCOON
OWNER/CLIENT COCOON DESIGN CO LTD
ARCHITECT/DESIGNER WICHAKOM TOPUNGTIEM
PHOTOGRAPHER KELLEY CHENG
TEXT SAVINEE BURANASILAPIN & THOMAS DANNECKER
LOCATION GAYSORN PLAZA, BANGKOK, THAILAND
TEL (OF SHOP) (66) 2 655 1256 7

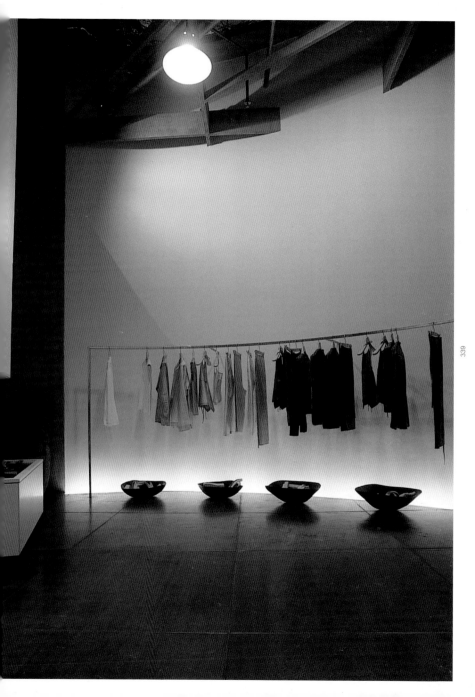

Cocoon may be best understood as a commercial basilica. One enters between burning candles to process down an aisle, towards an imposing polished steel pulpit, split in half, where priests and priestesses stand waiting at cash registers. On either side of the aisle, an array of interior furnishings congregates on massive low tables. Supplicating to the grander objects before them, and atop them, these tables are simple wooden affairs, with a medieval functionalism driving their proportions. Terminating the axis is a flat square of freestanding polished wood. Undecorated, monolithic and perfectly crafted, this is an appropriate altar for Cocoon's religion of exuberant minimal decor.

The side walls, with their overly-long shelves, are arrayed high with merchandise. A suspended diagonal grid, painted grey, coffers the imposingly tall ceiling, which hangs below silvery raw equipment that it partially screens from view. Glass-domed industrial light fixtures hang from the grid. Beyond the altar, and to the right, a secondary chapel opens onto the main space. This one is centrally planned, its objects of reverence distributed around its perimeter with a massive lantern hanging at its centre.

Cocoon utilises strong symmetry to give order to the awkward L-shaped footprint that it occupies. This allows the back "leg" (far from the entrance) to be experienced as an independent space, and allows for a division between lines without resorting to faux-domestic furniture arrangement.

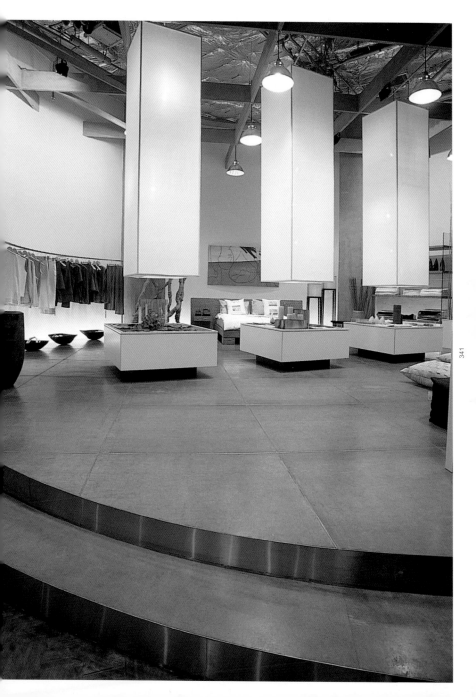

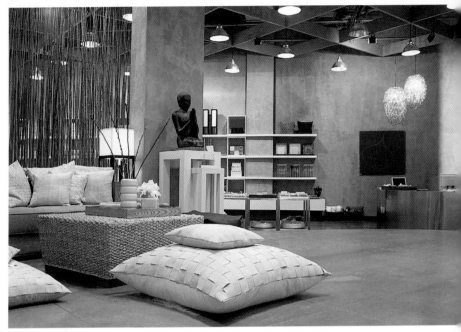

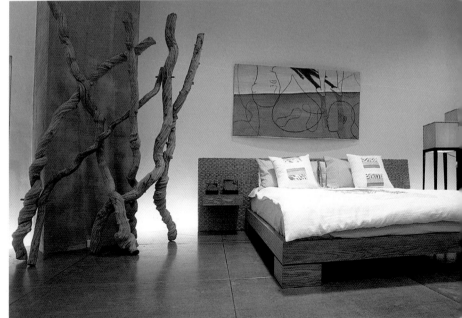

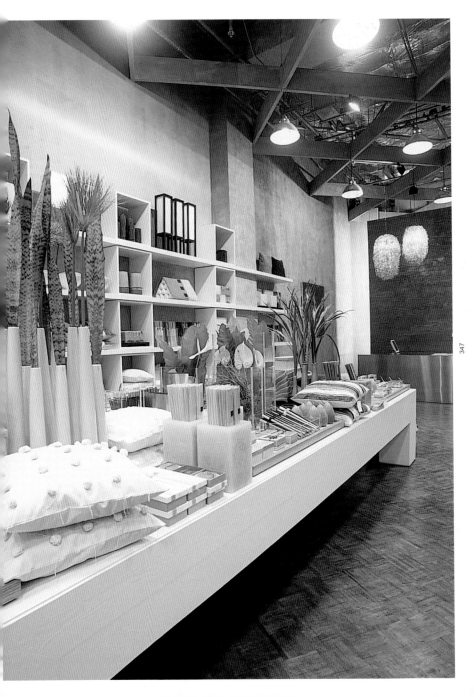

A CABINET OF COUTURE

fly now

A circular display room is the axis mundi of this couture clothing store, which could knock the unwary viewer back into the previous century with its museological tendencies.

NAME OF SHOP **FLY NOW**
OWNER/CLIENT **SOMCHAI SONGWATANA**
ARCHITECT/DESIGNER **CHANACHAI SONGWATANA**
PHOTOGRAPHER **KELLEY CHENG**
TEXT **SAVINEE BURANASILAPIN & THOMAS DANNECKER**
LOCATION **2ND FLOOR, GAYSORN PLAZA, BANGKOK, THAILAND**
TEL (OF SHOP) **(66) 2 656 1359**

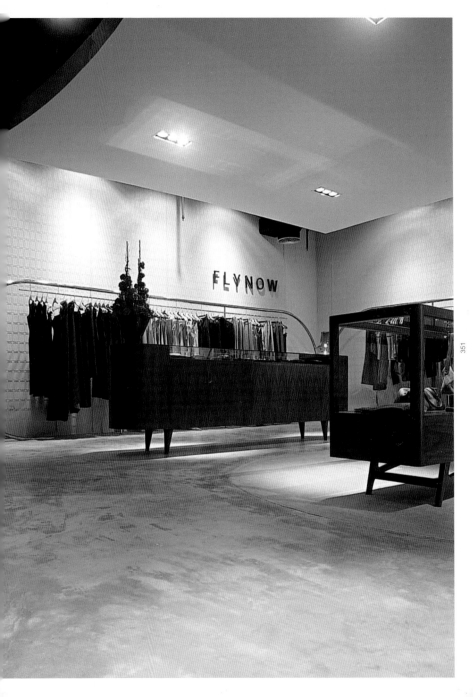

Fly Now occupies a shallow interior corner at Gaysorn Plaza mall, a space it uses to remarkable advantage. One wing is used as a formal entry. Relatively few clothes are held in this area – its function is to set a mood; to impart the sophistication of a Paris Boutique, where dresses are brought out one at a time, not crowded together on racks. Despite the massive glass and wood display shelf placed parallel to the entrance, this wing is nearly empty. Beyond that shelf is a similarly massive cashier's table, and further behind is a wall that obscures the store's back-of-house area. Emerging from behind this plane is a curving wall covered with brown-velvet that snakes its way back around towards the entrance, encompassing a sizeable circular room that occupies the central third of the store's plan.

The circular room is the axis mundi of Fly Now. No longer within sight of another store, the mall's corridor, or even conventional architectural geometry, every surface here is under the control of Fly Now's designers. Appropriately, this room is used for the display of Couture designs –those uncomfortable, unwearable, unaffordable, but infinitely desirable and influential dresses that drive the fashion industry. They hang from mannequins in elliptical glass cases, arrayed radially around the room. They face the centre of the circle, where a grey-coloured leather couch is available for their contemplation. If the entrance imparts some of the aura of a Paris Boutique, this museological display clinches the deal, and the unwary viewer is knocked into the previous century.

Outside the circle, in the left wing of the plan, is a section for off-the-rack designs, the very same that occupy Fly Now's shops within department stores worldwide. Even in this section, however, it is clear that this is the flagship store, dedicated to selling the brand, more than individual pieces of clothing.

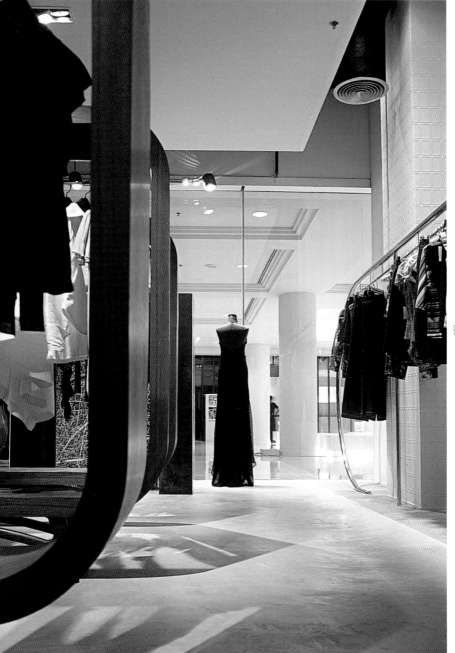

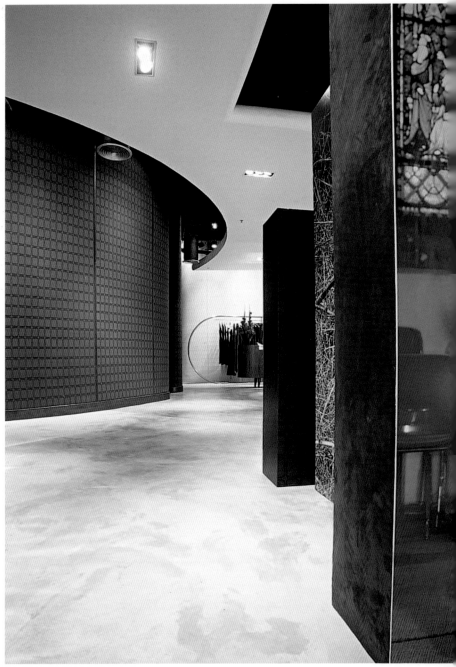

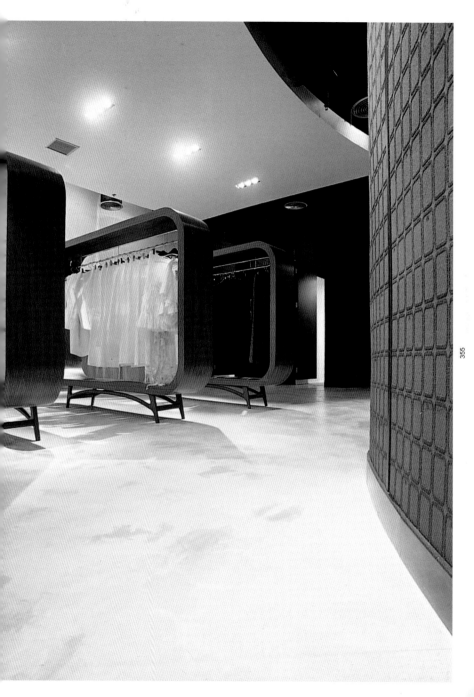

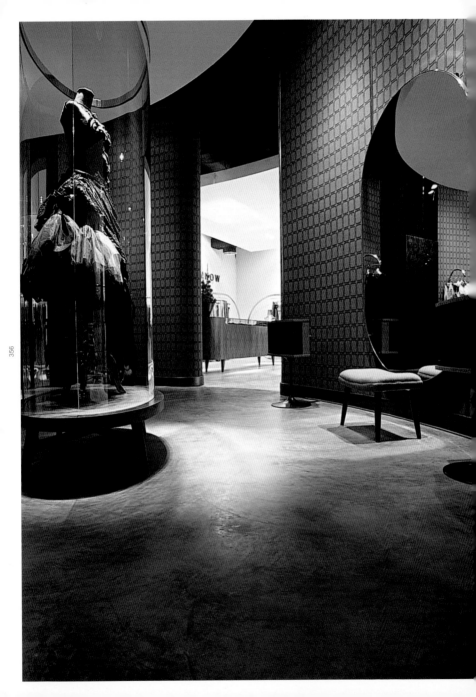

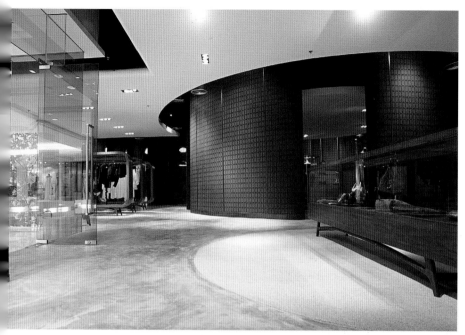

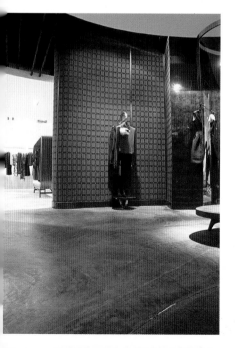

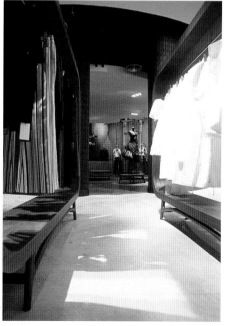

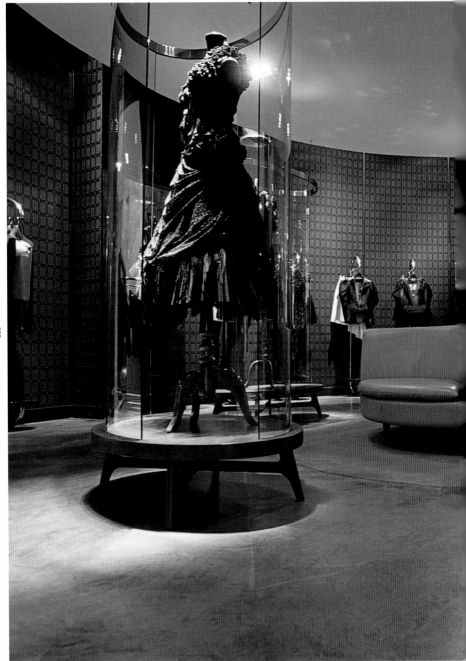

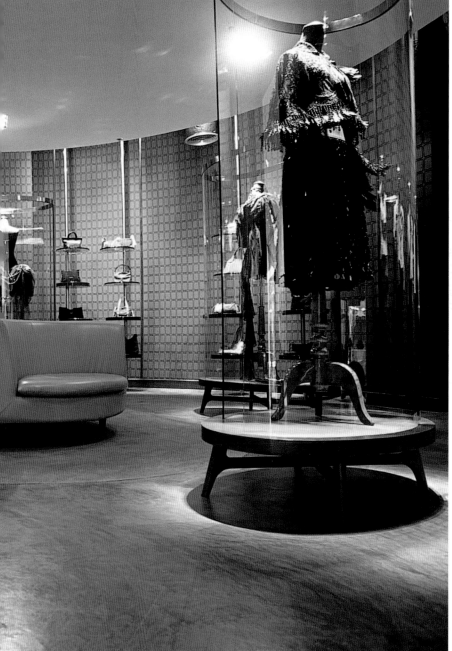

TRY BEFORE YOU BUY

mama secret

A central washbasin and an unobtrusive service counter leave customers free to sample the "secret recipe" soaps that are on sale in this small store.

NAME OF SHOP **MAMA SECRET**
OWNER/CLIENT **SORAT WONGPHAET**
ARCHITECT/DESIGNER **CHATVICHAI PROMADHATTAVEDI/PRO-SPACE CO LTD**
PHOTOGRAPHER **KELLEY CHENG**
TEXT **SAVINEE BURANASILAPIN & THOMAS DANNECKER**
LOCATION **CAMP DAVIS, SUKHUMVIT SOI 24, BANGKOK, THAILAND**
TEL (OF SHOP) **(66) 2 260 2747**

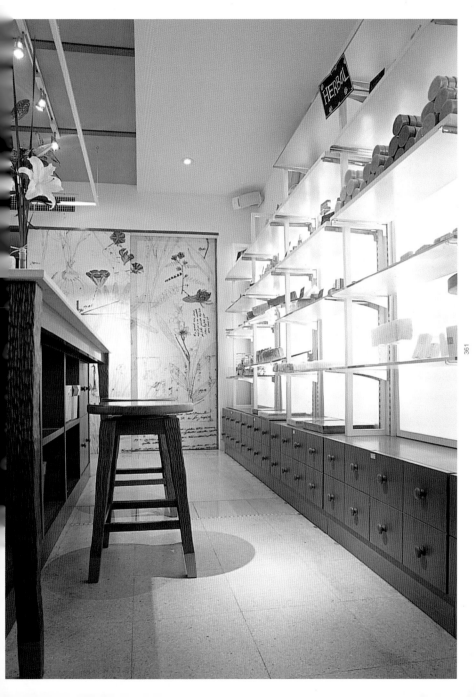

Located in the small-scale Camp Davis shopping complex, Mama Secret is a petite store; its footprint is less than 215 square feet. It sits atop its sister store, Yum&Tum. Mama Secret sells only one product: soap. However, it explores an astonishing variety of forms and an impressive assortment of scents and flavours, all from, as the name suggests, the owner's mother's secret formula. Entering the store, one is immediately struck with the fragrance of homemade soap, ranging from the usual scents of apple, raspberry and rose, to the more playful chocolate, coffee, and café latte, and the Thai influenced jasmine, green tea, coconut, and ylang ylang.

At the centre of the space is a large table with a washbasin where customers can sample the range of soaps available. Lining the space on either side of it is clean white steel shelving where soaps are displayed. Clear liquid soaps, shampoos, translucent and opaque bars of soap are back-lit, a lighting technique that, in ill-considered schemes, can blind the shopper and leave the displayed object in shadow. At Mama Secret however, the delicate translucent colours of the products are very much enhanced.

A floor-to-ceiling glass enclosure in the front corner reveals an opening cut in the floor to reveal the activity in Yum&Tum. The two establishments work in tandem as an aromatic, healthy-lifestyle store/restaurant. At the rear of the space, a sliding door lined with floral wallpaper opens to reveal the cashier's countertop. Placing a single employee in the back allows for polite surveillance of the customers, who feel welcome to browse, touch, and even wash themselves in the friendliness of Mama Secret.

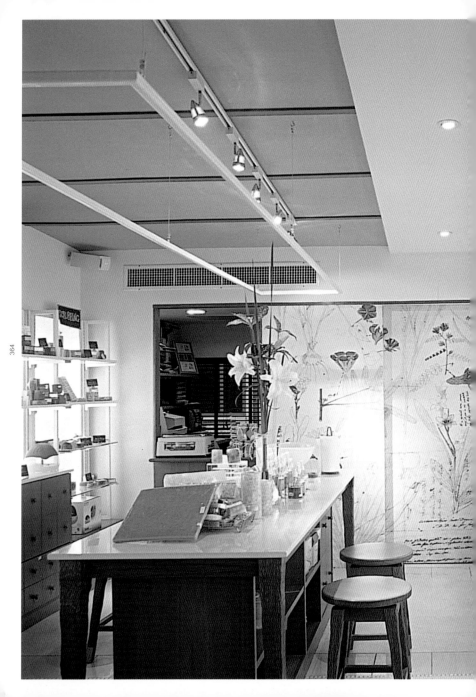

CONTEMPORARY TRADITIONAL

panta

A traditional aesthetic with a contemporary slant infuses both the objects on sale and the interior of Panta, which is the brainchild of four interior designers-cum-product designers.

NAME OF SHOP **PANTA**
OWNER/CLIENT **SAHASANETRA CO LTD**
ARCHITECT/DESIGNER **ML PAWINEE SANTISIRI/SAHACHA (1993) CO LTD**
PHOTOGRAPHER **KELLEY CHENG**
TEXT **SAVINEE BURANASILAPIN & THOMAS DANNECKER**
LOCATION **4TH FLOOR, SIAM DISCOVERY CENTRE, BANGKOK, THAILAND**
TEL (OF SHOP) **(66) 2 658 0415**

Panta cannot be treated solely as an exercise in retail design, so seamlessly is the design of the store integrated with what it sells, and the underlying business model. This store is the brainchild of four Thai interior designers who have branched into product design. Their furniture, textiles and homewares evoke aspects of traditional materials and craftsmanship, re-thought according to contemporary function and style.

Several of Panta's dramatic effects are bought about by the designers' bold first move. Elevating most of the shop's floor by two risers helps make the ceiling low enough to create unusually small and intimate spaces for displaying domestic furnishings. The raised portion of the floor is constructed with wooden planks, which resonate and echo with each footstep. To a shopper accustomed to pavement and the solid, unforgiving slab of a typical mall, the slight softness makes Panta feel eerily domestic. The central region of Panta is two steps lower than its periphery, forcing the visitor to walk just a little bit more cautiously than usual. Floor levels as well as divisive walls define the space.

Four parallel plastered walls, unusually thick and roughly finished, divide the space into three rooms and two corridors. The earthy mass of the walls, in typical Panta style, is revealed as an effect when the walls are cut open to expose shelves and clothing racks. The store's functional elements are on the raised platform at the back of the store. Delicate wooden screens, reinforced with stylish and contemporary translucent infill panels, run perpendicular to the four massive walls, and shield the cash register and storage areas.

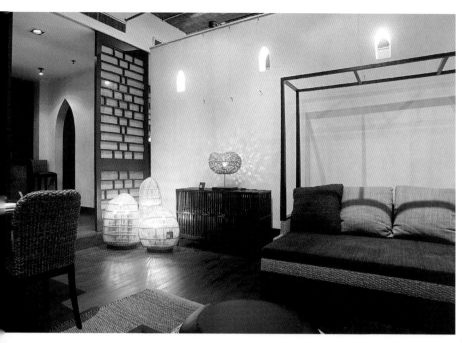

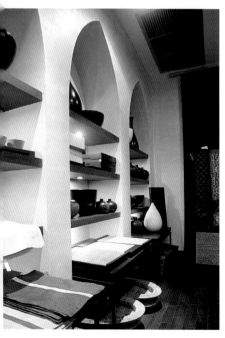

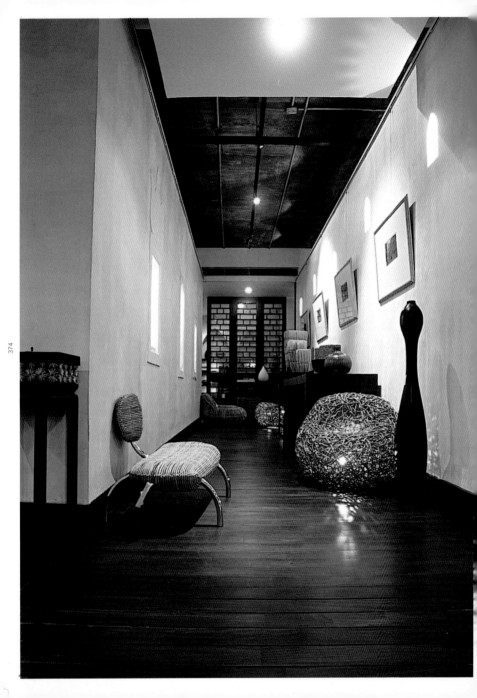

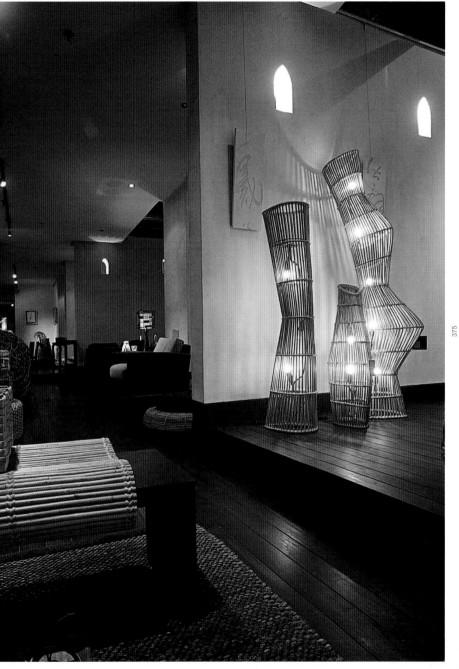

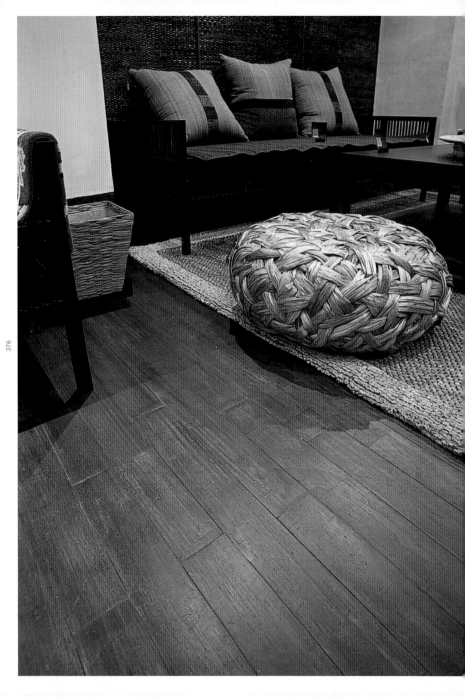

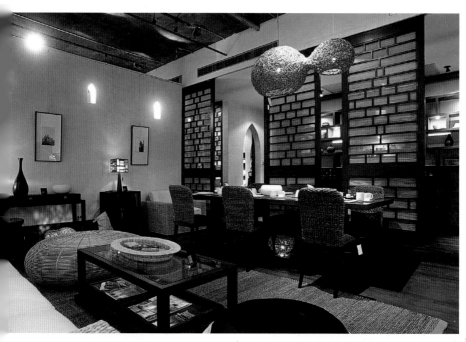

DESIGN DISSEMINATED

propaganda

The message of hip, off-the-shelf industrial products is disseminated at Propaganda – a showcase for designed objects in Thailand.

NAME OF SHOP **PROPAGANDA**
OWNER/CLIENT **PROPAGANDIST CO LTD**
ARCHITECT/DESIGNER **IAW LIMITED**
PHOTOGRAPHER **CHAIYUT PLYPETCH**
TEXT **SAVINEE BURANASILAPIN & THOMAS DANNECKER**
LOCATION **4TH FLOOR, SIAM DISCOVERY CENTRE, BANGKOK, THAILAND**
TEL (OF SHOP) **(66) 2 658 0430 1**

Propaganda's store is a marriage of quirky, hip design sense and off-the-shelf industrial products. The shelves in question are of two types. First come the spider-thin silver cubic frames on the sales floor. Filled with small, inexpensive designed objects, the shelves turn the space into something that could be classified as either figure or ground, depending on where you are standing. The second shelving type is heavier, and curvier. Smooth white cabinets stretch around the perimeter, encompassing storage, a tabletop for larger objects, and inlayed glazed cases for smaller, more precious objects. The same system, convoluted, forms a cash register station near the entrance.

Light fixtures abound, including several on sale. The show is stolen, however, by the rear wall, which turns the entire space into a lightbox. Opal acrylic panels diffuse the light emitted from the fluorescent fixtures behind them, but not enough to conceal their forms and arrangement. Transparent shelves in front of this wall are used primarily to showcase transparent objects, reducing them to apparitions, while allowing the range of colorful plastics towards the front of the store to glow.

Propaganda's designers have been sly in pulling the store's glass wall back from the edge of its leased space, permitting a part of their design to extend beyond the retail envelope. This dramatises the lightbox-effect by making their store seem narrower. Its concrete floor encroaches into the mall's space, as if the store could not contain its own exuberance for design. An isolated island of retail display, in the form of a perfect vitrine, has broken free of the store and sits in the mall corridor. Thus Propaganda is disseminated.

SPECIAL PRICE
CORNER

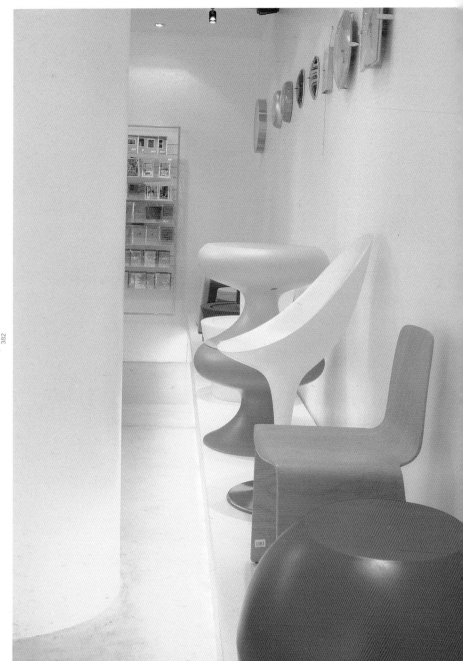

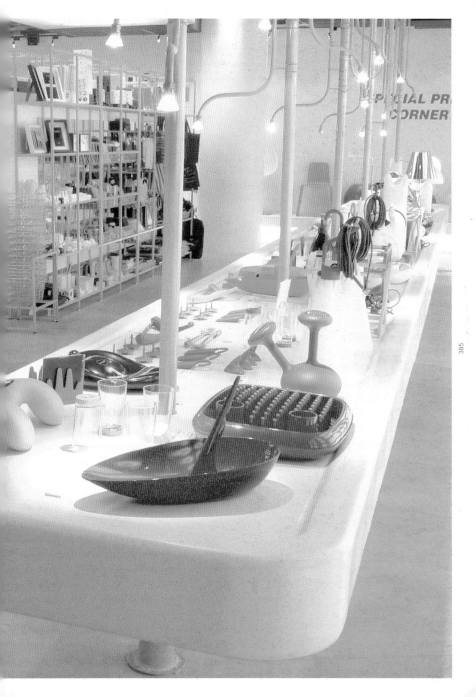

ore than perfect funct

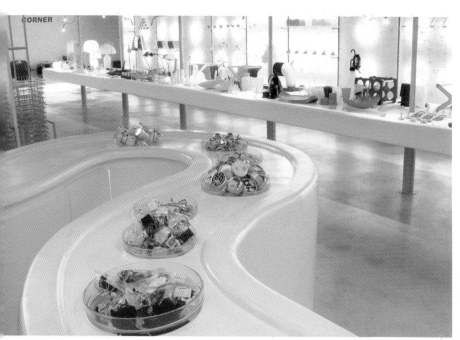

LET'S PLAY

senada* theory

Shopping in Senada* Theory is like playing in a closet, languishing in the dimly lit soft colours and textures, laughing at the cold world outside the half-opened door.

NAME OF SHOP **SENADA* THEORY**
OWNER/CLIENT **STRONG WAVES CO LTD**
ARCHITECT/DESIGNER **GILLES CAFFIER**
PHOTOGRAPHER **KELLEY CHENG**
TEXT **SAVINEE BURANASILAPIN & THOMAS DANNECKER**
LOCATION **2ND FLOOR, GAYSORN PLAZA, BANGKOK, THAILAND**
TEL (OF SHOP) **(66) 2 656 1350**

Senada* clothing is playful and hip, casually luxurious. The Senada*
Theory store is like a great big over-stuffed closet, full of clothing. The
store is visible from well down Gaysorn Plaza's wide white corridor.
While its neighbours adopt the party line of stark white minimal
interiors, Senada* Theory is lush with rich, dark textures that absorb
what few lumens fall upon them. To the uninitiated, the shop could
easily be mistaken for closed. Banks of purple halogen bulbs are lost in
the matte black of its ceiling. A handful of colourful, custom-made
lampshades hang low in the space, adding colour, but not much light.
The over-lit corridor outside is shrewdly used as a light fixture.

Standing inside Senada* Theory, looking out through its massive plate
glass front, the customer feels safely-hidden in uterine security. The
floor is mottled, rust-coloured concrete. The couch, chairs, display
stands, and chests of drawers are upholstered in a random patchwork
of coloured and textured leathers, which manage to hit every earth
tone between chocolate and sepia, stopping just short of beige.

Walls are difficult to find, as they are hidden in the back of the tall
closets that line them. Sliding and folding glass doors, with black wood
casements, selectively frame the clothes that are hung and draped
behind them. Armoires and bureaux inside the closets are covered in
the same patchwork as the furniture on the floor. Wallpaper, lining the
back of the closets, often obscured by the furniture and clothing, has a
faux-Victorian pattern, which amusingly appears to be assembled from
actual photographs of Victorian interiors – sconces and bedposts
interfere with the wallpaper-pattern, proper.

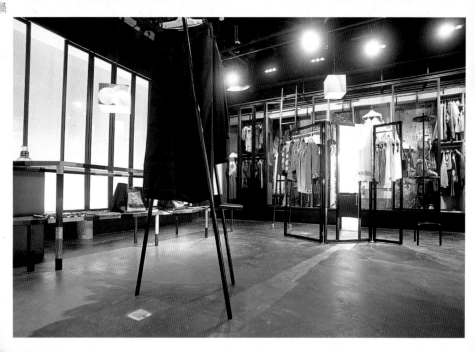

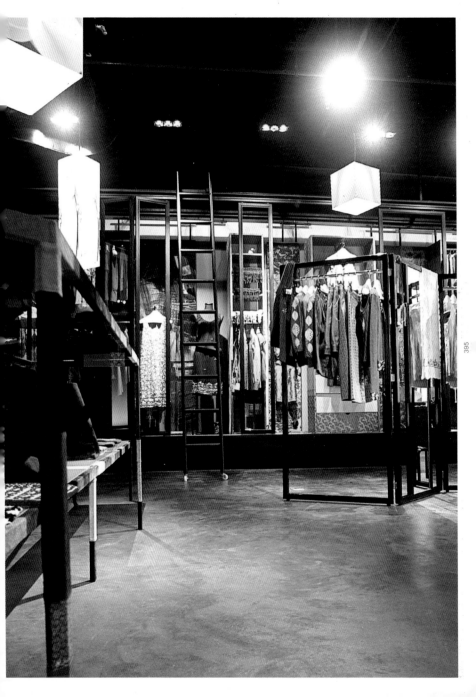

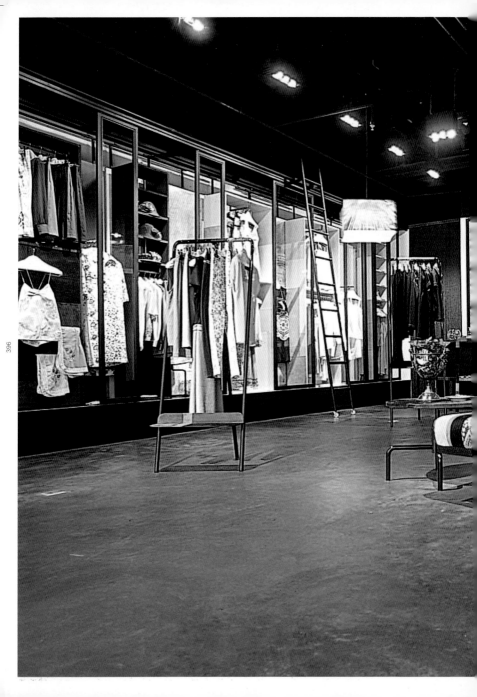

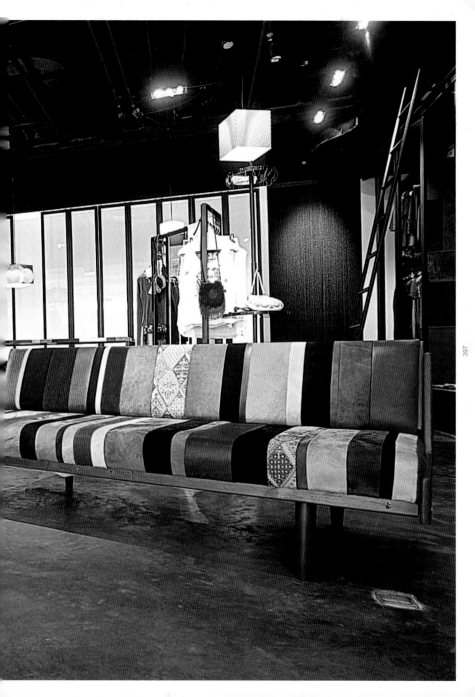

architects'
email index

AUSTRALIA

BBP Architects
bbparch@ozemail.com.au

Thomas Jacobsen
designs@thomasjacobsen.com

HONG KONG

AB Concept Ltd
info@abconcept.com.hk

Atelier Pacific Ltd
atpac@atpac.com

Axiom Oval Partnership
kelvin@axiomoval.com

Joseph Sy and Associate Ltd
jsahk@netvigator.com

KplusK Associates
kplusk@netvigator.com

MALAYSIA

John Ding, Ken Wong, Yik Swofinty/?
uodc@pd.jaring.my

Richard Se/Ph+D Design
phd_design@mac.com

SINGAPORE

Aamer Taher/Aamer Taher Studio
info@aamertaher.com

Cecil Chee, Robin Tan, Ng Lay Eng/Wallflower Pte Ltd
wallflower@pacific.net.sg

ECO-ID Architects & Design Consultancy Pte Ltd
ecoid@pacific.net.sg

Lawrence Ling
lawrenceling@consultant.com

Peter Tay
pompom@asia.com

Richard Chamberlain, Peter Teo, Philip Chin/
projectshopBLOODbros
mailroom@bloodbros.com

THAILAND

Archanart Bunnag
archanart@loxinfo.co.th

Chanachai Songwatana
chch777@hotmail.com

Chaivichai Promadhattaved/Pro-Space Co Ltd
prospace@inet.co.th

Gilles Caffier
senada@asianet.co.th

IAW Limited
lawbkk@asiaaccess.net.th

Mr. Pawinee Santisiri/Sahacha (1993) Co Ltd
sahacha1993@hotmail.com

Wichakom Topungtiem
cocoon@ksc.th.com

Sunaqua Concepts Ltd
sunaqua@hkstar.com

Three Dogs Studio
inbox@threedogsstudio.com

JAPAN

Masamichi Katayama/Wonder Wall Inc
contact@wonder-wall.com

Sybarite
mail@sybarite-uk.com

Tsutomu Kurokawa/OUT.DeSIGN Co Ltd
info@outdesign.com

Song Yih
msyaming@ms25.hinet.net

Soo Chan/SCDA Architects
csk@scdaarchitects.com

acknowledgements

We would like to thank all the architects, designers for their kind permission to publish their works; all the photographers who have generously granted us permission to use their images; all our foreign co-ordinators – Anna Koor, Barbara Cullen, Kwah Meng-Ching, Reiko Kasai, Richard Se, Savinee Buranasilapin and Thomas Dannecker for their hard work and invaluable help; and most of all, to all the establishments who have so graciously allow us to photograph their shops and to share them with readers the world over. Also, thank you to all those who have helped in one way or another in putting together this book.

Thank you all.